HIROSHIGE
Birds and Flowers

HIROSHIGE
Birds and Flowers

Introduction by Cynthea J. Bogel
Commentaries on the Plates by Israel Goldman
Poetry translated from the Japanese
by Alfred H. Marks

George Braziller, Inc., New York
in association with
The Rhode Island School of Design

Published in the United States of America in 1988 by George Braziller, Inc.

Reproduced from the Abby Aldrich Rockefeller Collection of Japanese Prints, Museum of Art, Rhode Island School of Design

For information, please address the publisher:

George Braziller, Inc.
171 Madison Avenue
New York, New York 10016

Library of Congress Cataloging-in-Publication Data:

Andō, Hiroshige, 1797–1858.
 (Hiroshige: birds and flowers / Introduction by Cynthea Bogel: commentaries on the plates by Israel Goldman; poetry translated from the Japanese by Alfred Marks.
 p. cm.
 "(Published) in association with the Museum of Art, Rhode Island School of Design, Providence."
 Bibliography: p.
 ISBN 0-8076-1199-9
 1. Andō, Hiroshige, 1797–1858 — Catalogs. 2. Color prints, Japanese — Edo period, 1800–1868 — Catalogs. 3. Birds in art — Catalogs. 4. Flowers in art — Catalogs. 5. Color prints — Rhode Island — Providence — Catalogs. 6. Rhode Island School of Design, Museum of Art — Catalogs. I. Goldman, Israel. II. Rhode Island School of Design, Museum of Art. III. Title. IV. Title: Birds and flowers.
 NE1325.ABA4 1988
 789.92'4 — dc19 88-1376
 CIP

Designed by Cynthia J. Hollandsworth

Type composed by U.S. Lithograph, typographers, New York

Printed and bound by Dai Nippon Printing Co., (Hong Kong) Ltd.

CONTENTS

FOREWORD

For most of us, the word *ukiyo-e* or "pictures of the floating world," conjures up images of the courtesans and actors, teahouses and theaters, romances, swashbucklers, and grotesqueries that formed the realities and fantasies of Edo Japan. In the same way, the name of the master Hiroshige at once evokes the city life of old Edo (modern-day Tokyo) or the great landscapes and little comedies to be seen while travelling the Tokaido – unforgettable pictures whose influence passed beyond his intended audience to take a formative role in the development of modern art in the West. Yet there is another side to Hiroshige's art – one that is understood in Japan and yet to be fully appreciated in the West. This is Hiroshige's bird-and-flower work (called *kacho-ga* in Japanese), in which the artist transforms a courtly Chinese painting tradition into a popular graphic mode that, in his hands, becomes a distinctive Japanese art form. It is thus with great pleasure that the Museum of Art of the Rhode Island School of Design greets this publication of treasures from its Rockefeller Collection.

It is now more than fifty years since Mrs. John D. Rockefeller, Jr. made her major bequest of prints to the Museum. As a collector, she focused upon the *kacho-ga* genre, building a comprehensive group of some 700 prints by 98 artists. Among these prints, more than 300 are works by Hiroshige, representing a full range of formats and subjects, in images of superb quality and condition, some unique surviving examples. This book is the first publication of a broad selection of these rarities.

The Rockefeller bird-and-flower prints are the largest single part of the Museum's Japanese print collection, which comprises more than 1300 images dating from the seventeenth through the nineteenth centuries. Most of these works were collected during the first part of this century and came to the Museum through bequests from Isaac C. Bates (1913), Mrs. Gustav Radeke (1920), Mrs. John D. Rockefeller, Jr. (1934 and 1941), and Marshall B. Gould (1946). In addition, a major gift of 88 *surimono* prints, formerly in the collection of Raphael Pumpelly, was given to the Museum in 1956 by George Pierce Metcalf. Today, the Museum continues to build its print collection through the generosity of donors such as Mrs. Leonard Granoff and through systematic purchase.

Mrs. John D. Rockefeller, Jr. (née Abby Greene Aldrich, 1894–1948) was born and raised in Providence. Her father, Senator Nelson W. Aldrich, collected books and art. He passed these interests on to his daughters. Abby's wide-ranging aesthetic interests – spanning modern art, American folk art, and Asian art – are well-known. Beginning with Japanese prints, Mrs. Rockefeller went on to collect Asian art in many media and is said to have been especially fond of her garden at Seal Harbor, which was landscaped in East Asian fashion and included many examples of Asian sculpture. Her elder sister, Lucy Truman Aldrich (1869–1954), also shared an interest in Asian arts and collected an extraordinary group of costumes and textiles which she gave to this Museum. The benefactions of the sisters form the core of our Asian collections.

We are delighted to acknowledge the efforts of the authors, staff members, editor, and publisher in introducing the bird-and-flower art of Hiroshige through this book. Cynthea Bogel, who served as Acting Curator of Asian Art at this Museum during 1987, and Israel Goldman selected the prints reproduced here. Ms. Bogel has written an introductory essay that places Hiroshige's bird-and-flower prints in an illuminating art-historical and cultural context. Mr. Goldman has contributed research and connoisseurship in his compilation of the annotated catalogue. Alfred H. Marks has provided translations of the poetry inscribed on the prints; in doing so, he brings the modern viewer closer to the experience of the Edo artist and his audience for whom poetry and picture together formed an integral aesthetic and emotional experience.

The superb quality of the reproductions in this book would not have been possible without the skill of the Museum's photographer Robert Thornton, who made the original transparencies. Melody Ennis, Assistant Curator of Education for Slides and Photographs, organized and expedited the production process. We also want to thank Beatrice Rehl, Fine Arts Editor, whose immediate enthusiasm set this project in motion and whose continued commitment saw it through. Finally, we extend our thanks and admiration to the publisher, George Braziller, whose devotion to capturing the textures and colors of original works of art through faithful reproduction has brought the intimate pleasures of rare European manuscripts, Chinese album leaves, and Japanese prints into the hands of countless modern viewers.

Maggie Bickford
Curator of Asian Art
Museum of Art
Rhode Island School of Design
May 1988

ACKNOWLEDGMENTS

To John M. Rosenfield, Abby Aldrich Rockefeller Professor of Oriental Art, Harvard University.

I have received the wise and kind assistance of many colleagues and friends in Japan, the U.S., and England during the preparation of this essay, for which I am most grateful. Timothy Clark at the British Museum gave pointed advice and corrections, which I acknowledge with appreciation. Any errors are my own. I thank the entire staff of the Museum of Art , Rhode Island School of Design for its continued support and especially the director, Frank Robinson, for his enthusiastic interest. Bob Thornton, museum photographer, deserves special credit. My own work owes the greatest debt to friends Minoru and Yō Nomura, who provided generous spiritual support and physical shelter on that cold winter hill in Roppongi.

Cynthea J. Bogel

I would like to thank Jack Hillier for his encouragement and advice. Chris Uhlenbeck kindly arranged for the Dutch scholars, the botanist L. Tjon Sie Far and the ornithologist G.F. Mees, of the Rijksmuseum van Natuurlijke Historie, to identify the species·of birds and flowers. To these two experts special thanks are due. I am most grateful to Roger Keyes who has so generously shared his knowledge and experience. He provided much helpful information, translated obscure seals, and corrected many errors in my text.

Israel Goldman

A number of scholars have assisted me in the preparation of this volume. They are, principally: Professor Haruko Iwasaki and Mrs. Fumiko Cranston, of Harvard University; Professors Takashi Kodaira, of Yokohama City University; Thomas Kondo, of Kapiolani Community College, Honolulu; Tokumoto Makita, of Kanazawa University, Kanazawa, Japan; Harue Summersgill, of Chaminade College, Honolulu; and Teruo Suga, of Nihon Medical College, Tokyo, as well as Mrs. May Michiye Uttal, of the Academy of Art, Honolulu, and Ms. Chui-chun Lee, of Sojourner Truth Library, State University of New York, New Paltz. What is accurate in the Japanese and English renditions and commentary on the poems is theirs; the mistakes are mine.

Alfred H. Marks

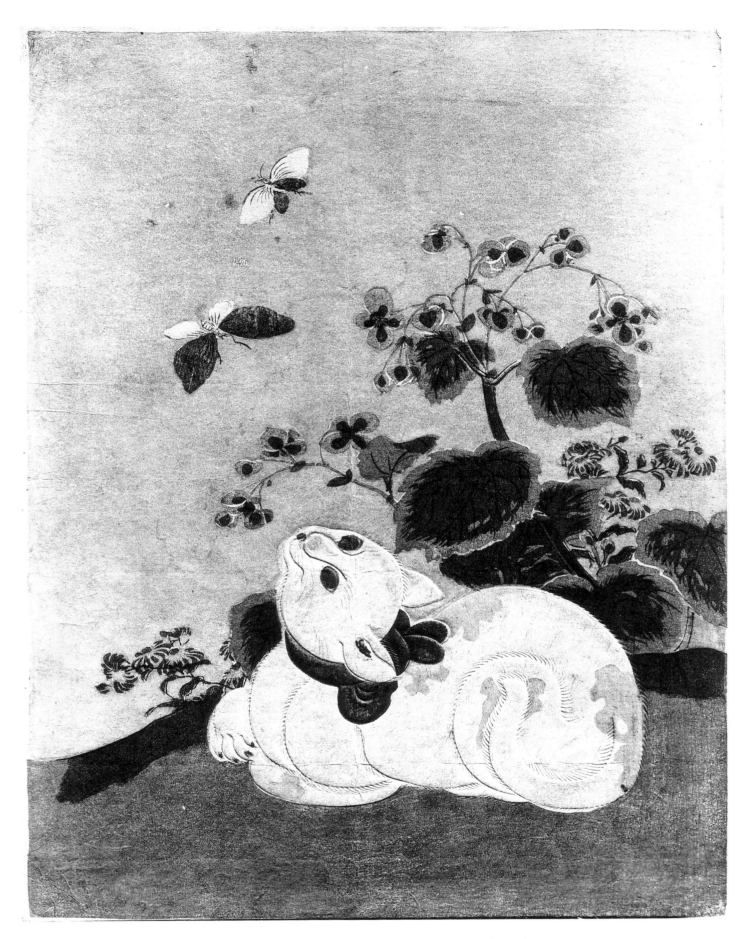

1. Suzuki Harunobu. *Cat and Begonia.* ca. 1760s. Printed ink and colors on paper. Abby Aldrich Rockefeller Collection, Museum of Art, Rhode Island School of Design.

INTRODUCTION

Hiroshige and the Bird and Flower Tradition in Edo Japan

The depiction of subjects from nature – particularly birds, animals, plants, and flowers – constitutes a rich tradition in the arts of Japan. This certainly applies to the well-known genre of Japanese wood-block prints, or *ukiyo-e*, which flourished in Japan between the seventeenth and twentieth centuries. Yet anyone familiar with *ukiyo-e* will inevitably cite themes other than flora and fauna as typical. Kabuki actors, lovely courtesans, erotica, scenes of the Edo capital, or travelers transposed against distant Mt. Fuji comprise the more commonly named subjects. Examples of this type were produced in abundance during the Edo period (1603–1868). They feature Japan's urban milieu prior to the influx of Western technology and tend to treat the particularly hedonistic aspects of a lively urban culture. But bird and flower prints are equally representative of this "floating world" – as the term *ukiyo* may be translated – because they document the evolution of a classical mode into a popular art form.

Andō Hiroshige (1797–1858) was one of the foremost wood-block print artists of his day, and through his genius, the bird and flower print genre achieved a popularity previously unknown. Bird and flower prints are not as common as *ukiyo-e* depicting other subjects, and examples in pristine condition are rare. This is the primary reason for the greater attention given landscape, courtesan, and actor prints in the literature on *ukiyo-e*. A bird and flower print collection of the caliber shown in part here, is exceptionally rare. Its assembly required intelligent foresight, discriminating taste, and financial means. Abby Aldrich Rockefeller possessed all of these. *Japonisme* in Europe and America from the mid-nineteenth century was stimulated by widespread interest in *ukiyo-e* prints. Both Western collectors and artists were fascinated by the unusual compositions, bright colors, provocative subject matter, and high level of technical achievement displayed by Japanese prints, and they found them quite in keeping with a developing image of the "exotic" Far East. This outside attention would stimulate contemporary interest in *ukiyo-e* in Japan, which had yet to retrieve it fully from its modern classification as a decadent manifestation of Edo culture and one of the period's most backward art forms.

Bird and flower print artists were generally less concerned with scientific observation or materialistic realism than with the portrayal of what is sometimes described as the "spirit" of a natural subject, or with interactions between natural elements. But from early times, the Japanese also displayed an interest in depicting and classifying plant, flower, and bird species. From the sixth century on, illustrated herbals were imported from China; independent Japanese *materia medica* and plant studies were produced shortly thereafter.[1] The European botanists and zoologists who visited Japan were quick to note the native interest in artistic and methodological study of the natural world.[2] Dutch landscapes and natural history treatises were among the few Western products that entered Japan through the limited free port of Nagasaki during the Edo period. Certain members of the Japanese artistic community took an interest in disseminating the styles they perceived in these works, focusing on mathematically derived perspective and a more objective, material approach to depicting nature. Despite the presence of these Western examples, other ways of depicting the natural world persisted in Japan, which suggests a fundamental difference in aesthetic or philosophic viewpoint. At the risk of oversimplification, it can be said that Japanese nature studies generally show a concern with life and movement. Apart from conscious experimentation in the "Western mode," the Japanese artists' more objective, detailed approach to representing nature was a style derived from Chinese court academy painting in the bird and flower mode. This courtly manner, however, is far from botanical or ornithological by Western standards.

Western viewers did not consider Japanese prints of birds and flowers to be natural history studies of the type to which they were accustomed. But there was significant scientific interest in the species of plants, flowers, birds, and animals depicted, and attention from other circles too. Many Impressionists and Post-Impressionists were aware of such prints and were intrigued by the conventions they employed. Bird and flower *ukiyo-e* were in the collections of Monet and other nineteenth-century artists, and flower paintings by Van Gogh – who painted copies of Japanese prints – show at least indirect influence. Moreover, Japanese bird and flower motifs – from prints and other art forms – were adapted for use in Western decoration arts. Their impact on the twentieth-century Art Nouveau movement was particularly significant.

An Edo-period author began his popular novel with a description of the *ukiyo* as the world where

> we live only for the moment, turning our thoughts to the moon, the snow, the cherry blossoms, and the maple leaves; singing, drinking, and diverting ourselves just in floating, floating, unmoved by the prospect of imminent poverty, resisting sinking spirits, we are buoyant, like a gourd floating along with the river: this is the floating world . . .
> Asai Ryōi (1610?–1681)
> *Tales of the Floating World* (ca. 1661)[3]

Asai's description represents one of the earliest recorded occurrences of the term "floating world" used with this particular nuance. For many centuries, Buddhist philosophy had employed the term to describe the ephemerality and impermanence of our earthly existence. During the Edo period, however, the acknowledgment of fleeting reality effected an unabashedly cavalier attitude toward life. "Floating world" was prefixed to many aspects of Edo-period life other than prints. *Ukiyo* fashion, coiffure, novels, and even umbrellas took on the epithet, epitomizing *ukiyo* as stylish and risqué. The Edo townsman's perception of an impermanent world was exacerbated by economic disadvantage and governmental restrictions, and by the frequent occurrence of fires, earthquakes, and famine. In this way the original meaning of *ukiyo* and a uniquely Edo interpretation of the term were merged.

Hiroshige's bird and flower prints are a rich combination of classical painting styles, literary references, symbolic meaning, poetic metaphor, calligraphy, and history. They are often regarded by both Japanese and Western

scholars as a somewhat distinct subject type in the *ukiyo-e* genre. Although this may be a reasonable distinction, scholars have long resisted categorizing bird and flower prints as forms of Japanese "popular art" on the order of actor, courtesan, and other *ukiyo-e* subjects. Unfortunately, they are misunderstood as anomalies in the *ukiyo-e* genre, labeled as one of several "alternative" themes that arose primarily in response to eighteenth- and nineteenth-century governmental censorship of figure prints. The nature of Hiroshige's characteristic poetic approach, the historical continuity of the bird and flower tradition, and the conditions that fostered the natural development of this *ukiyo-e* genre have frequently been overlooked.

Edo and the Floating World

The evolution of the *ukiyo-e* genre is in many ways synonymous with the growth of urban culture during the Edo period. The city of Edo was established in 1590 by Tokugawa Ieyasu, whose designation as shōgun in 1602 (or 1600) by the imperial court at Kyoto legitimized his power and began a long succession of Tokugawa rulers that lasted until January of 1868. The period boasts well over two centuries of internal peace. From 1639 the Tokugawa government enforced a "closed country" policy toward foreigners, allowing only limited contact through the port of Nagasaki on the western island of Kyushu. These factors allowed for a relative stability that fostered domestic commerce and saw an increase in agricultural productivity. The emperor in Kyoto had been rendered powerless by the shogun and feudal lords, or daimyō, who were supported by great numbers of samurai, or vassals. The Tokugawa government, known as the *bakufu* (literally, "tent government"), was able to check the potential power of the roughly 250 daimyō, in part, by requiring them to reside temporarily in Edo — usually for four months of each year. A period of absence from their domain presumably served to inhibit any attempts to raise forces against the shōgun, and the constant movement of the daimyō in and out of the new capital provided it with revenue — depleting their own coffers in the process.

The long established cultural values of the Kyoto-Osaka area, known then as Kamigata or "top region," distinguished it from the new urban center of Edo. Yet peacetime promoted the growth of cities and towns, and brought an increased level of cultural uniformity. Edo-period society was essentially one of a samurai mentality, even in the former capital of Kyoto. Because of the residency requirement for the lords, samurai households represented about fifty percent of Edo's population at any given time. The patronage, habits, and values of the urbanized warrior class influenced developments in the arts. Conversely, the slow absorption of once "exclusive" classical tastes by all the classes, and the popular expression of these tastes through new art forms, are a measure of the great economic and social changes experienced by the nation during the Edo period.

Edo was dependent on the two other urban centers of Tokugawa Japan, Kyoto and Osaka, for goods and services during much of the period. But by the early nineteenth century, the eastern Tokugawa seat of authority had become a city of over one million, as well as the new cultural and economic center of Japan. The pivotal Genroku era (1688–1704) is most often cited by historians as the time by which industry, commerce, and improved transportation showed some effect on both the urban and rural populations. Ironically, it was the group occupying the most despised position in the class hierarchy, the "parasitic" merchants, who came to be most influential in all but strictly governmental capacities. As money managers, the merchants (whose ranks might include both artists and samurai) won appreciable status and power with their liquid income. At the same time, ranks of samurai struggled to maintain an appearance befitting their high social status. Many daimyō incurred huge debts. The provincial regions, too, had been affected by a new commercial relationship with the cities. Farmers, although above both artists and merchants in social class, were generally impoverished. Before long, however, the rural gentry began to look for approximations of *ukiyo* world luxuries. Moreover, as literacy and political consciousness increased, the arts were further affected.

The government attempted to curb the new spending power of the *chōnin* (literally, "townsman") and to limit leisure activities. But these periodic "reforms" only seemed to hasten the spread of corruption and promote a doomsday outlook that spurred consumption. Excessive and unsanctioned tastes flowed freely like subterranean aquifers beneath a bedrock Tokugawa hegemony, yet external rather than internal pressures finally shifted the weight of the shogunal rule. Beginning in 1792 with Russian demands for trade negotiations — followed by those of the British, Dutch, and, in 1853, the Americans — Japan came out of seclusion and faced outside interests, at which time the "floating world" rose to the surface — only to dissipate without notice.

Hiroshige's World

The artist Hiroshige was born Andō Tokutarō in 1797, on the eve of the prosperous Bunka (1804–1818) and Bunsei (1818–1830) eras. Hiroshige's family, the Andō clan, exemplified a particular Edo class dilemma. Although each hereditary social group was defined by boundaries of decorum and economics, there was considerable variation in wealth within each class. This explains the phenomenon of the wealthy merchant, the gentleman farmer, the metalsmith who lived like a daimyō because the shōgun patronized his craft, and the samurai who was forced to find alternative sources of income. Poverty was sometimes inevitable for those within the low ranks of any class.

Samurai, who as members of the warrior class ranked higher in the social order than all but the shōgun and emperor, were gradually obliged to exchange their grants of rice (which had unstable value) for cash with which to buy goods. Lacking the skills and means with which they could earn a living, the increased numbers of impoverished samurai transferred more exorbitant taxation to the rural farming villages, whose populations ostensibly ranked immediately below the warrior class. Hiroshige's clan were low-ranking samurai (*go-kenin*), who probably numbered over 18,000 by the time he was born. The Andō-family held posts as *hikeshi-dōshin*, that is, fire-fighting league administrators. The family of the artist-to-be seems to have maintained a certain social advantage through its class. Their home — and Hiroshige's for nearly forty-five years — was the firemen's barracks located in an affluent section of Tokyo called "Daimyō Alley." But their daily existence was probably far from comfortable or economically secure. The Andōs were a typical example of Edoites whose economic status was increasingly diminished.

When Hiroshige's father died in 1809, the thirteen-year-old boy was obliged to take on the hereditary post of *hikeshi-dōshin*. His mother had died earlier that same year, and less than two years later the teenager was apprenticed to the *ukiyo-e* artist Utagawa Toyohiro. *Go-kenin* families were frequently engaged in cottage industries such as umbrella making, box construction, and wooden sandal production. Although an artist's apprenticeship was granted upon some display of skill and interest (Hiroshige

is said to have shown a fondness for drawing at a young age), its primary motivation, in Hiroshige's case and in that of many others was probably toward future economic security. Hiroshige held the rank of fireman's *dōshin* until 1832, all the while working under Toyohiro. His social status and chosen profession might appear to be contradictory, but were not, in fact, atypical for the time: While Hiroshige was born into the samurai rank and retained certain privileges in accordance with the status, he effectively lived as a craftsman.

The young Tokutarō received the artist's name Utagawa Hiroshige ("Utagawa," the school; and "hiro," part of his teacher's name, as was the custom), in 1812, after only one and a half years of apprenticeship. Many scholars cite this fact to illustrate his early talent, but it was common practice for apprentices to receive names around the age of sixteen, as Hiroshige nearly was. Moreover, his extant early work does not support claims of such prodigious skill. His training as a young boy in a samurai household may have exposed him to classical art, literature, and poetry, which are important to the bird and flower tradition. It is perhaps the unusual combination of latent samurai values or tastes, combined with experience in a pragmatic Edo artisan's world, that lends universal appeal to Hiroshige's work.

But the artist was not beyond availing himself of the small privileges his samurai status implied. Hiroshige's most famous landscape series, the *Fifty-three Stations on the Tōkaidō* (published 1833–34), depicts the way-stations along the highway running between Kyoto and Edo, and it launched his reputation as a leading landscape designer of the day. Practically speaking, the series was made possible because Hiroshige, through his samurai rank, secured permission to travel with a shogunal expedition to Kyoto, albeit as an artist who would sketch the ceremonies at the imperial grounds.

Hiroshige's first landscape work began only three years after his master Toyohiro's death in 1828, and his first bird and flower designs were produced about the same time. Both soon met with popular acclaim. It is no coincidence that when his reputation as an artist was secured during the 1830s, a substantial cross-section of Japan was becoming familiar with urban pleasures and artistic endeavors such as Chinese-influenced painting styles, Kabuki theater, and various forms of new and classical literature and poetry. Along with the appropriation of upper-class tastes, a greater consciousness of prosperous urban life had developed. The new cultural center to the east was increasingly refered to as "Great Edo" and "Flowering Edo" in the literature of the early nineteenth century. Hiroshige's bird and flower prints participate in this complex absorption process of traditional values into popular urban culture.

Ukiyo-e and its Audience

By the eighteenth century, the types and numbers of people who could, or cared to, afford art had grown. The first half of the nineteenth century witnessed the effects of varied tastes and audiences on art in a society experiencing great economic flux. Edo histories have traditionally focused on the first 150 years of the period and generally consider the years after 1760 to represent the beginnings of its demise. The art of the period is divided between "high culture" and "popular culture" — for the aristocratic or military elite, and for the masses. And because popular art is seen as a relatively new phenomenon in the history of Japanese art, a good deal of attention has befallen *ukiyo-e*, the infamous paradigm of art by and for the masses.

The term "popular culture" is one that has often been used to describe the activities and artistic products of Europe that ran contrary to academic or salon traditions or the culture for which we have fewer records and artistic remains. These distinctions between well-chronicled artistic traditions and the "other" aim to separate art — patronized by the ruling class, clergy, and intellectual elite — from popular culture. Early writers on Japanese prints saw an analogy here between the art of the West and that of Edo-period Japan. However, much of the work of the *ukiyo-e* artists' French contemporaries, for example, was often stridently political and, moreover, opposed to *l'art pour l'art*. Ukiyo-e artists delighted in poking fun at political and social events, but they were more concerned with *avoiding* governmental notice so that their work could be sold, enjoyed, and revised to be sold and enjoyed again. The artists were aware that their style was different from classical modes, but they did not consciously counter the latter. As several modern writers on French popular culture (Chartier, de Certeau, and Davis) have set out to show, common use of the word "popular" erroneously assumes the passive or dependent nature of cultural consumption.

Prevalent opinion, which holds that *ukiyo-e* was made by and for the masses, has been formed, in part, by the belief that *ukiyo-e* images depict the "popular." Popular Edo-period Japan is thus defined as a place of pleasure in an urban "floating world," or as a land of happy peasants in a picturesque countryside. Because our idealized vision of *ukiyo* culture depends, to a great extent, on the images offered us by the printed pictures and literature of the Edo period, we misunderstand the nature of the problem when we ask whether it is appropriate to define *ukiyo-e* as popular art. First, the meaning of "popular" should be questioned. Popular culture is not the art or literature that we single out as representative: it is a relationship between the product and its audience. Who determined the themes and contents of *ukiyo-e*? who purchased it? and who created it? are all questions that need to be asked. The answers should necessarily include the audience.

The great range of *ukiyo-e* presentations — satirical, historical, affectionate, poetic, pornographic, humorous, sober, symbolic, or graphic — suggests the complexity of the relationship between print and viewer. Ukiyo-e prints could be used as advertisements for Kabuki plays or "teahouse" courtesans, or serve as indirect devices to excite and please the imagination. They were pasted on walls, pillars, boxes, and screens, mounted in albums and on fans, set aside on desks, collected in quantities, traded, given as souvenirs, and discarded when fashions changed. They were offered singly and in sets. Prints as well as illustrated novels or picture books were sold in tiny publishers' storefronts or by itinerant peddlers, or given away to patrons. A distinct type of deluxe print, called *surimono*, was used for private distribution, primarily within poetry coteries.

By the mid-Edo period, print production was usually orchestrated by the publishers, who also oversaw distribution. They served, in effect, as interpreters of an envisioned public's demand. The voice of the *ukiyo-e* artist was at least of equal importance in determining subject and content. Each artist had stylistic trademarks and thematic preferences, and each maintained a mutually influential relationship with publisher and audience. But even the most talented or enterprising designers might be dependent upon the publisher's vital sponsorship. In order to be more economically independent, some print designers were themselves publishers and owners of bookshops, or they were otherwise employed. As one artist being pressured by a publisher explained, "Poverty is the common fate of the samurai, so why should I break my back for a few bushels of rice [the same that he receives as stipend]?"

Besides the publisher and designer, there were two other important participants in *ukiyo-e* production, the engraver and the colorist/printer.[3] Without each member of the "*ukiyo-e* quartet," as Volker calls them, the genre as we know it would not have materialized. Both the engraver and the printer (often working in groups) were frequently under the direction of the publisher. The *chōkō*, or block carver, possessed great technical skill. Records indicate that designers sometimes requested particular engravers. In the hands of the engraver, precise, fine lines and profuse detail belie the inherently rigid nature of the block.

Hiroshige's bird and flower prints utilize many special printing and carving effects. These include scraping the surface of the wood (*ita-bokashi*) to produce a tactile or volumetric quality in the color areas, carving lines in the manner of brush strokes, using blind printing (*karazuri*) for an embossed effect, and wiping color across the blocks (*fuki-bokashi*) before printing to produce graded color effects. With the advent of full-color printing around 1760, the printer, too, became a virtuoso technician. For a single print, a printer, or a group of printers, might coordinate as many as twenty different color blocks with a black line "key" block made from the artist's sketch, rubbing the back of each inked block with just the right pressure for the desired effect. Sometimes the publisher and printer, rather than the designer, determined the colors, just as the engraver familiar with an artist's style or current fashion could independently execute the background or details such as kimono patterns. However, the fine sense of color exhibited in the works of Hiroshige and other artists, and Hiroshige's consistent use of certain pigment combinations, support the opinion that many talented artists themselves specified the colors for their print designs.

Finally, as to the purchasers of prints, there is reason to believe that an extremely heterogeneous audience existed: from the farmer who returned to the countryside after an Edo business trip with a freshly illustrated novelette, to the high-ranking samurai we find — presumably — caught in the act of indulgence in several contemporaneous book illustrations. What we know of Edo culture, however, is confined to the cultural products we have probed. The inherent nature of *ukiyo-e* was not one that aspired to permanence or exclusivity. It is fair to surmise that *ukiyo-e* prints were more widely enjoyed than any other non-functional Japanese art form up to the time of their development, but just how widely cannot be accurately determined. The variety of themes available to the consumer indicate the range of tastes; similarly, the degree of elaboration in printing techniques and coloration reflect an audience with a wide range of financial means.

"Popular" culture is best evaluated as both the "art of doing" and the "art of doing with."[4] People read printed books in many ways, as there existed various degrees of literacy and understanding. Many popular novel forms and countless guide books — each with varying emphases on text and illustration — existed during the Edo period. Single sheet prints could also be "read" in various ways depending on a viewer's particular knowledge or view of contemporary culture, history, and literature. Social status and education were a major determinant in the interpretation of printed images, but these were not the only factors. Bird and flower imagery is heavily dependent on metaphor and symbolism. While they can be fully enjoyed by someone who does not understand these references, bird and flower prints might possess a certain appeal to the viewer who recognizes other levels of meaning. In any case, the "popular" nature of *ukiyo-e* prints involves a complex relationship of attitudes, expectations, consumption, and production. Though bird and flower prints do not actually depict the world of urban pleasures often as-sociated with *ukiyo-e* prints as a genre, they, too, participated in a popular urban culture as images to be enjoyed by the widest possible audience.

Edo Painting Schools and Sources for Bird and Flower Prints

Various schools of painting that reflect the intellectual allegiances, privileges, and limitations of the social classes flourished during the Edo period. All reveal some debt to schools that developed in the ancient cultural region centered around Kyoto. Many of these artistic traditions were derived from styles introduced by several waves of Chinese influence that reached Japan prior to and during the Edo period. It is to these traditions that one must turn to search for the sources of Japanese bird and flower painting.

Intercourse with China was limited during the Heian period (793–1185), and "native" modes developed in several directions. The heavily pigmented, static, and schematized interior court scenes and landscapes of the Yamato-e ("Japanese-pictures") school are typical of the work of the imperial painting office (*e-dokoro*) during this period. Painters attached to the court also produced lively genre-scene handscrolls. Literary references also indicate that a Chinese-derived ink tradition of landscape, bird, and flower themes existed at the court.

An imperial court painting atelier had thus already existed for centuries when the Ashikaga shoguns occupied imperial Kyoto from the mid-fourteenth century. The new warrior-class rulers fancied the ink-painting style of Chinese Chan (Zen) monks, which now challenged the superiority of the court tradition. During the subsequent Momoyama period (1568–1603), the military elite established a shogunal academy, with an independent lineage and style, led by the Kanō school. They employed Kanō artists to decorate the sliding doors, screens, and ceilings of castle and residential building interiors; this lasted well into the Edo period.

The Kanō were the main proponents of a Chinese-derived style, and the early Kanō artists were greatly influenced by the influx of Zen-associated painting. The predominant Kanō themes were birds and flowers of the four seasons, mythical or historical figures, and landscapes, all of which the school produced for both the shogun and Buddhist temples. Kanō works gradually came to be characterized by eclectic borrowing and innovations in a wide range of styles. The Edo-period Kanō artists varied the earlier (primarily ink) repertoire of the school with many works characterized by crisp, fine outlines in bold pigments. As in previous centuries in the Chinese court academy of painting, assemblies of natural objects in seasonal settings were a favorite seventeenth-century theme. An example of the Edo-period Kanō style is illustrated in figure 2. Shown is a detail, from one of a pair of six-fold screens, of the *Four Seasons* attributed to fifth-generation Kanō painter, Sanraku (1559–1635). The screens were originally owned by a daimyo of the powerful Ōwari domain, west of Edo.

Sanraku was the best of the Kanō painters who remained in Kyoto after the school formed a main branch in the new capital of Edo during the early 1600s. His style represents the school at its most confident. Although Kanō Sanraku sometimes worked in ink alone, these screen paintings are executed like many of his other works, in rich colors on gold leaf and gilding. In addition to the cock and hen beneath a blossoming plum tree, the full screen shows ducks in a pond, cranes, a variety of flowers, and many smaller birds in trees. This profusely detailed mode is derived from a Chinese court style that was known to Japanese artists from paintings that were brought back

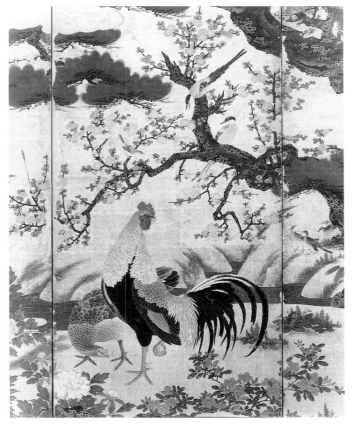

2. Detail. attr. Kanō Sanraku. *Birds and Flowers of the Four Seasons*. Early 17th century. Pair of six-fold screens. Ink, colors, and gold leaf on paper. 158.4 × 355.6 cm. each. Tokugawa Art Museum.

to the islands by priests and envoys prior to the Edo period. Many elements of Sanraku's style are derived from the Chinese academic tradition: the portrayal of the birds and flowers in overlaid pigments with fine outlines – or with no outline at all – known as the "boneless" mode; the formal and relatively static presentation of an outdoor scene; the schematized and highly ordered spatial arrangement of pictorial elements; the depiction of space through ascending rather than illusionistically receding forms; the standardized bird types; and the profusion of symbolic natural elements. Evident, too, are features derived from the Yamato-e style, such as the rounded land forms and the lozenge-shaped gold cloud at the upper left. Several of Hiroshige's bird and flower prints, such as the *Peacock and Peonies* of plate 25, the *Wild Duck* of plate 5, and the *Pheasant* of plate 65, show indebtedness to a Chinese-derived Kanō style.

The appellation used here, "Bird and flower pictures," in Japanese *kachō-ga* is the generic abbreviation for a traditional Chinese classification of painting that is, in fact, not limited to bird and flower subjects. Along with figure and landscape painting, it constitutes one of several major thematic groups and concentrates on flowers, plants, grasses, trees, birds, animals, fishes, and insects. In Japanese the larger category is sometimes called *kachō-fūgetsu* (literally, flower and bird, wind and moon – that is, nature). The charming color print of a cat eying some butterflies near a begonia plant (fig. 1), dated in the 1760s and attributed to the well-known *ukiyo-e* artist Suzuki Harunobu (1674–1770), is an example of this broadly defined *kachō-e* tradition.

Bird and flower painting, fostered by imperial patronage, flourished during the Chinese Song dynasty (960–1297). The Song emperor Hui Zong (r. 1101–1126) was himself a painter of natural subjects, and it is recorded that he had a collection of over 2,700 bird and flower works in his possession. Much of the flower, plant, and animal symbolism that had developed earlier in Chinese literature was adopted by painters during the Song dynasty and made its way to Japan during the fourteenth century. Flowers were also used in early Buddhist art as symbols of purity. Later, the *literati* added new meanings to natural elements and singled out certain plants and flowers such as the bamboo or the plum blossom to serve as icons for their world view. In the Kanō screen detail discussed above (fig. 2), the peonies in the left foreground and the plum branch above the rooster are classical Chinese symbols of summer and early spring that were by this time part of the Japanese vernacular.

Nearly all the birds and flowers used in Hiroshige's *kachō-e* prints derive from Chinese or Japanese literary and artistic sources. Flowers are particularly admired by both cultures, and nearly all have anthropomorphic or symbolic meanings. Many natural elements in the arts of both China and Japan are invested with spiritual, intellectual, and symbolic values. These associations are mythological, religious, literary, political, natural, and experiential. In Japan, flowers in particular convey a reserve of subjective emotions in addition to their standard seasonal associations: plum or cherry for spring, peony for summer, chrysanthemum or morning glory for autumn, and camellia or the bamboo plant for winter. The cherry, for example, stands for ephemeral beauty; the plum and narcissus represent twin purities of emotion; the morning glory is often mentioned in literature as a symbol of illicit love; the peony represents regal wealth; and the peach suggests spiritual freedom. Particular birds or animals are associated with these flowers or have similar symbolic meanings, for example, the pheasant is associated with autumn and the chrysanthemum; the kingfisher, with the iris; the wagtail (*sekirei*), with sexual love; the sparrow or swallow, with camellias (or the swallow with the peach blossom); the courtly peacock, with peonies, symbols of opulence; the falcon, with royalty or military strength; the crane and the pine – representing 1,000 and 10,000 years, respectively – with longevity; the crow, with the gods, as their messenger; the cuckoo (*hototogisu*), with summer; the pawlonia tree, with rectitude; rabbits and the moon, with fertility; ducks, with conjugal fidelity; geese and the nightingale (*uguisu*), with autumn. The list goes on. Some of the earliest bird and animal associations relate to the ancient Chinese zodiac; the lion, rooster, and rabbit are favorites in art.

Ancient Chinese painting texts taught artists to imitate the work of the masters, to transform these models, to observe nature, and to develop personal expression and individual virtuosity. To capture the essence of nature, one did not work directly from scenery or specimens; rather, one observed the natural world, conceptualized it, and painted from the understanding captured in the mind's eye. In the course of this study, a great reverence for the natural world developed. The "Eastern" philosophy of the natural world, so widely publicized in the West, derives from Buddhism. Generally speaking, humankind is seen as a nonobtrusive participant in the natural world. The artist, therefore, aims to capture the spirit or essence of the object depicted, not strictly its material form. Although particular attitudes and philosophies toward nature are evident or latent in art, we should be cautious about deriving conclusions regarding an individual's or group's perception of a flower, for example, from its painted form.

A Kyoto-based school of painting that originated in the early Edo period, known today as Rimpa, draws much of its subject matter from nature. The painter Tawaraya Sōtatsu (fl. 1630–1650) and the calligrapher Hon'ami Koetsu (1558–1637) were the nucleus of an arts group that produced not only paintings, but also ceramics, textiles, and lacquerware. The earliest Rimpa designs are bold

3. Nakamura Hōchū. *Plovers and Waves*, from *Kōrin Gafū (Kōrin's Sketches*, compiled by Hōchū). 1826 (second edition) Abby Aldrich Rockefeller Collection, Museum of Art, Rhode Island School of Design.

and abstract interpretations of natural elements. Ogata Kōrin (1658–1716), an important Rimpa artist, lived and worked in both Kyoto and Edo during the culturally prosperous Genroku era (late seventeenth century). In virtually unprecedented fashion, Kōrin sketched from nature. His final designs — first used on pottery made by his brother, Kenzan, and then on painted screens and handscrolls — transformed his ink impressions of grasses, flowers, and birds into stylized designs that belie the realistic detail of his original drawings. His designs were also used on kimonos, incense wrappers, fans, cloth, and other practical items. Many of Kōrin's designs were copied by eighteenth- and nineteenth-century Rimpa artists for use in printed books. One fine example, shown in figure 3, is an illustration of plovers and waves from the picture book *Kōrin Gafū (Kōrin's Sketches)*, compiled by the early nineteenth-century Osaka artist Nakamura Hōchū. As is typical of many Rimpa works, the image can be read as either "picture" or "design." Most studies of Edo art downplay any real Rimpa impact on Edo and insist that the style is a paradigm of the spirit of the Kamigata region during the early Edo period. While this is essentially accurate, the Rimpa school was revived in Edo just before Hiroshige achieved fame in the early nineteenth century, and some of his *kachō-e* prints indicate familiarity with the Kōrin style. The fan-shaped print of irises in a marsh shown in plate 45 is a good example of a Kōrin-derived Hiroshige design, as is the medium panel print of a plum tree against the moon in plate 34 which recalls Edo-period Rimpa works of the same subject.

Whereas in earlier periods strong Chinese influence on Japan was, to a great extent, fomented by Buddhism and its arts, during the Edo period, interest in Chinese culture was dominated by a native interest in the study of Con-fucianism. The Tokugawa shoguns promoted neo-Confucianism, ostensibly as the national code of ethics; with it came the philosophical texts and artistic pursuits of China's newest generation of *wen-jen* ("literati"). The Japanese samurai officials and scholars who pursued *literati* studies gradually became interested in paintings by Chinese *wen-jen*, some examples of which were imported through Nagasaki.[5] They sought the *literati* works by amateur-painters of the Sung and Yuan dynasties, but instead found mainly late Ming (1368–1644) and early Qing dynasty (1644–1912) examples in a range of styles by both amateur and professional painters. Another source of current Chinese painting styles were the Huang-po (in Japanese, ōbaku) monks, who returned from study in China with paintings or painting skills.

The so-called Nanga school, which like the Ukiyo-e and Rimpa schools originated during the Edo period, is the Japanese counterpart to Chinese *literati* painting.[6]

The works designated by the Japanese as Nanga style are not necessarily *literati*. Among these are bird and flower paintings executed by late Ming and Qing artists who worked for the court or who painted in a courtly, academic manner. For the first time in Japanese history, a number of Chinese artists came to the islands during the Edo period. A few Chinese painters were officially invited to Japan by the *bakufu*, who had also appointed a connoisseur of Chinese painting (*kara-e-mekiki*) to the government compound at Nagasaki. Others were merchants or monks who also painted. Their instruction was sought by Japanese painters, who passed on their learning to their pupils. Many of these Chinese painters were not well known in their own country, but they were of utmost importance to Japanese artists of all schools and many geographic areas. In fact, these visitors contributed much to the evolution of bird and flower painting. Their styles reflect the melding of court and *literati* traditions that had occurred in China, where many professional artists were in demand for private commissions, and traditionally amateur *literati*

artists were selling works to a new elite merchant class.

One such Chinese emigré artist was Shen Quan (active 1725–1780), who though not well known in his homeland, was to inspire a cultlike following in Japan. Better known as Shen Nan-pin (in Japanese, Chin Nanpin) he was a Qing dynasty academic bird and flower painter, who came to Nagasaki in 1731 at the behest of a *bakufu* official. Although he stayed less than two years, Shen's influence continued for several decades and is apparent in paintings and prints by artists of many Japanese schools. As late as 1813, Japanese literatus Tanomura Chikuden (1777–1835) could still write:

> Today's painters, when depicting birds and flowers, usually follow the 'boneless' technique that was made popular by Shen Quan. . . . he painted with adroit contours and his pigments were thick and charming. During these times of protracted peace, people had become tired of the Sesshū and Kanō schools, so everyone praised Shen and his style advanced quickly.[7]

Not only did the Shen style spread rapidly, but the artist also continued to receive commissions from Japan after he returned to China. Other painters who came to the islands were asked to produce works in the Shen style, which was probably an insult.

Shen's style reveals a concern with both the meticulous representation of natural objects, and their life and

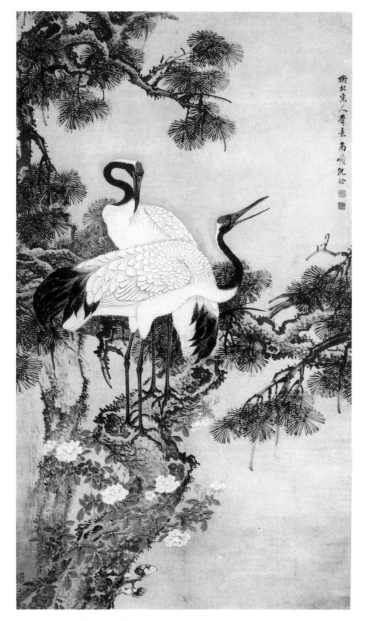

4. Shen Quan. *Two Cranes in a Pine Tree.* 18th century. Ink and colors on silk. 169.3 × 90.3 cm. The Hashimoto Collection.

movement. Accordingly, he combined the "realistic," courtly mode with "impressionistic" conventions, fusing detail and illusion. These features here are evident in the Shen painting, *Two Cranes in a Pine Tree,* shown in figure 4. Cranes, symbolic of felicity and longevity, are perched upon a twisting old pine tree, also representative of long life. Peony flowers and mushrooms are painted on the lowermost section of the tree trunk, further adding to a convincing portrayal of an outdoor scene. Shen employs conventions that lend an empirically descriptive effect to the work, for example, shading the fowls' beaks and sections of the tree to convey a three-dimensional effect, and carefully delineating specific surfaces of the birds and the flowers. These features contrast with a more traditional ink-style handling of the tree trunk with wet, loose strokes and stippling. Shen uses a characteristic technique – a variant of the "boneless" mode of painting forms without ink outlines – whereby ink lines are lightly painted and then color is laid on top, rendering them pale. He also typically painted in both thin ink or color washes and bright, heavy pigments. The composition of *Two Cranes in a Pine Tree* is standard for both Shen and his generation of academic painters: the tree twists in and out of the picture plane, creating a brief passage of spatial depth into which the birds are neatly placed.

Most Japanese devotees of the Shen mode modified his palette to paler tones and adopted a closer viewpoint than is usually applied in his work. Although many authors note the popularity of Shen Quan's style, few suggest a reason for its appeal to Japanese *literati* painters who were avowedly nonacademic. Perhaps it is because of his attention to the material, "realistic" depiction of forms – something that was not seen in the majority of *literati* styles to reach Japan, but which had already attracted native interest in other Chinese and Western works of art. Unlike the early Chinese academic tradition represented in Japan by the works of the Kanō school, the attention to detail in Shen's paintings does not produce an overall decorative effect, nor does surface description prevail over real anatomical concerns. In this regard his works are closer to the scientific natural history studies brought to China during his time by the Jesuits, though, more idealized.

The pervasive influence of the Shen style was transmitted by his pupils and gradually blended with the bird and flower styles of other Chinese artists who visited Japan or whose works were imported. Chief among subsequent influences was the style of Yun Shou-ping (1633–1690), an earlier painter whose works appear to have reached Japan after Shen's sojourn. That the Japanese were able to choose their models freely – albeit from a limited number of Chinese examples – is central to the development of Japanese Nanga and its influence on other painting schools. The range of interpretations of Chinese-inspired bird and flower styles may be discerned in two very different works by artists contemporary with Hiroshige (figs. 5 and 6). The painting by Japanese Nanga artist Tsubaki Chinzan (1801–1854) in figure 6 reveals a combination of Shen and Yun Shou-ping styles.[8] Chinzan's *Birds Amid Cherry Blossoms* shows two empirically described birds (the colors are subdued but precise, the species and structure accurate, the feathers of many textures and types), which are all but overwhelmed by delicate pink blossoms and pale green leaves. All the botanical elements are painted in the "boneless" style, which by 1828 (the date of Chinzan's work) was well known to Japanese artists. Chinzan's objective depiction of the birds may be the result of his study with Watanabe Kazan (1793–1841), a prominent exponent of Western painting styles. Chinzan was also active in printed book illustration.

The second example (fig. 5) that makes reference to Qing Chinese bird and flower painting styles is a large-format wood-block print by well-known *ukiyo-e* artist Katsushika Hokusai (1760–1849). It was executed around 1834, when *kachō-e* prints were becoming widely popular through the work of Hokusai and Hiroshige. The work depicts the same symbolic crane and pine motif seen in Shen Quan's work, but in contrast to the Chinese work, the birds are pressed right to the foreground picture plane, and the print is consequently much bolder in effect. Although Hokusai's work clearly differs from Shen's, and falls just as certainly under the rubric of the *ukiyo-e* style, certain similarities are striking. Firstly, the Hokusai print adopts an identical arrangement of the curving pine trunk, here moved to the center of the composition. The cranes occupy the same characteristic spatial cell used in Shen's work. The detailed manner in which the birds' feathers are handled, and the Chinese ink mode employed for areas of the snow-laden pine tree in the Hokusai print are also indebted to imported Qing styles. The calculated turn of the crane's neck, while echoing the spatial arrangement of the pine branch, turns our attention to the expressions of the birds, which Hokusai handles with characteristic interest. Among the *kachō-e* prints by Hiroshige that reflect a knowledge of seventeenth-century Chinese academic bird and flower styles is plate 63.

Significantly, some of the most influential Chinese artworks to reach Edo-period artists beyond Nagasaki were not paintings, but block-printed Chinese books and albums.[9] Examples such as *The Ten Bamboo Studio Calligraphy and Painting Albums* (*Shizhu zhai shuhua pu*), published in sixteen volumes between 1627 and 1633; and the *Mustard Seed Garden Manual of Painting* (*Jiezi yuan huazhuan*), published in twelve volumes between 1677 and 1701, with a final volume in 1818, first appeared in Nagasaki not many years after they were circulated in China. They became more widely available in Japan after a ban on foreign books was lifted in 1720. These two works and others were reissued by the Japanese using blocks recut from the original plates.[10] These Chinese works are relevant to bird and flower *ukiyo-e* in at least two ways: the books influenced the development of printing in Japan, and thus *ukiyo-e* in general; and many of the Chinese books featured birds, flowers, plants, and trees, which served as models for Japanese artists. Although the styles shown in the printed Chinese works were not as current as in many of the paintings known to Japanese artists, they did not seem to make a great distinction between the two forms. The Chinese books and albums that influenced Japanese artists are sometimes erroneously described as painting manuals. This is, in fact, only true for some, notably the *Mustard Seed Garden Manual*. Other works were manuals in name more than in usage, and were deluxe volumes enjoyed primarily by the moneyed middle-class Chinese patrons of the seventeenth and eighteenth centuries; *The Ten Bamboo Albums* is a fine example. In any case, even the *Mustard Seed Garden Manual* did not serve a pedagogical purpose in Japan in the same way it did in China, where it was used as a copy book. Rather, all the printed books were seen by the Japanese as paradigms of current Chinese style.

While the development of full-color printing in Japan owes something to these Chinese models, other factors contributed significantly to the evolution of Japanese printing. Economic feasibility, public response, and artistic interest were equally decisive issues.[11] One of the earliest books to utilize a full range of colors with accomplished printing registration is the *Sō Shiseki gafu*, which was published in three volumes in 1765. It was designed by the Edo artist Sō Shiseki (1712–86), who traveled to Naga-

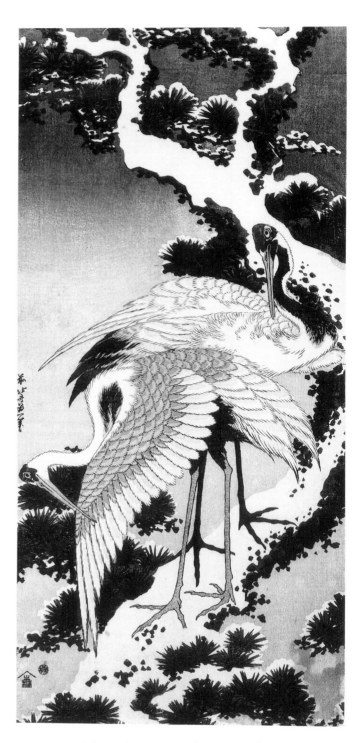

5. Katsushika Hokusai. *Pair of Cranes in Pine*. ca. 1834. Printed ink and colors on paper. Abby Aldrich Rockefeller Collection, Museum of Art, Rhode Island School of Design.

saki to study Chinese styles. He trained there with Shen Quan's major pupil, Kumashiro Yūhi (1693 or 1713–72), and mastered the Nanga style, which he then introduced to Edo when he returned in the mid-eighteenth century. (Tani Bunchō is traditionally [and correctly] credited with its proper introduction later in the century.) Thus, some of the current Chinese painting styles to first reach the Edo art world were tinged with the Shen-style academic bird and flower painting mode.

Given the element of realism in the Chinese styles that reached Edo-period Japan — at least some of which was Western-influenced — it should come as no surprise that many of the artists who pursued continental styles were also interested in Western modes of description. The Japanese exploration of European learning, which they called *Rangaku* (literally, "Dutch studies"), focused primarily on the natural sciences. Other interests were generally opposed by the *bakufu*, who considered abstract philosophical thought, for example, a threat to the neo-Confucian principles they espoused. Hiraga Gennai (1729–79) and

16

Shiba Kōkan (1747–1818) were early proponents of foreign thought. Kōkan was an artist, and some of his experiments in oil painting and copper-plate etching reflect his early training in the Shen Quan bird and flower style, combined with a Dutch-influenced, low-horizon perspective. The artist often depicted rare bird species native to Japan, indicating his awareness of ornithological studies.

Kōkan's efforts initiated more artistic and scientific work of greater depth, and by 1820, many Japanese scholars were publishing their own texts based on Western topics. Landscape *ukiyo-e* produced by both Hiroshige and Hokusai during the 1830s show familiarity with mathematically derived perspective and composition.[12]

An interest in empirical, Western modes of depicting nature may have influenced the leader of an important "return to nature" movement in eighteenth-century Kyoto. Maruyama Ōkyo (1733–1795) declared that artists, instead of copying the works of ancient masters, should study the scene or object, and sketch it before painting, thereby coming to know both its spirit and form. Although this is largely in response to the prevalent use of painting models by Nanga artists, Ōkyo's paintings are so distinctive and full of a life energy theretofore uncaptured by an artist's brush that his philosophies must be considered as consonant with his method.

Ōkyo excelled in landscape, figure, and bird and flower painting, and had many students. Matsumura Goshun (1752–1811) studied under Ōkyo and then moved to the Nanga studio of Yosa Buson. Goshun's style is generally considered to be a fusion of Ōkyo's particular naturalism and many technical and aesthetic features of the Nanga school. Without Buson's special talent and poetic sensibility, this "fusion" would have little meaning, however. During the last half of the eighteenth century, the modes and theories that had developed with Ōkyo, Buson, Goshun, and others influenced the works of many Kyoto artists, who are together loosely defined today as the Shijō or Maruyama-Shijō school.[13] It is the influence of the Shijō artists that is most prevalent in the bird and flower prints by Hiroshige. Shijō advocates preferred nature or genre subjects, and they worked in the mediums of both painting and printed books. The latter developed admirably in the hands of the Shijō school. They were dedicated to a spontaneous, "subjective" depiction of nature that was, nevertheless, based upon a prescribed means of gaining familiarity with the inner life of the subject. Because of the particular training and viewpoint of the Shijō artists, their products were generally more impressionistic than Nanga works.

It is not easy to characterize the Maruyama-Shijō school. Poetry was important to their work but not in the academic manner in which it was pursued by Nanga artists. The best Shijō works are lyrical studies of nature without being insipid. They are charming and impressionistic in the spiritual sense of the words, and yet fully aware of their own conventions. It is useful to look at Shijō works with the understanding that there is a cultivated self-consciousness at the basis of the school's approach, a "style" of self-consciousness that can be compared to works by the Rimpa school, but to different effect. The Shijō works do not appear calculated, nor do they emphasize pattern and design over "picture." Although utilizing some of the same pictorial conventions and painting techniques of the academic Ming and Qing works, there is little apparent concern with descriptive realism of a similar type. Technically, the artists often employed a soft brush, utilizing muted but varied colors with bright accents, or painted in plain black ink of graded tones. They mastered the full range of "boneless" or "semi-boneless" modes, and explored these modes through refined print-

ing techniques. The compositions of Shijō works are often simple, with close-ups and isolated subjects prevailing. The same basic designs often occur over and over again, but they are rarely contrived or repetitious. The works of second-generation Shijō artists illustrated here — an ink painting of the 1820s by Goshun's pupil Okamoto Toyohiko (1773–1845) in figure 9, and the 1834 color woodblock illustration from *Sonan gafu* by Ōnishi Chinnen (1792–1851) — in figure 10 — should convey the range and common features of the Shijō school more readily than words.

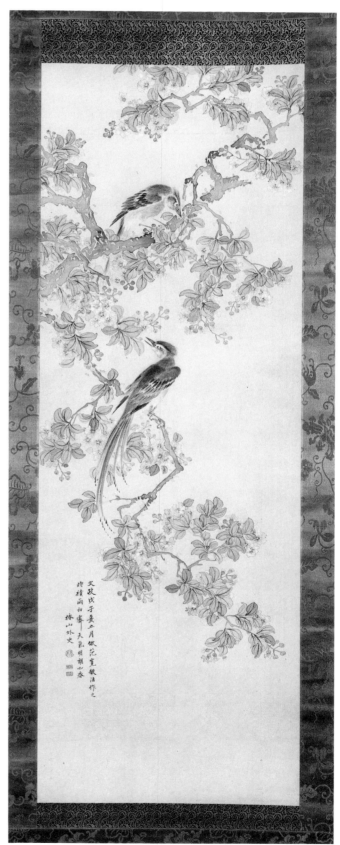

6. Tsubaki Chinzan. *Birds Amid Cherry Blossoms*. Dated 1828. Printed ink and colors on silk. 124 × 42.1 cm. Spencer Museum of Art, Promised Gift of Mr. and Mrs. Mitchell Hutchinson.

Toyohiko's seemingly effortless depiction of a sparrow and bracken in soft, wet ink is first and foremost a design supported by a series of relationships both physical and temporal (fig. 9). The natural setting is conveyed by suggestion, the setting made real by the implication of a moment in time where the sparrow is caught in flight. The natural forms are tersely depicted and yet fully convey the representation of a vast natural world. The Shijō artist often insisted on capturing particular moments, movements, or moods in life and nature, and some artists could, at times, lapse into sentimentality or overidealization. Toyohiko's work resists this tendency.

Ōnishi Chinnen, designer of the warblers and persimmons in figure 10, was an Edo-born samurai. Like many Shijō artists, he studied broadly, absorbing various Chinese styles and classical techniques. He learned of Maruyama Ōkyo's style from Watanabe Nangaku (1763–1813), who essentially introduced it to Edo during a three-year period of residency in the eastern capital. Chinnen's illustrations and paintings reveal a sensitivity toward both humor and pathos, and a verve that is easily attributed to his urban setting. His use of color in the illustration from *Sōnan gafu* is very similar to Hiroshige's, as are the printing effects: a full palette of subtle colors with bolder accents, and graded tones in both "boneless" and outlined forms.

The Shijō designers used the print medium as an expression of original designs and explored it for its unique characteristics. Artists such as Chinnen clearly delighted in the manipulation of the block and ink for both painterly and printed effects. Chinnen, and many other Shijō artists (notably Yamaguchi Soken [1759–1818]) produced superb studies of plants, flowers, and birds that reveal a scientific understanding of natural forms. The works rarely display a hard realism, however, but often use a calli-

graphic line and atmospheric or illusory devices. As in many Shijō examples, Chinnen's creatures are depicted with sensitivity and charm. The Edo Shijō artists were influenced by the *ukiyo-e* style and its urban subject matter. Conversely, as is clear in the work of Hiroshige, some *ukiyo-e* artists were well aware of the Shijō school's approach to natural subjects in the print medium.

Ukiyo-e and New Meanings for Birds and Flowers

The widespread notion that *ukiyo-e* was the new art by and for the Edo masses is occasionally contrasted with the opinion that it represents a fusion of all the styles of Japanese painting. This oversimplifies the broader picture of Japanese art history. For although *ukiyo-e* did not emerge suddenly, without connection to existing traditions, the same can be said for the schools discussed above, for example, Rimpa or Kanō. *Ukiyo-e* artists were often trained in classical styles, and their work invariably contains elements of these schools. On the other hand, the use of relatively unprecedented subject matter and a certain frankness of vision are clearly the distinguishing trademarks of "floating world pictures."

Some *ukiyo-e* artists moved with ease and skill between various artistic styles. Hiroshige, for example, preferred a Shijō mode for his nature subjects; but he sometimes modified courtly Chinese compositions and designed a few dragon prints in the Kanō tradition. Utamaro — famous for courtesan portraits in the *ukiyo-e* style — preferred a Chinese-derived, detailed mode for illustrating poetry books with shells, insects, and birds (fig. 7). Such command of styles, however, hardly saved the new breed of *ukiyo-e* designers from the criticism and classical bias of the established art world. Few artists whose reputation lay with other schools produced works in the *ukiyo-e* mode. Shiba Kōkan, who experimented widely in Chinese, Western, and Japanese styles, remarked of his undetected Harunobu courtesan-print forgeries and his own *ukiyo-e* fashion designs under the name Harushige: "I illustrated the new style [of hair ornamentation], which subsequently became

7. Kitagawa Utamaro. *Bush Warbler and Penduline Titmouse*, illustration from *Ehon Momochidori Kyōka Awase* (*A Hundred Birds Matched with Kyōka Verses*). Two volumes, published ca. 1791. Printed ink and colors on paper. 25.3 × 19 cm. The Harvard University Art Museums.

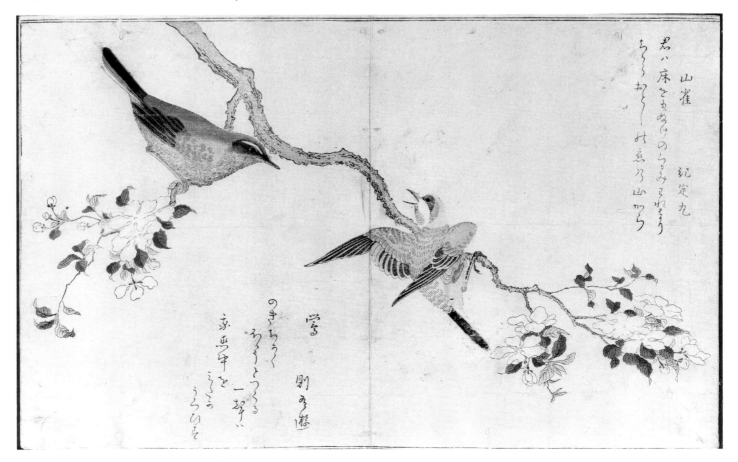

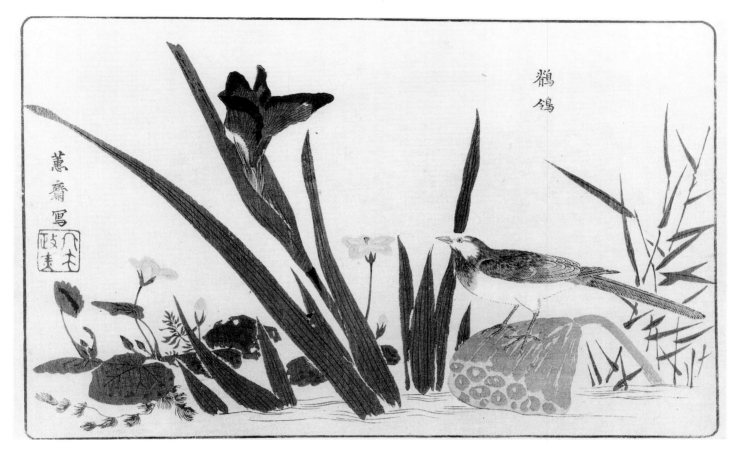

鶺鴒

8. Kitao Masayoshi (Kuwagata Keisai). *Iris and Wagtail on a Lotus*, from *Kaihaku raikin zui* (*A Compendium of Pictures of Birds Imported from Overseas*). One volume album, originally published 1789; republished 1793. Printed ink and colors on paper. 25.6 × 18.8 cm. Abby Aldrich Rockefeller Collection, Museum of Art, Rhode Island School of Design.

exceedingly popular. But I feared that such work would damage my reputation, and I gave it up."[14] Hishikawa Moronobu (ca. 1618–1694), the artist credited with giving impetus to early Edo *ukiyo-e* development, prefaced his signature with "*yamato-eshi*" (literally, "Japanese painter"). His intention may have been to recall the classical Yamato-e tradition or to call attention to what he considered to be the genuineness or nativeness of the new *ukiyo-e* mode.

The response of the public and publishers to the early prints and books that featured favorite pastimes and persons of the floating world made it evident to all concerned that this was potentially "popular" material. Toward the end of the seventeenth century, the prints produced by these artists were being called "pictures," that is, art. Thus, *ukiyo-e* took its position between the legitimate art world and an untraveled path with an unexplored audience. It flourished from this unlikely spot, despite the mistrustful watch of the *bakufu*. *Ukiyo-e* would evolve during its 250-year history, but it never disengaged itself from the popular embrace. Edo quickly became and remained the spiritual center of *ukiyo-e*, but the popularity of prints grew elsewhere. The *ukiyo-e* genre remained viable not because it *depicted* popular activities and figures, but because it *participated* in creating "the popular." As "art," these prints offered images of the floating world; as "cultural products," they also prefigured it. Ultimately, many of the same urbanites and officials who scoffed at these fashionable ephemera called *ukiyo-e* were drawn to the printed image. They, too, had become part of the floating world.

Many of the early print designers, particularly those based in Kyoto, produced bird and animal subjects in addition to actor, courtesan, and erotic themes. Nishimura Shigenaga (1697–1756) was notable in this regard. Until

Hiroshige's day, the predominant format for *kachō* themes was that of printed books and deluxe, privately commissioned prints. The literature on the first two centuries of *ukiyo-e*, in its emphasis on landscape and figure studies, has neglected the occurrence of single-sheet *kachō-e* designs. Bird and flower prints owed even more to Kanō and classical modes for subject and style than did early *ukiyo-e* figure prints, and they thus evoked high-class tastes. But their audience extended well beyond the patrons of traditional styles and art forms. Classical and academic associations evidently made *kachō-e* prints attractive to commoners. Judging from extant designs dating before 1765, the *kachō-e* mode gave the *ukiyo-e* designer an outlet for stylistic diversity or experimentation, and offered to both artist and viewer a variant subject matter in the already circumscribed range of themes for *ukiyo-e*. During the early eighteenth century, several new publishing enterprises were set up outside central Edo (the site of the earliest shops), near the roads that linked the western Kamigata region and Edo. One can reasonably infer that their target client was the Kamigata traveler who was most familiar with classical themes, which may explain the number of *kachō-e* works produced by early *ukiyo-e* designers.

The first *kachō-e* prints may have been designed by Torii Kiyomasu (1694–1716?), who produced, in addition to Kabuki actor prints, large-format eagle and falcon prints derived in part from the *Nigiri Kobushi* book of falconry, which was published in 1687.[15] His contemporary, Okumura Masanobu (1686–1764), an extremely talented and lively artist responsible for many of the technical and pictorial innovations of early eighteenth-century *ukiyo-e*, designed the *sumizuri-e* falcon print shown here (fig. 11). The subject implied privilege and grace. Falcon-hunting was restricted to samurai and nobility in Edo Japan, and artistic depictions of these birds had long been associated with the court and with China. Hiroshige's many falcon designs attest to their continuing popularity (plates 23, 60). But his nineteenth-century examples are not as obviously based on the Kanō style as the Masanobu work. But not all early *kachō-e* prints did have classical or courtly references. Humor and puzzling symbolism also figure in

19

known designs, which show a range of creatures including monkeys, boars, owls, sparrows, and other animals and birds.

The early *kachō-e* efforts by *ukiyo-e* artists coincided with a continuing Rimpa tradition in Kyoto and the beginning of the new "realistic" representation by Maruyama Ōkyo. Not long after, imported books from China, scientific materials from the West, and the cultural products of the Kamigata and Nagasaki *literati* were being perused by artists who gathered together in Edo. Early in the nineteenth century, Rimpa was revived and transformed in Edo by Sakai Hoitsu, and, at the same time, Ōkyo-inspired students who comprised the Shijō school found their way east. Edo came into its own, and *ukiyo-e* artists became a vital and distinguishing feature of its spirit.

The next major change in *kachō-e* prints was concomitant with the new developments in printing techniques and a related boom in demand for *ukiyo-e*. As the cultural pursuits of samurai and *chōnin* began to overlap, the artistic products made by and for these unlikely comrades showed that elegance and popular culture were no longer strangers. Around 1765, delicately colored picture calendars began to be produced for poetry circles comprised of the wealthy and educated new middle class. They represent the earliest extant block prints in half a dozen or more hues. The artist whose work is most closely associated with this new development was Harunobu. The print attributed to Harunobu in figure 1, exemplifies this landmark phase in *ukiyo-e* technique. When examined in the original, the scene of a cat eying butterflies displays a great delicacy of color and line and a refinement of printing technique that characterize privately commissioned and distributed works with printed verses known as *surimono*.

At this time there were two basic types of single-sheet prints: the privately distributed *surimono*, and the "commercial" (for lack of a comparable term) *ukiyo-e*. Both types continued for the duration of the Edo period. Although they influenced each other, these printed genres were, because of their patronage and intent, more distinct than similar in style. Many *surimono* artists worked exclusively on commission. Some *ukiyo-e* artists also produced designs for private commissions. Some privately distributed, full-color *surimono* prints were apparently so popular that they were recut and reprinted for later commercial use. Publishers succeeded in systematizing some of the fancier aspects of the new techniques to make prints economically feasible. By the late 1760s, multi-block color-printed commercial sheets, called *nishiki-e* or "brocade prints," became the standard for *ukiyo-e*. The future of *ukiyo-e* thus gained new security. At the same time *ukiyo-e* artists, as the purveyors of a popularly acknowledged and eminently marketable style, became more historically aware of themselves; they began to make references to the works of earlier *ukiyo-e* artists by evoking their trademark themes or styles in their own prints.

Bird and flower prints soon became an established subgenre of the now viable *ukiyo-e* mode. Conversely, *kachō-e* were no longer slaves to their classical referents: *ukiyo-e* artists had achieved an independence that saw them blending artistic styles, or reviving classical modes, with license. In late life, Harunobu designed willowy teahouse ladies and produced only a few bird and flower pictures such as that illustrated in figure 1. His contemporary (and pupil), Isoda Koryūsai (d. 1760), produced many *kachō-e* designs in various formats characteristic of his day, including the long, narrow "pillar" prints and the vertical *chūban* employed much later by Hiroshige.

The fourth quarter of the eighteenth century is considered the golden age of *ukiyo-e*. New styles and techniques

9. Okamoto Toyohiko. *Sparrow Flying Above Bracken*. ca. 1820s. Private Collection.

were developed or appropriated by *ukiyo-e* artists. Shiba Kōkan introduced copperplate etching and other Western techniques to Edo. About this time a block-printing technique that imitated the ancient Chinese method of stone-rubbing (in Japanese, *ishizuri-e*) was also developed. These prints convey the characteristic effect of a white reserve design against a background of stone-rubbed grain in black or blue ink, through the use of wooden blocks. *Soken-sekitatsu* (ca. 1768), one of many printed books of this type, shows plants and calligraphy executed by the Kyoto eccentric Itō Jakuchu (1716–1800), who is best known for hyperrealistic bird, animal, and flower designs. Hiroshige designed a number of *ishizuri-e*, many with *kachō-e* subjects. As exemplified in plate 24, most use the Prussian blue pigment imported to Japan during the 1820s (and so important to Hiroshige's landscape prints), and are thus sometimes called "blue prints" (*aizuri-e*). *Ishizuri-e* frequently used birds and flowers traditionally associated with China; plate 24 employs ancient seal script for the Chinese couplet and shows an unidentifiable bird and a loquat — the latter a Chinese court symbol. Classical elegance was evoked in *kachō-e* prints by the addition of Chinese verse and a sober composition.

The evolution of deluxe printing techniques parallels the popularization of *literati* and samurai values in Edo-period society. Classical literary references, symbolic bird and flower subjects, and the use of decorative effects (such as metallic pigments) were once considered high-class but were gradually appropriated by the pictures and novels composed both by and for other social groups. Early *kachō-e* prints are indicative of this trend. Bird and flower prints achieved a predominant status in the *ukiyo-e* genre through the works of Hiroshige and Hokusai, and the persistence of traditional symbolism and metaphor in their work is notable. Hiroshige's *kachō-e* prints display a variety of styles that testify to the dissemination and blending of artistic modes that occurred during the Edo period. Some parallels may be drawn with the situation in China centuries earlier. There, the bird and flower painting tradition, long associated with a resplendent court style, had for some time been adapted for the enjoyment of the cultivated gentry, whose favorite painted subjects included birds, flowers, fruits, and rocks. These were the themes depicted in *The Ten Bamboo Studio*, the luxurious printed albums discussed earlier.

By the second quarter of the eighteenth century, a broad segment of urban society had fully absorbed the achievements of four major artists from the Genroku era (1688–1704) who worked in popular forms: Chikamatsu Monzaemon (1653–1724), Kabuki playwright; Ihara Saikaku (d. 1693) novelist; Matsuo Bashō (1644–1694), haiku poetry master; and as previously mentioned, the harbinger of the *ukiyo-e* style, Hishikawa Moronobu (ca. 1618–1694). Their work had, for the most part, addressed a wide audience; but where it did not it was transformed by the audience. This is the feature that distinguishes the moment, that designates the reciprocal relationships of "popular" culture. From the mid-eighteenth century, the Edo townsman would be an integral part of artistic determination and not just on a "popular" level. The popular would also affect the classical tradition, integrate it, and extract from it what was relevant for the new mode.

Widespread poetic consciousness was one development critical to Hiroshige's *kachōe;* spurred by new verse movements, a fusion of the arts ensued in Edo. Haiku, the 5–7–5-syllable verse form familiar to many Westerners, was among the most popular forms. Matsuo Bashō was its creative force. When poet-painter Yosa Buson moved to Edo in the 1750s, his verses stimulated the illustrated *haiku* movement in painting. About that same time the haiku verse became common in printed book form. Another style of versification to flourish at this time was the 31-syllable *kyōka* (literally, "mad verse"), a typically humorous or satirical free verse form that parodied the traditional *tanka* form. It was revived in Edo during the 1770s and became the most influential literary style of the day. The practice of poetry composition spread from the private meetings of samurai and wealthy *chōnin* to large associations known as *gawa,* which boasted hundreds of members from smaller affiliated circles or clubs called *ren* situated throughout the cities and provinces. The many illustrated poetry books and single-sheet prints with poems that were commissioned by coteries are a union of two creative modes that are, nevertheless, independent. Haiku were traditionally required to have a seasonal element (*kigo*), and bird and flower illustrations were often used for this purpose. *Kyōka* were generally less explicitly seasonal, but nature themes often figure in their clever allusions.

The illustrations used with the poems were not merely "accompaniments," however. Some designs offered suggestive or parallel meaning to the poems, others provided the proper atmosphere for appreciating the verse, and many were not even related to the poem in theme or allusion. A complementary aesthetic effect might involve a similar image or a contrary one. A study of the poems that occur with Hiroshige's *kachō-e* will illustrate the point.

The printed examples shown in figures 7, 8, and 12 represent the artistic and technical achievement of these private publications for connoisseurs. The first two are perhaps the most important bird and flower works by *ukiyo-e* artists produced during the eighteenth century. Figure 7 is a two-page spread of a bush warbler (*uguisu*) and penduline tit (*yamagara*) from the *kyōka* anthology *Ehon momochidori kyōka awase* (*A Hundred Birds Matched with Kyōka Verses*) by Kitagawa Utamaro (ca. 1753–1806), printed in two volumes around 1791. Utamaro is best known in the West for his studies of female physiognomy in single-sheet *ukiyo-e,* but he made great achievements in both prints and book illustration. *Momochidori* constitutes the third title of an illustrated *kyōka* trilogy; the two volumes that precede it have to do with insects and reptiles, and seashells. The deluxe nature of *Momochidori* is evident in its lavishness: the paper, colors, printing, and calligraphy are of the highest quality, and a Chinese-type album format is used. Moreover, advertisements for the bird volume appeared in the volume on insects in 1788,

10. Ōnishi Chinnen. *Warblers and Persimmons,* illustration from *Sōnan Gafu.* One volume, published 1834. Printed ink and colors on paper. The Ravicz Collection.

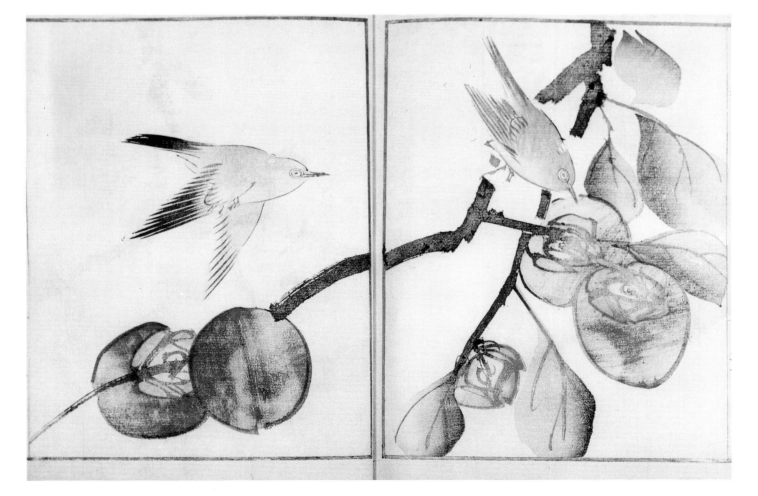

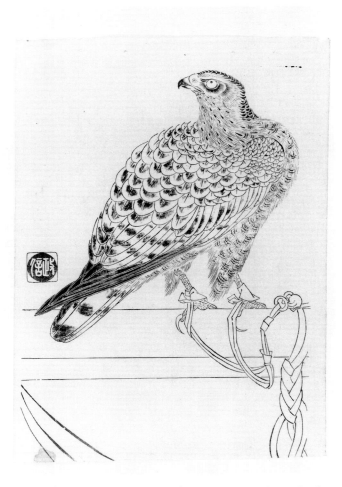

11. Okumura Masanobu. *Falcon.* ca. 1725. Printed ink on paper. Abby Aldrich Rockefeller Collection, Museum of Art, Rhode Island School of Design.

and one can infer from this that between two and three years were allotted for poets to submit verses and for Utamaro to prepare designs.

The *kyōka* poems that accompany Utamaro's fine illustration (fig. 7) read:

Near the eaves	Not a sign of you
I hear the warbler	Do I find
Sing a song of envy;	In your bed tonight;
He must be	Alone and sad,
watching us,	I am but a titmouse
My lover and me.	in love.[16]

In the *kyōka* book, the soberness of the illustration frequently belies the humorous or lewd nature of the verse. Utamaro presents nearly thirty different birds with flowering trees and grasses, in a variety of poses and relationships to the verse, in the two volumes. All are distinguished by a concern with naturalism that was uncommon at this time. Utamaro was undoubtedly aware of Western ornithological and botanical studies.

Utamaro may also have been influenced by the work of the Edo artist Kitao Masayoshi (1764–1824), who in 1789, just prior to *Momochidori*, published a remarkable volume of studies of imported birds and plants in a highly realistic, Chinese-derived style. A sheet from *Kaihaku raikin zui* (*A Compendium of Pictures of Birds Imported from Overseas*; republished in 1793 with the title *Ehon kachō kagami* [*A Mirror of Birds and Flowers*]) is shown in figure 8, and portrays iris and wagtail on a lotus. The book was said to have caused a sensation when it was published, undoubtedly because of its "exotic" style and subject matter. The preface is in Chinese (which emphasizes its uniqueness), and the foreword, in Japanese, explains to the reader that the unfamiliar birds were brought to Japan by Chinese and Dutch sea captains. Masayoshi's designs

are explained as reduced facsimiles of paintings by a Chinese artist.

Whereas Utamaro's birds show virtually none of the unoutlined forms or standard Nanga spatial arrangements, or designs discussed earlier from the Shen Nan-pin school of bird and flower painting, Masayoshi's work clearly draws upon the Shen bird and flower tradition. Moreover, it displays the more current Chinese influence that reached Japan through late seventeenth-century Qing period books and imported paintings by artists such as Yun Shou-ping (1633–1690): a "pure boneless" technique, a more subdued coloration, and a gestural quality preferred by later *literati* artists and sponsors. These same qualities are evident in the 1828 Nanga school painting by Tsubaki Chinzan discussed above.

Hiroshige was almost certainly aware of both the Utamaro and Masayoshi books, which represent major achievements in the *kachō-e* print genre. The abundance of bird and flower themes in privately commissioned work such as these books or *surimono* was of great significance to the development of the *kachō* genre during the Edo period. Roger Keyes, in his work on *surimono*,[17] suggests that the number of bird, animal, and flower themes in *surimono* may have encouraged Hiroshige to design commercial *kachō-e* prints in the 1830s. Most important, he notes the subsequent decline in popularity of the privately commissioned works after the advent of commercial *kachō-e* prints. It remains, however, a moot point whether Hiroshige developed a "popular" form of *kachō-e*, or whether the latent demand existed reflecting the public's interest in themes and styles shown by the more exclusive *surimono* and limited edition books.

Hiroshige's Birds and Flowers

Hiroshige's artistic approach to *kachō-e* subjects is varied, as the present selection will reveal. Hiroshige designed about 10,000 single sheet prints and several hundred book illustrations during his more than forty year career.[18] Bird, animal, flower, plant, insect, or animal subjects probably account for over 500 of these designs.[19] Although only a fraction of Hiroshige's *kachō-e* works can be illustrated here, the breadth and quality of the Abby Aldrich Rockefeller Collection is such that the works illustrated in this volume can be considered a representative cross-section of his *kachō-e* oeuvre. In fact, Hiroshige's small-format *kachō-e* designs have frequently been neglected in favor of his popular *ōtanzaku* ("large panel") prints, a tendency countered here by the presentation of a variety of print sizes and types.

Only approximate dates are possible for Hiroshige's *kachō-e* works. Approaching the works by size and format offers an alternative method of appraisal. Exact dimensions vary, depending upon later cropping and trimming. *Tanzaku,* translated here as "panel prints," are narrow vertical designs of three sizes: large (*ōtanzaku*), medium (*chūtanzaku*), and small (*kotanzaku*).[20] Hiroshige utilized all three types of *tanzaku* for *kachō-e*. In the case of the standard block formats of full-, half-, and quarter-block (*ōban, chūban,* and *koban*), he frequently used *ōban* for landscapes (for example, plate 91) with both *chūban* and *koban* also well represented in the *kachō-e* oeuvre.[21] Hiroshige also designed *kachō-e* to be mounted as fans, called *uchiwa-e*. These were glued to the bamboo supports of nonfolding fans, the shape of which is described by that of the print (see plates 40–47). The supports merge below the print area to form a solid handle. As most fan prints were actually used as such, undamaged and unfaded examples are rare and generally comprise sheets from fanshop sample books. Hiroshige was apparently fond of the

unusual shape. Roger Keyes estimates that Hiroshige produced 300 to 400 fan designs during his career.[22] His *uchiwa-e* designs are, in fact, among the most admired of that type within the *ukiyo-e* genre.

In addition to these formats, Hiroshige executed large prints known as *kakemono-e* made by two *ōban* (full block) prints attached vertically. The name refers to the hanging scroll painting format, which they emulate. The striking example of a peacock and peonies in plate 25 represents the type, which is rarely preserved in such fine condition. Another print format illustrated in the plates is an *ebangiri-e* ("horizontal letter sheet"), measuring about 19×51.5 cm. and represented by the cranes of plate 39. Finally, the plates also include a rare example of an original artist's drawing (pl. 6). The engravers generally worked from these drawings by gluing them (face down) to the surface of the blocks. In some instances, however, the artist's design may have been recopied by someone whose specialty was making drawings for blocks. Other *kachō-e* formats not illustrated in the plates shown here are the small envelope sets (*fūtō*) that typically carry landscape or bird and flower scenes; and *harimaze*, groups of small, variously shaped designs printed on one sheet, which were often cut apart. Both these types are found in the Rockefeller collection.

It is significant that Hiroshige began producing *kachō-e* prints about the same time as the landscapes that established his reputation. Around 1830 or 1831 he is thought to have designed *kachō-e* in *koban* or *yotsugiri* ("quarter-block") and *kotanzaku* ("small panel") formats. From then on the sizes and types varied considerably. Hiroshige probably designed *kachō-e* up until his death in 1858, at the age of 62, but most were executed before 1840. The Hiroshige bird and flower prints to receive the most attention from connoisseurs are, without a doubt, the first edition *ōtanzaku* series published by Jakurindō in the very early 1830s (pls. 1, 7, 10, 11, 15, 16, 17, 19). From the mid-to-late 1830s, the majority of *chūtanzaku* ("medium panel") designs were probably executed.

Fish subjects are a minor but interesting theme in the *kachō-e* genre. Among Hiroshige's *ōban* (full-block) and *chūban* (half-block) format work are six series of fish, in both still-life arrangements and natural settings. Hiroshige may have known the fish studies by Watanabe Kazan — the Bunchō pupil and Western enthusiast noted earlier — or may have been familiar with similar Chinese examples. One horizontal *ōban* fish set was published by Eijudō, probably around 1832. That they were produced in collaboration with a group of *kyōka* poets establishes his participation with poetry circles in the early 1830s. This coincides with the production of a number of his famous large-panel bird and flower designs. Another theme within the bird and flower genre consists of the twelve animals of the traditional (Chinese) zodiac. Eight extant designs of one such assembly by Hiroshige in *chūtanzaku* format are known. Color is used sparingly in these animal designs, with shades of black and gray, and accents in pink or red predominating. The animals are presented in an endearing manner that resembles contemporary animal depictions of the Shijō school rather than their Chinese sources. Hiroshige also painted in the *kachō-e* mode. One admirable, large-scale work of the wild "mountain cherry" species seen in several print designs in the plates is extant in the form of large, painted doors for Senkoku-ji temple in Kanagawa prefecture. This work was painted during the late 1830s, for the brother of Hiroshige's second wife, who was chief priest at the temple.

A great range of styles and techniques are used by Hiroshige to convey the splendor of nature. His prints exploit every technique of wood-block cutting and print-ing that have been discussed thus far, and his designs convey spontaneity and a concern with portraying relationships between elements in the natural world. All these features immediately bring to mind the work of the Maruyama-Shijō school artists. Indeed, Hiroshige wrote in his picture book of ca. 1848, *Ehon tebiki gusa* (*Hints on Illustrated Books*): "A painted image derives from the shape of an object, but when the artist adds the interpretation of his brush to the familiar likeness, then the result will be 'a picture.'" Elsewhere he wrote, "I copy the things around me just as I see them,"[23] which echoes the "return to nature" philosophy of Maruyama Ōkyo.

The artistic conventions used by Hiroshige for *kachō-e* may be approached from several standpoints. Many contain poetic verses. Haiku are by far the most common, followed by *kyōka* and then classical Chinese or native forms. The format and size comprise one rough stylistic grouping. These, in turn, reveal a correspondence to the type of poetic verse used, if any, and the type of calligraphic script employed. The history of bird and flower painting and prints as it has been traced through this essay allows the reader to discern certain classical references, innovations, and contemporary influences in Hiroshige's *kachō-e*. In general, the larger format prints show the styles that are most obviously derived from the Chinese. When poems are included here, they are typically written in a standard calligraphic script (*kaisho*), which is associated with ancient China. Moreover, these verses are almost always Chinese-style poems or Japanese classical *waka*. Several works of this type will be discussed below. But the predominant mode seen in Hiroshige's *kachō-e* prints is only distantly related to the carefully detailed, finely colored Chinese academic bird and flower style. Hiroshige's characteristic *kachō-e* is lyrical, graceful, and often executed with a loose, calligraphic brush. Most show a native haiku verse, written in one of two cursive (rather than the blocklike standard) script types. These designs are charming without being overly sentimental and show an unsurpassed sense of color. In short, their style is very close to that of the contemporaneous Shijō school. The similarity is somewhat evident even in Hiroshige's landscape work, but it is particularly apparent in his *kachō-e* oeuvre.

One of the most formal designs in the present selection is the opulent peacock and peony (pl. 25). The detailed description of the bird's feathers and the luscious, soft petals of the varicolored peonies recall Chinese Song-period academic painting as translated by Kanō Sanraku (fig. 2). The stable arrangement of forms in a slow S curve is also typical of later Kanō works, as is the choice of subject. A comparison with plate 19 offers insight into Hiroshige's nineteenth-century artistic viewpoint: although the same references to classical modes are evident in this *ōtanzaku* composition of a pheasant perched on a chrysanthemum-studded crag (both flower and bird are icons of autumn), a greater transparency of color and looseness of line is apparent. These features indicate some familiarity with Qing bird and flower modes, which merged Chinese court and popular styles, or familiarity with Nanga and Shijō works influenced by such Chinese sources. The application of two-tone color patches to leaves without black outlines resembles Ming Chinese printed books, and the handling of the rocks is executed in a traditional Chinese ink mode. A glance at the medium-panel print of plate 29, *A Little Bird Amidst Chrysanthemums*, indicates the direction Hiroshige more often takes with his fluid brushwork. Here, the flowers breathe with the same life voiced by the open-mouthed bird.

Other large panels that display a formal, Chinese-derived style or theme are the colorful parrot of plate 15, the ex-

otic bird of plate 16, the in stone-rubbing style (*ishizuri-e*) print of plate 24, the sparrow and bamboo of plate 22, the peonies of plate 63 and the rooster of plate 20. However, the latter print, featuring a cock, morning glories, and umbrella, clearly represents a different type of formal presentation. The composition, arranged as though it were a still life of natural objects, calls to mind similar compositions in *surimono* prints. This work also shows an awareness of the Rimpa school in its self-conscious design. All three elements are standard classical literary reference, symbolizing the parting of lovers described by the verse. The noncursive *kaisho* calligraphy used for the *kyōka* verse, which parodies the classical lovers' lament at dawn, is appropriate to the formality of the composition. It is interesting to compare this rooster design with the one in plate 57, which is far more painterly in execution and humorous in effect.

Many of Hiroshige's fan prints and half- or quarter-block flower studies are done in a highly schematized, naturalistic mode and are printed in translucent or opaque colors with fine outlines. Many are reminiscent of Shijō printed books of flowers, and more specifically printed *kachō-e surimono* and book illustrations by Matsumura Keibun (1779–1843), Goshun's brother and early Shijō master, which Hiroshige may have encountered in Kyoto or through the Shijō circle in Edo. This same style is translated into more delicate and atmospheric terms in the exquisite *ōtanzaku* examples in plates 1, 10, 11, and 13, and in countless smaller format examples, where forms rendered in blind printing, delicate tones, and pure color without outline create images that evoke seasonal and poetic effects. The charm of these large panel prints is irresistible: birds hang upside down, flutter in the moonlight, or greet the viewer with an engaging grin. The subtle and poetic nuances of these works suited the taste of the middle class Edoite and his new artistic interests. Hiroshige may have shared the same sense of aesthetics. The large format and deluxe printing techniques suggest that the patron was able or willing to pay for his preference.

Hiroshige's *kachō-e* in the medium- and small-panel and or half- and quarter-block formats are stylistically and symbolically varied. The medium panels are particularly stunning. From the elegant trio of geese winging across the moon-graced sky, of which the Rockefeller collection can boast two states (pls. 3 and 4), to the tumbling young swallows (pl. 9), or the delicate dragonfly and begonia (pls. 14), each panel successfully offers a complete pictorial or conceptual statement. Hiroshige skillfully adapts standard compositions so that they appear unique; the designs are complete in even the smallest format.

If one studies these examples, several stylistic types can be distinguished, but they are all clearly the work of the same artist. It is interesting that nearly all the works with borders drawn around them (for example, pls. 80, 83, 89) bear a likeness in coloration and compositional techniques to the artist's landscapes, many of which also include such borders. The trends of nineteenth-century *ukiyo-e* are well represented by the striking *koban* of a crane and wave in plate 72, which resembles several designs of the same subject by Hokusai. In other small-format examples, a distinctly Chinese mode reminiscent of the Kanō school is adopted (for example, pheasant in snow, pl. 65; sparrow and bamboo, pl. 18; bird on fuyo tree, pl. 64; grapevine and inko bird, pl. 56), although there are few, if any, quarter-block images that are as distinctively Chinese-derived as the several large-format works discussed above. Designs such as that of the inko bird are strongly linked to the straightforward manner of the *Mustard Seed Garden Manual*, and interestingly, this particular example carries a Chinese verse, as if drawing attention to its stylistic source.

A number of designs of ducks appear in Hiroshige's *kachō* oeuvre, primarily the "mandarin" type associated with China. In pairs, ducks symbolize fidelity and wedded bliss. Many of the poems on the prints make reference to this traditional meaning, such as "thin ice is a wedding cup" in the unusual print shown on plate 28 – with its overhead viewpoint and stylized spiral composition – or "The morning tempest/sees even mandarin ducks/go separate ways" of the small panel print of plate 31. The single wild duck design in *ōtanzaku* format, plate 5, shows Kanō school spatial conventions (overlapping and diagonal arrangement of forms), definition, and detailing. Hiroshige undoubtedly knew the work of Maruyama Ōkyo's pupils perhaps including the many duck paintings by Mori Tetsuzan (1775–1841). Some of Hiroshige's designs resemble the latter's. Examples such as plates 6, 61, and 67 are similar to the work of contemporary Shijō-school artists, as are the *koban* illustrated in plates 74 and 81. The simple diagonal and vertical compositions, and the close-up viewpoint or single-focus approach used by Hiroshige in these and other works, are also characteristic of the Shijō school.

So striking is the use of conventions associated with the Shijō school in Hiroshige's prints that one is compelled to search for concrete associations between Hiroshige and Shijō artists or works. There is no evidence that Hiroshige studied with a master of the Shijō school. It is far more likely that at an early age he worked with a Kano teacher, and that he later studied with Nanga master Ōoka Umpō, who was a pupil of Tani Bunchō.

Kanō Hiroyuki suggests that Shijō artist and lacquerer Shibata Zeshin (1807–1891) was responsible for the lyrical, Shijō-like qualities of Hiroshige's *kachō* work, although he does not explain how.[24] Kanō also maintains that Zeshin disseminated a particular new theory of "realism" that was built upon that of Maruyama Ōkyo. Early in the nineteenth century, artists from both Kyoto and Edo adopted new conventions of material realism that cannot be specifically traced to the influence of Western botanical studies or to Chinese styles. Keyes notes that around 1830, the drawing style in *surimono* prints becomes tighter and more detailed.[25] Zeshin may have articulated these trends as artistic theory, but the stylistic mode was certainly not defined by him. Edoite Zeshin studied the Maruyama Ōkyo style under Suzuki Nanrei (1775–1844), then traveled to Kyoto at Nanrei's behest in 1830 to study Shijō painting with Toyohiko fig. 9. There, Zeshin also studied classical *waka* poetry and literature. Back in Edo in 1832, Zeshin established his reputation as an artist. It would appear that Edo artists, including perhaps Hiroshige, knew the work and ideas of Zeshin by this time.

Hiroshige may also have encountered Toyohiko's work during his 1832 trip to Kyoto by way of the Tōkaidō Road. From these travels, he derived inspiration for his series *Fifty-three Stations on the Tōkaidō* (1833–34), in which author Kanō sees the clear influence of the Shijō school.[26] Hiroshige's extant travel diaries, which date between 1841 and 1844 include many haiku, *kyōka*, and ditties he composed along the road, which attest to his poetic interests. He wrote poetry elsewhere under the name of Tōkaidō Utashige.

Hiroshige's participation in poetry circles would also have brought him into contact with Shijō artists, who were illustrating *surimono* and books with verse. Only the *kyōka* verses on his *kachō-e* are contemporary with his work, suggesting Hiroshige's familiarity with Edo poetry circles. Most of the haiku are from *Haikai kojin gohyakudai (Five Hundred Titles of Haikai by Past Masters)*, a collection of haiku verse published in 1787 and containing variously

dated works. Hiroshige may have executed his designs with selected haiku in mind, or he may have chosen the poetry later. As has been noted, the image and poem may complement each other, or they may have no obvious relation. That they often work together to express the nuance of an emotion or season suggests that Hiroshige possessed a deep understanding of poetic metaphor and nature's beauty. The contemporaneous *kyōka* on the prints again attest to the artist's familiarity with Edo poetry circles. Hachijintei (Kataki), the poet whose signature is on the *kyōka* found on several *kachō-e* prints illustrated here, is known only through Hiroshige's work. During the 1840s and 1850s, the artist also collaborated with *kyōka* poet Hinokien Umeaki (1793–1859) on a number of anthologies illustrated primarily with landscapes and urban scenes. In his later years Hiroshige's *kachō-e* work gave way to more landscapes, but apparently his poetry interests continued to broaden.

It is not surprising that Hiroshige — given his social and economic status, and the fondness for the out-of-doors he expresses in his diaries — was drawn to Shijō styles. As a young man, Hiroshige received some classical training in the arts, which may have aroused his interest in nonurban themes. His *ukiyo-e* teacher, Utagawa Toyohiro, produced landscapes but few *kachō-e*. After Toyohiro's death, Hiroshige concentrated on *kachō-e* and landscape designs.

Few records of contemporaneous public response to Hiroshige's bird and flower works are extant. The critic Saitō Gesshin wrote in *Zōho ukiyo-e ruikō*, published in 1844, that the artist's work was admirable, singling out the fish as particularly "realistic" (*shasei*).[27] But it does not appear that Hiroshige's "realism" drew the same type of reaction that Masayoshi's *Imported Birds* did. Hiroshige's work seems to have gained popularity because it suited the tastes of a growing urban society. His frequent use of the *tanzaku* panel format, in which several prints could be taken from one sheet because of the vertical division of the blocks, made the individual prints more economical. This may have offset the cost of special printing effects in his *kachō-e*.

Conclusion

As wealthy merchants and educated samurai shaped a new elite culture in the second quarter of the nineteenth century, *kachō-e* prints became increasingly popular. Hiroshige's *kachō-e* prints prospered because he and his publishers were able to meet the public demand for images that presented traditional styles and symbolism in a' modern format enlivened by Hiroshige's special poetic sensibility. Popular taste craved images that celebrated life's most transient and poetic aspects.

Although Hiroshige's customers were not as highly educated as the very wealthy patrons of the other Edo-period arts of painting and lacquer, they wanted to own prints that were equally lavish in subject matter and effect. Visitors from the provinces also carried home prints as souvenirs, for by Hiroshige's day, *ukiyo-e* had long been considered "famous products" of Edo. As "high culture" spread, the outsider as well as the back-street Edo resident were anxious to have a bit of classical imagery to call their own. The ancient Japanese poetic verses and the well-known Chinese examples, the popular haiku, and the contemporaneous *kyōka* that Hiroshige used on his prints added to their appeal.

This is not to imply that the public no longer demanded kabuki or courtesan *ukiyo-e*. Even when the government censored figure prints in 1790[28] and again in 1841–42, (at which time Utamaro and other artists, publishers, and authors were arrested or punished), these modes continued to circulate in various guises. Before long, they found their way back into production. But during the late eighteenth and early nineteenth centuries, Utamaro, Masayoshi, Hokusai, Shigenobu, and other print designers discussed above experimented with many "non-*ukiyo-e*" styles and subjects, as if the limitations of the genre were being tested. Moreover, the continuing influx of new painting styles from the Nagasaki and Kamigata regions during this time was of importance to *ukiyo-e* artists.

The Bunka and Bunsei eras (1800–1830) are generally viewed as prosperous but decadent times that were responsible for the governmental restrictions and economic hardship of the Tempō era (1830–1844). Under the rule of Shogun Ienari, described by one historian as an exhausted voluptuary, the nation sank into debt. During the Tempō famine, which began around 1832 and lasted over four years, the whole nation experienced great economic difficulty, and riots broke out in both the city and the country. Critics of *ukiyō-e* often note that figure prints declined in quality during the first quarter of the century, beginning with the death of Utamaro in 1806 and that of his influential publisher Jusaburō Tsutaya nine years earlier. Moreover, print-making continued successfully in Osaka and Nagasaki throughout the first half of the nineteenth century. Therefore, landscapes and *kachō-e* were not the only "alternative" for buyers or designers. A saturation point had occurred, however, and the moment was ripe for a new *ukiyō-e* modes to take precedence. It was Hiroshige's talent, in part, that brought *kachō-e* to the fore.

Narazaki Muneshige, a prominant *ukiyo-e* scholar, said of Hiroshige that he "gave expression to the national sensibility in terms of birds and flowers," adding that "he saw nature's colors, forms and moods as expressions of subjective human emotions."[29] This is certainly the predominant Japanese opinion of Hiroshige's work; and although it is easy to understand why these qualities are attributed to his *kachō* oeuvre, the same "poetic aesthetic" permeated many areas of Japanese art and culture by the mid-Edo period. Hiroshige, however, gave this trend a unique visual expression. Conversely, although most Western scholarship on *ukiyo-e* recognizes the lyrical quality of Hiroshige's work, scholars have avoided equating Hiroshige's *kachō-e* work with a popularized form of "serious" classical or *literati* culture, as if doing so would render the bird and flower prints "pretty pictures." If Japanese opinion can be criticized for neglecting the broader context of Hiroshige's "poetic spirit," it can nevertheless be applauded for distinguishing between Hiroshige's lyricism, and flaccid sentimentality.

Hiroshige died in 1858, only ten years before the historical end of the Edo period. With him passed the special vision of the natural world that he gave the *ukiyo-e* image. No one who has admired plums or camellias blooming in the snow, or geese silhouetted against a full moon on an autumn night, can mistake the poetic spirit that imbues Hiroshige's *kachō-e* images for anything less than the natural splendor they portray.

Notes

1. For a discussion of the Edo-period Japanese herbals and related works see: Kitamura Yotsura, "Edo period Medicinal Plant Studies" (In Japanese), Sasaki Jōhei, ed., vol. 6, *Kachō no sekai* series, (Tokyo: Gakken, 1982), pp. 130-135.

2. Engelbert Kaempfer, a German physician posted as a surgeon with the Dutch East India Company, wrote of the Japanese he met during his sojourn there in 1690:

All the Japanese companions of our voyage . . . were extremely forward to communicate to me, what uncommon plants they met with, together with their true names, characters and uses, which they dili-

gently enquired into among the natives. The Japanese are very reasonable and sensible People, and themselves great lovers of plants, look upon Botany as a study both useful and innocent, which pursuant to the very dictates of reason and the law of nature, ought to be encourag'd by everybody...
Calvin French, *Shiba Kōkan*, p. 7, from Engelbert Kaempfer, *Kaempfer's History of Japan*, translated by J.G. Scheuchzer, 3 vols. (New York: Macmillan, 1906), 2:285 (originally published in 1728). Kaempfer also brought back to Europe from Nagasaki in 1692 a group of early Chinese prints now in the British Museum, the Bibliothèque Nationale and private collections, which show bird, flower, and fruit subjects.

3. *Ukiyo-e monogatari*, in *Tokugawa Bungei Ruiju*, vol. 2 (Tokyo: Kokushokankokai, 1914–15), pp. 334-335 (translated portion).

4. Michel de Certeau, *L'invention du quotidien*, vol. 1: *Arts de faire* (Paris: n.p., 1980), as quoted by Roger Chartier, "Culture as Appropriation: Popular Cultural Uses in Early Modern France," p. 236, in Steven L. Kaplan, ed., *Understanding Popular Culture: Europe from the Middle Ages to the Nineteenth Century*, pp. 229-253.

5. In *Japanese Quest for a New Vision: The Impact of Visiting Chinese Painters, 1600–1900*, a catalogue on Nanga and Nagasaki painters, Stephen Addiss has suggested that the Japanese were not ready to adopt a literati painting style early in the Edo period. He cites the case of the artist Chen Yuan Yun (1587–1671), who was recognized in China as an accomplished literati painter and who lived in Japan for thirty-three years, until his death while in service to the lord of Owari (modern-day Nagoya region, west of Edo). Chen was apparently far more successful in Japan as a scholar, potter, and *gong-fu* (*kung-fu*) teacher than as a painter.

6. The word *nanga* is an abbreviation of *Nanshū-ga*, or "Southern School Painting." The "southern" designation is based on a Ming Chinese painting theory that perceived two painting traditions in China, northern and southern, which has no particular significance. As James Cahill states in his study of the Nanga school:
"Northern School" painting was considered to be: skillful, detailed, relatively realistic, colorful, traditional, conservative. "Southern School" painting, by contrast was supposed to be: less realistic, more spontaneous, intuitive, individualistic, even when it made use of earlier styles....
See James Cahill, *Scholar Painters of Japan: The Nanga School*, p. 10.

7. From *Sanchūjin jōsetsu* (*Chitchat of a Mountain Hermit*), translated by Addiss, op. cit., p. 45.

8. Stephen Addiss, ibid., p. 45, and p. 63 (plate 23) for a discussion of this work.

9. Very little work of substance in English exists on Chinese printed books. Dawn Delblanco's unpublished dissertation, "The Mustard Seed Garden Manual" provides an excellent discussion. See also: Sören Edgren, et. al., *Chinese Rare Books in American Collections*.

10. *Eight Albums of Painting* (*Bazhong hua-pu*), 8 vols., ca. 1620 was reprinted in Japan in 1671 as *Hasshu Gafu*, in black and white. It was followed by *Minchō seidō gaen* (*Living Garden of Ming Painting*), a work based on several Chinese albums in 1746, and the popular *Mustard Seed Garden Manual*, published as *Kaishien gaden* in 1748 and several subsequent editions, both printed in color and monochrome.

11. That the Japanese were capable of simple color printing is apparent in early non-commercial examples from the 1630s and 1640s. David Chibbett, *The History of Japanese Printing and Book Illustration*, pp. 35-38, notes that the earliest extant printed color examples on paper include a mathematical treatise (*Jinkō-ki*) printed in several editions in the 1630s

and 1640s, followed by more works on mathematics, military strategy, and calendrical studies. Popular color, commercial *ukiyo-e* were not produced until the 1760s.

12. Perspectival prints, called *uki-e*, offered mathematical "Western" perspective as their primary selling-point and were based on *camera obscura* views. The earliest were interior scenes (especially theaters) produced during the 1740s, followed by landscapes and cityscapes, which became popular in the late 1750s. The mathematically derived perspective utilized by Hiroshige, Hokusai, and many other artists in their prints was generally less prominently featured.

13. Shijō is the name of the street where Goshun lived in Kyoto.

14. French, op. cit., p. 29, from *Shumparō Hikki* (*Notes by Shumparō*), unpublished manuscript by Kōkan, completed in 1811, in *Nihon zuihitsu taisei*, vol. 1, pp. 395-466.

15. Roger Keyes, *Japanese Woodblock Prints*, p. 57.

16. Translation by James T. Kenney in *Utamaro: A Chorus of Birds*, n.p.

17. Roger S. Keyes, *Surimono: Privately Published Japanese Prints in the Spencer Museum of Art*, p. 16.

18. Roger S. Keyes, *Japanese Woodblock Prints*, p. 15. The actual number of designs produced by Hiroshige is impossible to determine, but Keyes' figure is based on extant works. Uchida Minoru estimated the artist's output at over 8000 examples.

19. None of the standard sources offer more than a rough estimate of the number of bird and flower designs produced by Hiroshige during his career. Suzuki Jūzō, the foremost Hiroshige scholar, does not give any figure at all in his classic study (*Hiroshige*). The late Carl Schraubstadter, a print connoisseur and Hiroshige collector who examined the Rockefeller collection at R.I.S.D. in 1936, counted 600 *kachō* designs known to him (letter to the director of the Museum, 1936). Keyes, ibid., p. 15, notes "several hundred."

20. Tanzaku prints measure approximately 38 × 18 cm., 38 × 12.5 cm., and 33.5 × 11 cm., respectively.

21. Block-format prints occur in both horizontal and vertical presentation and measure approximately 38 ×25.5 cm., 26 × 19 cm., and 19 × 12.5 cm., respectively.

22. Keyes, *Japanese Woodblock Prints*, p. 15. Most fan prints measure approximately 22 × 30.5 cm., but there is greater variation in their sizes than for other formats.

23. From *Fuji mi hyakuzu* (*One Hundred Views of Mt. Fuji*), printed in 1858, but published posthumously in 1860. Kanō Hiroyuki, "Hiroshige and Keisei" (in Japanese), in Kōno Motoaki, ed., vol. 8, *Kachō no sekai* series, p. 130.

24. Kanō, ibid. pp. 129-135.

25. Keyes, *Surimono*, p. 14.

26. Kanō, op. cit., p. 130.

27. Suzuki, op. cit., p. 45.

28. The sumptuary laws of 1842, for example, required the three major licensed Kabuki theaters to move to sites beyond the city, banned new forms of comic and popular novels, and restricted personal decoration, figure prints, and coloration and printing techniques for *ukiyo-e*.

29. Narazaki Muneshige, translated by John Bester, *Studies in Nature: Hokusai and Hiroshige*, *Masterworks of Ukiyo-e* series, p. 20.

A Note On the Calligraphy and the Poems

Hiroshige's bird and flower prints provide a marvelous opportunity to witness the collaboration between artists and nature in the creative process. The print designer Hiroshige reigns supreme, but he often surrenders much of his domain on the page to the brush of the calligrapher and the sentiments of the poet. The lines of the writing may work with the lines of the picture; they may also work against them. The poetry, similarly, may reinforce the meaning of the image or may touch on it only lightly. By reading the poems and learning something about the way in which they are written, however, the reader can participate in the creative process that combined bird,

flower, poem, and handwriting in the work of art.

The Japanese write their language using Chinese characters, which they call *kanji*. Working with *kanji* is, for both Chinese and Japanese, an inexhaustible source of enjoyment, whether it involve writing or reading, newsprint, the advertising on utility poles, the brush and ink inscriptions on works of art, or the many products of business and private correspondence. The inscriptions used on Japanese prints are thus almost as important to readers of the language as the pictures. They are an integral part of the artistic whole, involving not only the content of the written message but also the manner in which it is written — the calligraphy.

Writing the characters provides the Chinese as well as

the Japanese with opportunities to please with graceful lines and to parade the writer's manual dexterity, his erudition, and his knowledge of his nation's long cultural history. The characters are written in three principal styles: *kaisho*, *gyōsho* and *sōsho*, as they are called in Japanese. The *kaisho*, or "square-character writing," is the form used in print. Every stroke has its own integrity; the brush or writing instrument leaves the paper after each one. The strokes can be counted, and the minor configurations they make within the character separated, classified, and indexed by number of strokes in character dictionaries. The *kaisho* makes order possible.

Not so orderly is the *gyōsho*, or "cursive writing," in which the strokes are often gracefully linked. The poem on plate 56 is written Chinese, in calligraphy that is largely *gyōsho*. Quick and fairly legible, it is the style of writing most commonly used by Chinese as well as Japanese for everyday correspondence and utilitarian communication and record keeping. In this passage it is masterfully controlled and tastefully organized on the page, in keeping with its subject: the ability of calligraphy to convey the character – particularly the sobriety – of the writer.

The *sōsho* is more artistic and less legible than *gyōsho*. The brush – the tool of choice – leaves the paper as little as possible. The strokes, and often the characters, are thus usually connected, with many strokes omitted, forming configurations that are interpreted by few dictionaries: Although the general reader will not be able to deduce its meaning, the informed reader will delight in this writing. Plate 21, also in Chinese, is written entirely in *sōsho*. The best way for the person who knows no Chinese or Japanese to enjoy *sōsho* is to see it displayed with its *kaisho* equivalent nearby, so that the viewer can see what the calligrapher was embellishing as he wrote. For those who are familiar with Japanese, romanizations are provided for the Japanese texts in this book.

Sōsho, as used by the Japanese, is unfortunately, even more difficult than it first appears. The Japanese had no way of writing their language until approximately the fifth century, when visitors from Korea and China, and Japanese visitors to those lands, found themselves expressing Japanese words, particularly place-names, using Chinese characters. Thus the difficult task of combining these two very different languages began, in a process that took several centuries to produce a widely intelligible result. Even modern Japanese calligraphers continue to indulge themselves in the nostalgia of writing in the confused idiom of that formative period of linguistic development.

The Chinese language, which is monosyllabic, uninflected, and tonal, is entirely different from the Japanese language, which is polysyllabic, highly inflected, and fairly atonal. Each character in Chinese has a meaning; few characters are used for their sound alone. Every Japanese sentence, however, requires a number of syllables that have only grammatical meaning: particles to designate subjects and objects, suffixes to identify adjectives and adverbs, suffixes to combine with those suffixes, and a dazzling variety of verb endings that can be added to each other to show tense, voice, honorifics, causality, potentiality, negatives, and interrogatives.

The Japanese had little difficulty finding Chinese characters that would convey the basic meanings of their nouns, verbs, and adjectives. The difficulty lay in finding enough characters that had no meaning, that they could use as simple indicators, and that could be combined with each other. Thus they were forced to use, simply for their sound, Chinese characters that normally had a meaning in addition to the sound. From that necessity stem some of the most vexing problems of Japanese calligraphy. Plate 20 is a stunning imitation of early Japanese calligraphy. It

looks like Chinese, written in twenty-six characters, but only five of those characters have any ideographic meaning within the text of the poem. Characters that normally would have the meanings "wave," "old," "foundation," "tail," "woman," "joy," and "anger" are used simply as phonetics, with their pronunciations in broken Chinese, spelling out – as if they were letters in English – Japanese words with different meanings and grammatical functions.

In a process that took about half a millennium, a system of standardized phonetics, called *kana*, or "temporary names," was slowly developed. That system is based on fifty sounds, expressed in two different sets of simplified characters, representing, at first, all the sounds the Japanese language seemed capable of making. One set, called *katakana*, or "square *kana*," is based on very simple characters that are small segments of larger characters with the same pronunciation. The other set, the *hiragana*, or "cursive *kana*," is a *sōsho* simplification, never varying, of a character with the same pronunciation. Thus modern Japanese was born, in a combination of *kanji* with *kana* – mostly *hiragana* – with the *katakana* reserved for special purposes, particularly foreign words. Plate 38 is another imitation of Japanese orthography before the invention of *kana*. It uses, like plate 20, the character mixture called *manyōgana*, after the first imperial poetry anthology (the *Manyōshū*, or *Collection of a Thousand Leaves*), which came out late in the eighth century. Plate 5 is the same poem after the process of invention got moving: five of the eight characters are in the abbreviated form covered by the generic term *kana*.

Yet two of those *kana* characters, however simplified, are not legible to readers who know only the modern *kana*. They are holdovers from previous centuries when the *kana* were not standardized. Thus, Japanese *sōsho* produces yet another complexity to impede those who wish to read it. It is what is called the *hentaigana*, or "altered shape *kana*." The *hiragana* character for the sound *shi*, which looks like a reversed J, is derived from a character pronounced, in Japanese, *shi*, or *kore*. The version of it given in plate 5, however, is derived from another character pronounced *shi*, which is pronounced *kokorozashi*. The character following it, which is pronounced *ha*, or *ba*, is another example of *hentaigana*.

Thus the reading of the poems on the prints is part of a game of concealment and discovery, somewhat like a crossword puzzle, between 1,000 and 1,500 years old. The educated calligrapher, of course, can immediately read and appreciate the poem and its connections with the accompanying picture. Even he, however, might miss a pun or a recondite *hentaigana*, many of which are easily confused with each other and may even have been used to throw him off. The less talented reader must use the picture and the patterns of the Japanese language and the meanings of the few characters he can recognize to reconstruct, by fits and starts, the words on the page.

The prints that have been selected for this volume are widely varied, not only in the styles of the anonymous calligraphers whose work is being shown, but also in the orthography. There is *gyōsho*, and there is *sōsho*, in Chinese and in Japanese. There are examples of *manyōgana* and of *tensho*, which developed out of the seal characters. There is an example of *reisho*, the old square characters. Although all the calligraphy was undoubtedly produced in a short period of the nineteenth century, every line reflects dim gleams of the dawn of Japanese literacy.

The Poetry

The task of the reader of the calligraphy is simplified somewhat when he is reading Japanese poetry, most of

which has a structure that can function, like the numbers and black and white squares of a crossword puzzle, to give contextual clues to the language. Almost all the poems in this volume, in fact, have a common structural element: the grouping of syllables in alternating fives and sevens in the Japanese poems and in character-groups of fives or sevens in the Chinese poems.

The long history of Japanese poetry is dominated by the syllabic patterns of alternating fives and sevens, principally in the form known as the *tanka*, or "short poem," which is important even in the first imperial anthology (the *Manyōshū*) issued in the middle of the eighth century. The *tanka* is the only form used today in the yearly poetry contest, with millions of entries, presided over by the emperor. It is a poem thirty-one syllables long, made up of five phrases in a syllabic pattern of 5–7–5–7–7, written, as are all Japanese poems, in an unbroken line down the page. The haiku, with its shorter 5–7–5, which is the form used more than any other on the Hiroshige bird and flower prints, evolved out of the *tanka* and its progeny, and came to full flower in the presence of Matsuo Bashō (1744–1794). The *kyōka*, or "mad poem," which is used on ten of the prints in this volume, has the same syllabic pattern as the *tanka*, but none of its aristocratic content or pretensions. It is, nevertheless, a genre that has a charm all its own and a history in the Japanese print older than that of the haiku.

Japanese poets seldom venture into more than one poetic arena; one form is difficult enough. This may be because most Japanese avocations, as well as vocations, are practiced in a social setting, which for artists is a tightly organized coterie. Those who write haiku are known as *haika* or *haijin*, and those who write *kyōka* are known as *kyōshi*. Their publishing demeanor and even the pseudonyms they concoct for themselves are similarly specialized. Thus the haiku poets take names, called *haimyō*, that are usually a compound of two characters using Chinese pronunciations, like *Bashō*, or *Buson*, or *Issa*. Their names announce them as devotedly aesthetic, reclusive, monkish men, conscious of their mutability and yet buoyed by the adulation of younger colleagues. The *kyōka* poets build their pseudonyms, their *kyōmei*, out of more characters — much like the names of the print artists — with sometimes as many as six or seven characters. The surname as well as the given name often combine to form a witty phrase, such as "Daijōdan Mononari," meaning "It's a big joke," or a sentimental phrase, such as "Empō Tomoari," meaning "far away there's a friend." The name Toshigaki Maharu, poet of the two kyōka on plate 6 in this volume, means "Year-barrier True-spring."

In spite of its unpromising exterior, the signature of the poet is required on printed *kyōka*, at least while he is alive. Thus almost all of the *kyōka* are signed. Although haiku, too, must be signed, most of the haiku on the bird and flower prints are not recent compositions but instead old favorites, largely taken from the anthology *Five Hundred Titles of Haikai by Past Masters*, or *Haikai Kojin Gohyakudai*, published in 1787. One or two of the haiku, furthermore, have been subtly altered — sometimes in only one character — in such a way as to embellish or parody the original meaning of the poem and thus establish a new author, who may or may not wish to be identified.

The haiku as used on the bird and flower prints has five principal recurrent elements. First is the syllable count, the seventeen syllables arranged in phrases of five, seven, and five. Although haiku poets nowadays flout this rule often, syllable count was closely observed by poets of Hiroshige's time. (It does, incidentally, simplify the task of the reader who must read the poem in *sōsho*.) Second is the season word, a word or phrase associated with a particular season, often for no good reason save habit. Every haiku must evoke one season, and only one, either in context or in vocabulary. Thus once a word has been accepted as a season word and assigned to a season, it can be used only with a poem appropriate to that season. This is particularly relevant to displays of prints bearing the poem — in the home, at tea ceremonies, or in places of business. The season word establishes the season during which that print is properly to be hung. Thus *ume*, meaning the plum blossom, is a spring word; *botan*, or peony, is a summer word; *asagao*, for morning glory, autumn; and *kamo*, for duck, winter. A poem that looks like a haiku but has no season word is still rejected as a haiku by purists.

The third important element of the haiku is the cutting word *ya*. It functions like the caesura in the Petrarchan sonnet and establishes the topic for the poem. The rest of the poem is a pithy comment on that topic. It can be seen at work in the poem on plate 19: "*Kiku no ka ya fukumeru tsuyu no chirutabi ni.*" The first four words, ending with the *ya*, mean "chrysanthemum scent." They hang there at the beginning of the poem, suspended in midair by the cutting word, like a pervading fragrance. Then the explanation comes: "every time a drop of dew drips down from inside." The cutting word can often be ignored or translated with a punctuation mark like a dash or colon.

The fourth important element is the word *kana* at the end of the poem, which means, roughly, "Ah," or "Indeed." It may or may not be translated. The fifth is the pure wit of the content, a flash of insight, though not necessarily one that calls forth laughter. The haiku in this volume are more humorous than the norm, perhaps because of the connection with the prints and the tastes inculcated by the devil-may-care *kyōka*.

The *kyōka* is a thirty-one syllable, humorous poem (rather like the English limerick) which was in vogue late in the eighteenth century, when groups of poets and artists achieved great popularity with their *surimono* — lavish woodblock prints with texts of three and more *kyōka*. Unfortunately, the frequently irreverent content of the poems called forth repressive measures by the government, and the movement was blighted. The *kyōka* was no longer considered dangerous when Hiroshige was in his prime, but it was, nevertheless, regarded as passé. Hiroshige used *kyōka* exclusively, however, in his *Edo Kinkō Hakkei* and was a *kyōshi*, or *kyōka* poet, himself. The *kyōka* are usually dependent on puns, the more outrageous the better, befitting the image of the mad poet.

A number of the poems on the prints are in the Japanese version of pure Chinese, which is called *kambun*. The poems make sense in Chinese but often violate Chinese tonal requirements, creating unpleasant sounds for the Chinese aesthete. Many of Japan's greatest authors, however, wrote *kanshi*, as these poems are called. They are represented in two principal forms in this volume: the poems with five words to the line, or *gogonkoshi*; and those with seven words to the line, or *shichigonkoshi*. When these poems are arranged in quatrains, the five-word pieces are called *gogonzekku* and the seven-word pieces are called *shichigonzekku*.

The translations that follow, which are not intended as substitutes for the original poems, are nothing more than translations — that is, the transference of something successful in the medium in which it was created into a medium in which it cannot hope to have the same success. There are subtleties in the texts that are impossible to render in any language other than the original. To help the reader understand as much as possible of what is going on in the original language, notes and romanizations of the Japanese have been provided. Wherever, it

28

was possible to keep a 5–7–5–syllable pattern in the English without doing violence to the sense, I have done so, even though I may be criticized by many haiku poets writing in English. I am willing to take that risk in order to convey to the reader unfamiliar with Japanese poetry something of the rhythmic pattern that has been part of Japanese literature for a millennium and a half.

The Birds

The birds and the flowers referred to in the poems, regardless of their functions in the illustrations, have lives of their own in Japanese poetry. This is particularly true of the *sekirei*, or wagtail, which appears in a prominent place in one of the earliest works of Japanese literature, the *Nihon Shoki*, completed in 720. A pair of mating wagtails provides a model for Izanagi and Izanami, the Japanese Adam and Eve, who, instructed by the birds, become progenitors of the Japanese race. The *hototogisu*, usually identified in English with the cuckoo, though it has little in common with that bird as it is known in Western literature, is another bird that appears in poetry early in Japanese history. Its song is described by ornithologists as a six-syllabled *"kyoh-kyoh-kyo-kyo-kyo-kyo,"* but to the common Japanese it sings a spectacular *"teppenkaketaka."* The *hototogisu*, like the European nightingale — a name usually assigned by translators to the songster known to Japanese as the *uguisu* — has tragic associations. Its red mouth has given rise to the belief — comparable with the story of Philomela — that it bleeds from the throat while it sings. Probably the greatest haiku poet of modern Japan, Masaoka Shiki, took his penname from an alternate way of reading the characters for *hototogisu*, as a reminder of the tuberculosis that racked him as he wrote.

The sparrow and the swallow are as important to the Japanese as they are to Western peoples. The sparrow has a place in one very old folktale in which it does miraculous things for an old couple who nurse it to health after its tongue has been cut. The swallow, thanks to its habit of nesting beneath the eaves of Japanese houses, has a close relationship with life in the house it is using. That goes for its children, too, a familiar sight as they stretch their heads in a tight little group to be fed. Young sparrows are the subject of many distinguished haiku. In fact, the phrase "sparrow children" is a member of the select group of words known as season words. When it appears, the reader knows he is reading a spring poem.

One other bird deserves discussion, and that is the rooster, used prominently in plate 20. The connection here is not with the character of the bird but with the years of the Chinese zodiac, specifically the year of the cock. The cycle of twelve animal signs is offset by a cycle of ten element signs. 1981 was the year of the cock; it will be back in 1993. The full cycle of sixty combinations resulting from the combination of twelve animal signs and ten element signs provides a unique method of dating every sixty years. The present cycle began in 1984.

The Flowers

The Japanese love of chrysanthemums is well known. Not so well known is that they love all flowers to such an extent that they come in great throngs to particular places at specific times of the year to see the flower of the season. The displays of hydrangeas in early July all over Kamakura create one such event. The cherry blossom, so important to the Japanese that simply the word "flower" in a poem automatically means "cherry blossom," scarcely needs mentioning. The plum, beloved by Chinese and Japanese because it is the first flower of spring, is almost as important. The iris is another favorite, and the variety of iris with the Japanese name *kakitsubata* (see plate 45) has an impressive literary pedigree. It appears with haunting associations in the tenth-century classic *Tales of Ise* in an episode that provided the inspiration for the Noh play *Kakitsubata*, attributed to Zeami Motokiyo (1363–1443). The peach blossom also has a strong Chinese association, particularly in plate 1, where it calls up visions of the Taoist heaven. A bite of certain peaches, in Chinese myth, is said to confer a thousand years of life.

The morning glory — which to many American gardeners is only an annoying, entangling weed — has a special place in Japanese culture. This is best shown in the poem by a lady known as Kaga Chiyo. The poem goes: *"Asagao ni tsurube torarete morai mizu."* It can be translated as:

> My well-bucket caught
> in morning glories, I go
> to borrow water.

In the towns on the Japan Sea, one can buy little well-buckets, alone or with a standing female figure alongside, in memory of that lady who treated her morning glories with such exquisite tact. It is handled with appropriate care in the poems on plates 12, 46, and 74. The Princess Asagao, or "Morning Glory," is one of the most haunting beauties in *The Tale of Genji*, Japan's greatest classic. She alone never surrendered to the importunities of the handsome Prince Genji. The Japanese have involved themselves with the cultivation of morning glories and the development of new varieties of the flower for well over 150 years.

The peony is a favorite flower of the Japanese and is probably even more loved by the Chinese. One unforgettable sentence is a line of advice given young Japanese women who wish to charm: *"Tateba shakuyaku, suwareba botan, aruku sugata wa yuri no hana."* It means: "Stand like a *shakuyaku* [a herbaceous peony, *paeonia albiflora*], sit like a peony; as you walk, imagine you are a lily." That sentence sums up the way in which flowers of many varieties and subvarieties entangle themselves in Japanese life and art, and bring all together in natural harmony.

Another caveat must be made on the reading of the texts reproduced in this volume. Perhaps enough has been said about the difficulties of that task, one that would daunt the great majority of today's educated Japanese. Every effort has been made to come up with accurate readings of the poems — after all, one misread syllable can change the meaning entirely. There is room, even among specialists in calligraphy, however, for differences in reading and interpretation, and it is not uncommon to find an empty square here and there in a printed version of a *sōsho* text, indicating that the reader was stumped. There are some lacunae of that kind in this volume.

29

PLATES AND COMMENTARIES

1. Swallows and Peach Blossoms under a Full Moon

Spring has come and all the streams
are filled with peach blossoms.
Nobody knows where Heaven[1] is,
but all wonder.

Size: Large Panel. 38.6 × 18.1 cm.
Date: early 1830s.
Bird: Hirunda rustica Linnaeus, *house swallow*
Flower: Prunus Persica, *peach blossom*
Signed: Hiroshige hitsu
Artist's Seal: Ichiryūsai
Publisher's Mark: Wakasaya Yoichi (Jakurindō)
Censor's Seal: Kiwame
Poetry: Kambun. Shichi-gon-koshi, or poem of seven
character lines
Provenance: F. E. Church (November 1928)
References: Ledoux, 42; TNM, 3489; Suzuki, 181;
Vever, 861; Buhl, 42.
From the Abby Aldrich Rockefeller Collection of Japanese Prints,
Museum of Art, Rhode Island School of Design,
accession number 34.286.

This seems to be the finest extant impression of one of Hiroshige's loveliest bird and flower prints. The Rockefeller print was shown in New York in 1924 as part of the Grolier Club exhibition (when it was owned by Frederic E. Church), and it was later described as "extraordinarily beautiful" in the catalogue of the noted collector and connoisseur Louis V. Ledoux.

This impression, which appears to be the only one recorded of the first state, has the publisher's mark of Wakasaya and a *kiwame* seal in the lower left corner. Impressions of the second state (Tokyo National Museum, Suzuki, Vever, and Buhl) lack these seals and differ in the printing of the peach branches, which are almost entirely in black and not pink merging into black as here. Also, the breast feathers of the birds in the first state are printed in pink, rather than in black. In the second state, the birds are strongly contrasted with the flowers and moon, while the Rockefeller print with its extremely subtle and unusual color harmonies places the greater emphasis on capturing the mysterious and atmospheric quality of moonlight.

The third state Ledoux impression has the publisher's mark of Kikakudō beneath the poem and is somewhat coarse in printing quality.

1. *Sengen,* land of the Taoist immortals.

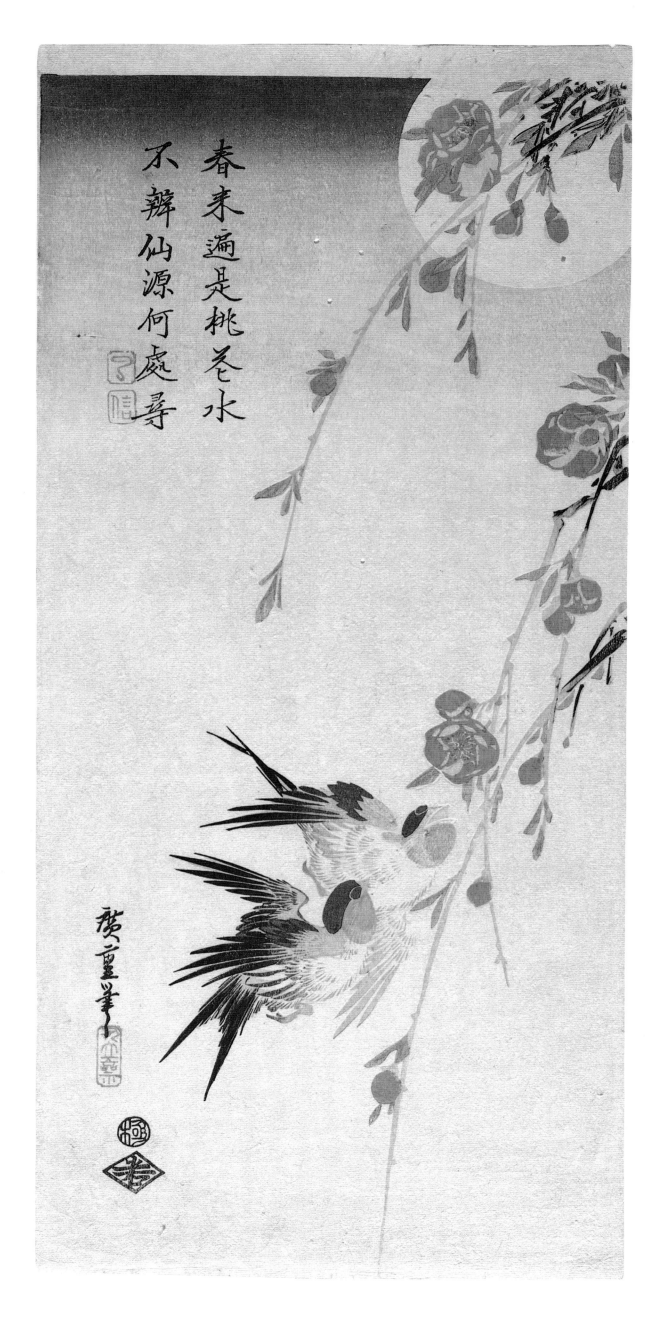

2. A Little Brown Owl on a Pine Branch with a Crescent Moon Behind

Mikazuki no
funa yusan shite
mimizuku[1] wa
mimi ni iretaki
matsukaze no koto.[2]

The long-eared owl
asail for a three-day cruise
on the three-night moon,[3]
longs to hear pine music
float slowly through his ears

Size: Medium Panel. 36.4 × 13 cm.
Date: mid-1830s
Bird: Otus scops japonicus Temminck & Schlegal,
* Japanese scops owl*
Signed: Hiroshige hitsu
Artist's Seal: Yūsai
Poem: Kyōka
Poem signed: Hachijintei[4]
Provenance: William Lawrence Keane (Yokohama,
* 1921)*
References: Ledoux, 43; Suzuki, 58; Vever, 866;
* UTK, vol. XI, pl. 6.*
From the Abby Aldrich Rockefeller Collection of Japanese Prints,
* Museum of Art, Rhode Island School of Design,*
* accession number 34.220.*

An endearing aspect of Japanese art is the ability of artists to project personality onto animals without, as is often the case in Western art, becoming overly sentimental. Artists of the Shijō school, of which Hiroshige was an avid disciple, are particularly known for the warmth and humor of their animal depictions — qualities that abound in this print of a little, sleepy, brown owl.

The poem refers to the three-day-old moon and, as Ledoux writes, in Japan, "the moon is supposed to be most delicately beautiful when it is just three nights old...."

In the earliest impressions (before the Rockefeller print), there is shading around the edge of the moon.

1. The poem resounds with assonances, beginning with the syllable *mi*, meaning "three." That sound is doubled in the word for "ear," pronounced *mimi*. Those two syllables are part of the word for "owl," *mimizuku*, which has a folk meaning of "ears sticking up" and is also a pun on "ears strumming."

2. This line is a standard phrase in Japanese poetry, similar to "Aeolian harp" in English. It refers to the wind through the pines that recalls music from the strings of the classical instrument the *koto*. It is also an allusion to the Noh play *Matsukaze*, named after its love-crazed heroine, whose name means "wind through the pines."

3. Referring to the new moon. The association of the owl, known for his distaste for bad weather, with the new moon may express the wish for good weather in the near future.

4. Full name: Hachijintei Kataki. Kyōka poet and friend of Hiroshige, according to Suzuki Jūzō.

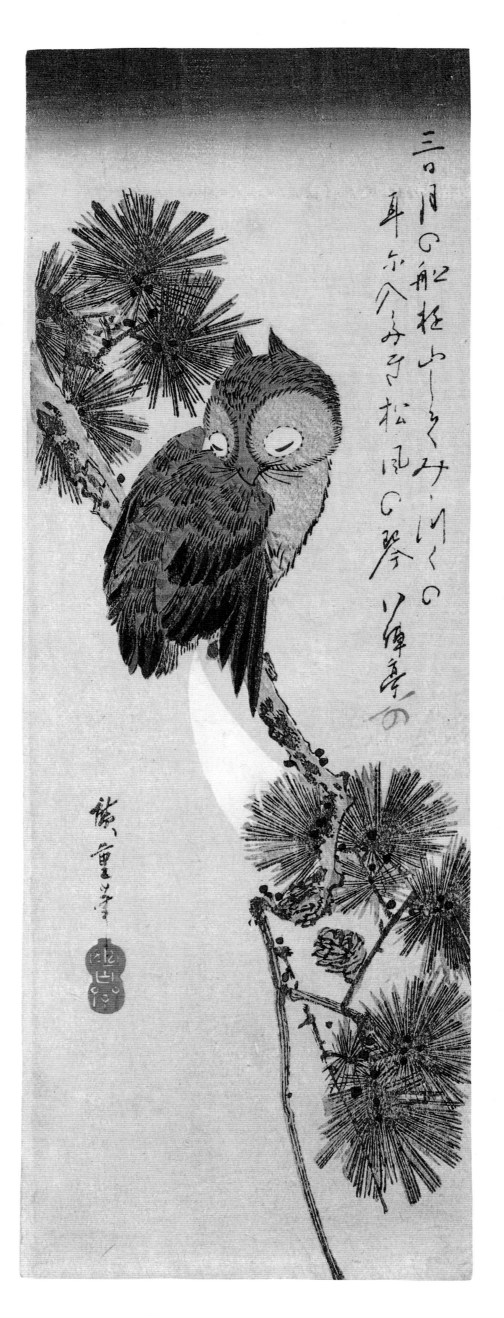

3. Three Wild Geese Flying across the Moon

Komu na yo ga[1]
mata mo arō ka
tsuki ni kari.

Will it come again —
another night like this one?
Wild geese and the moon.

Size: Medium Panel. 36.6 × 12.1 cm. (trimmed)
Date: early 1830s
Bird: Anser fabalis Latham, bean goose
Signed: Hiroshige hitsu
Artist's Seal: Fukuju
Publisher's Mark: Shōeidō han (Kawaguchi Shōzō)
Poetry: Haiku
Season word: kari, "wild geese" (autumn)
Provenance: Yamanaka & Co. (January 1920)
References: Ledoux, 43; TNM, 3525; Tamba, 85;
* Suzuki, 61; Vever, 867; UTK, vol. XI, pl. 5;*
* Buhl, 50.*
From the Abby Aldrich Rockefeller Collection of Japanese Prints,
* Museum of Art, Rhode Island School of Design,*
* accession number 34.227.1.*

4. Three Wild Geese Flying across the Moon

Size: Medium Panel. 37 × 13 cm.
Date: 1830s
Bird: Anser fabalis Latham, bean goose
Signed: Hiroshige hitsu
Artist's seal: Fukuju Kaba
Publisher's mark: Shōeidō han (Kawaguchi Shōzō)
Poem: Haiku, same as plate 3
Season word: kari, "wild geese" (autumn)
Provenance: Arthur D. Ficke (December 5, 1924)
References: Ledoux, 43; TNM, 3525; Tamba, 85;
* Suzuki, 61; Vever, 867; UTK, vol. XI, pl.5;*
* Buhl, 50.*
From the Abby Aldrich Rockefeller Collection of Japanese Prints,
* Museum of Art, Rhode Island School of Design.*
* accession number 34.227.2.*

One of the more pleasurable activities of the study of original prints is the comparison of different impressions of the same design, which allows one to observe a range of expressions in a single image. Mrs. Rockefeller was seriously interested in upgrading her collection as opportunity arose, and she frequently exchanged her prints for ones that were earlier or in superior condition. She was, however, keen to acquire duplicate impressions if there were significant block or coloring differences, and the museum is extremely fortunate to possess the two different states of one of Hiroshige's most celebrated kachō-e.

In plate four, as with the Vever, Suzuki, and Ukiyo-e Taikei impressions, the cloud pattern at lower left runs parallel to the birds. In plate three, like the Ledoux, Tamba, Tokyo National Museum, and Buhl impressions, the cloud crosses the direction of flight. It is unclear why this change in the blocks occurred, but plate four is the earlier state. In this state there is embossing around the edge of the moon and in the feathers of the geese, which is absent in plate three. Plate four is printed on thick, deluxe paper, which is usually the sign of an early edition, while the paper used for plate three is of a more standard quality. The most obvious difference between the two states, though, is in the inking of the blocks. The extreme subtlety of the printing of plate four, particularly in the birds' feathers, is exchanged in plate three for a darker, more intense coloring, enhanced by the shading around the moon, which changes the mood entirely.

1. Yo here is written as "night" but means "world" when written with a different character.

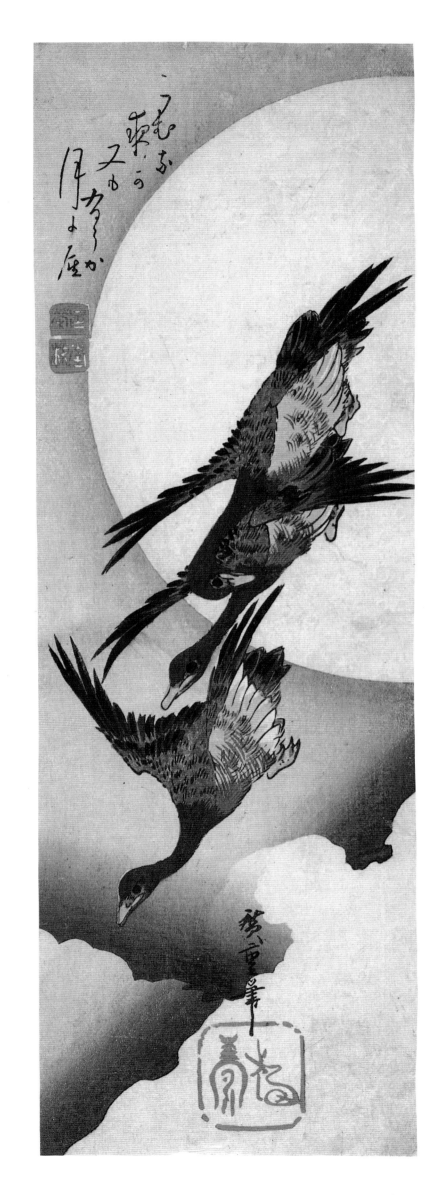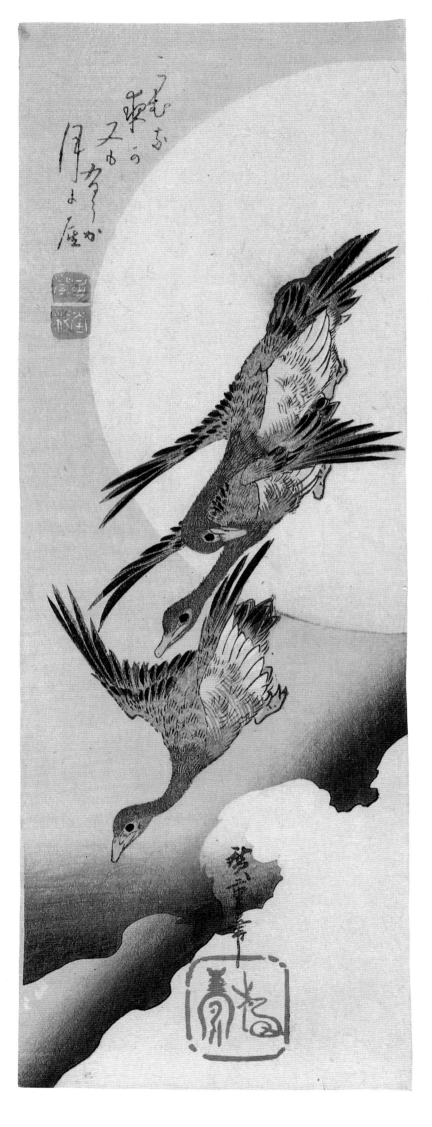

5. A Wild Duck Swimming beneath Snow-laden Reeds

Kamo naki ya
kaze fukishiwamu[1]
mizu no omo.

A duck calls softly;
a breeze sets ripples moving
over the water.

Size: Large Panel. 37.8 × 17.5 cm.
Date: early 1830s
Bird: Anas platyrhynchos Linnaeus, *breast*
suggests Anas falcata Georgi *but other details*
do not fit
Signed: Hiroshige hitsu
Artist's seal: Fukuju
Poem: Haiku
Season word: Kamo, "duck" (winter)
Provenance: F. E. Church (November 1928)
References: Vever, 868; UTK, vol. XI, pl.93;
Buhl, 49.
From the Abby Aldrich Rockefeller Collection of Japanese Prints,
Museum of Art, Rhode Island School of Design.
accession number 34.272.

This is a fine impression of another famous *kachō-e*. The Vever impression, apparently a later state, has the seal of the publisher Kikakudō replacing the artist's seal. According to Roger Keyes, Hiroshige's seal, which has caused some confusion in the literature, reads *Fukuju* ("Happiness and Longevity"), with the characters drawn to resemble a horse and a deer. As Keyes notes, if the seal were read as though these characters had been *written*, and they were pronounced in Chinese style, one would get the word *baka*, which means "fool." This unusual seal also appears on the prints in plates three and four but with the characters and animals reversed.

Copies of this design were made during the Meiji period, and these can be deceptive.

1. *Shiwamu* means, literally, "to wrinkle," as in "wrinkling one's brows."

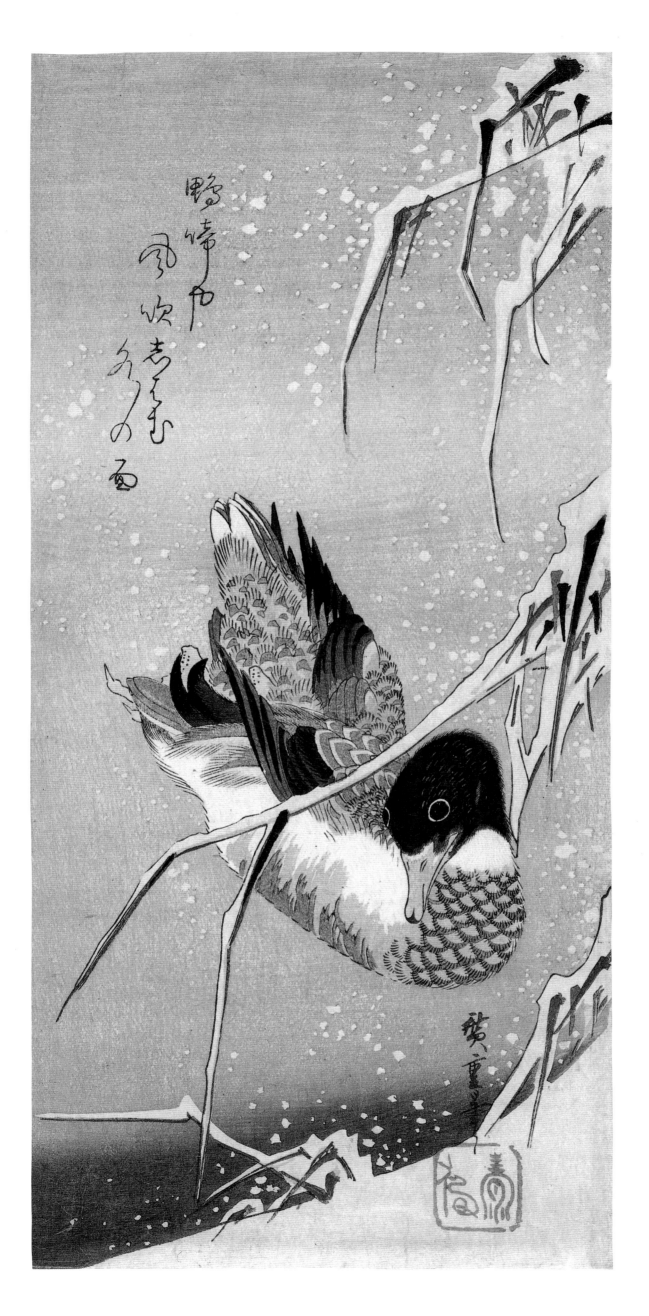

6. Titmouse on a Flowering Plum and Mandarin Ducks in Snow

Urawakaki
ume[1] o kugurite
shijūkara[2]
haru o sakasa ni
kosu kokochi sen.

Little chickadee,
twisting about the plum tree,
glowing with youth,
must want to be upside down
when New Year's Day arrives.

Oku shimo no
ue ni mo yuki o
kasanekite
kireba[3] kiemu to
oshidori no naku.[4]

A layer of frost,
and on top of that a snow,
slowly deepening.
"We will perish if we part,"
the mandarin ducks are crying.

*Size: 39.1 × 17.6 cm. (Original drawing. Ink and
 color on paper.)*
Date: early 1830s
*Bird: Parus major, great tit and Aix galericulata,
 mandarin duck*
Signed: Hiroshige hitsu
Artist's seals: Utagawa; Hiro.
Poem: Two Kyōka
Signed: Toshigaki Maharu
Provenance: F. E. Church (November 1928)
*From the Abby Aldrich Rockefeller Collection of Japanese Prints,
 Museum of Art, Rhode Island School of Design.
 accession number 34.296.*

Hiroshige's drawings for prints range from brief, initial sketches to finished designs such as this which were ready to be sent to the engraver. The prints after this drawing are not recorded and may not have been published, but another Rockefeller print, "A Mandarin Duck on a Snowy Bank" (plate 31), shows how closely an engraver might have reproduced Hiroshige's drawing style.

A Hiroshige drawing in the Victoria and Albert Museum, London is similarly made-up of two *kachō-e* designs and also has poems signed by Toshigaki Maharu (see Edward F. Strange, *The Colour-prints of Hiroshige* [London, 1925], plate facing page 112).

Hiroshige was himself a kyōka poet and wrote poetry under the name of Tōkaidō Utashige. Hiroshige's original *kachō-e* drawings could help determine who drew the poetry for the prints — a professional calligrapher, the poet, or Hiroshige himself.

1. Traditionally the first tree to flower in spring, the plum is closely associated with New Year's Day, which under the lunar calendar marked the first day of spring.

2. *Parus major,* also known as "great tit," a bird noted for furious activity in feeding.

3. *Kire-* means both "stop snowing" and "part company." *Kiemu* means both "will melt" and "will die away." The translation takes only one of the many possible meanings.

4. *Naku* can mean either "sing" or "weep," and from that ambiguity countless Japanese poems on birds derive their tension. The Japanese do not seem to be offended by the voice of the duck. It does not "quack" to them but utters a softer, indeed singing, sound, like "kiyu."

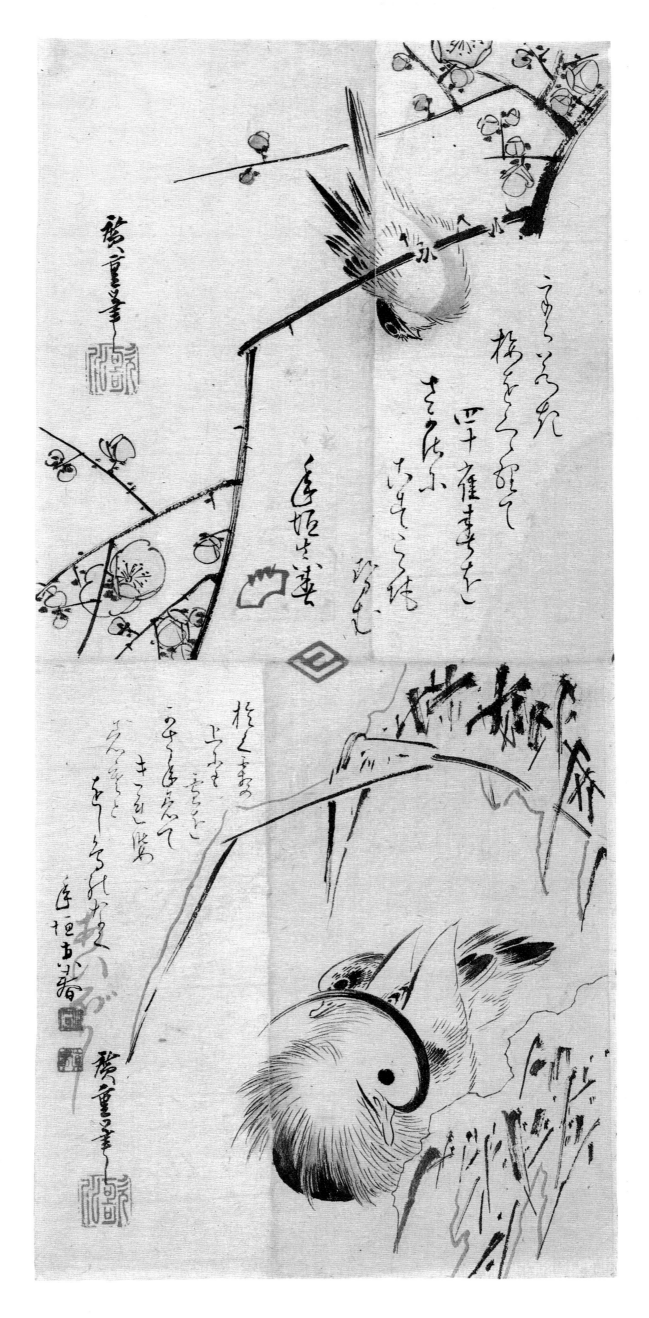

7. A Parrot on a Flowering Branch

Size: Large Panel. 38.9 × 17.5 cm.
Date: early 1830s
Bird: Aix galericulata, *parrot, spec.*
Flower: Possibly Malus halliana, *apple*
Signed: Hiroshige hitsu
Publisher's Mark: Jakurindō (Wakasaya Yoichi)
Censor's Seal: Kiwame
Provenance: F. E. Church (February 1927)
References: TNM, 3494; Oberlin, 1298.
From the Abby Aldrich Rockefeller Collection of Japanese Prints,
 Museum of Art, Rhode Island School of Design,
 accession number 34.275.2.

This very fine and early impression was printed on thick, deluxe paper. The orange pigment used in the background of the print is unusual for Japanese prints, and this impression is noteworthy for the freshness and warmth of its color.

This is the first edition that was published by Jakurindō. Many of the Hiroshige large panel prints that were initially published by Jakurindō (Wakasaya Yoichi) were later reissued with the mark of the publisher Kikakudō (Sanoya Kihei), and the Rockefeller collection also contains a faded impression of the second state Kikakudō edition that came from the Blanchard sale of 1916 (American Art Galleries [New York, 1916], lot 504).

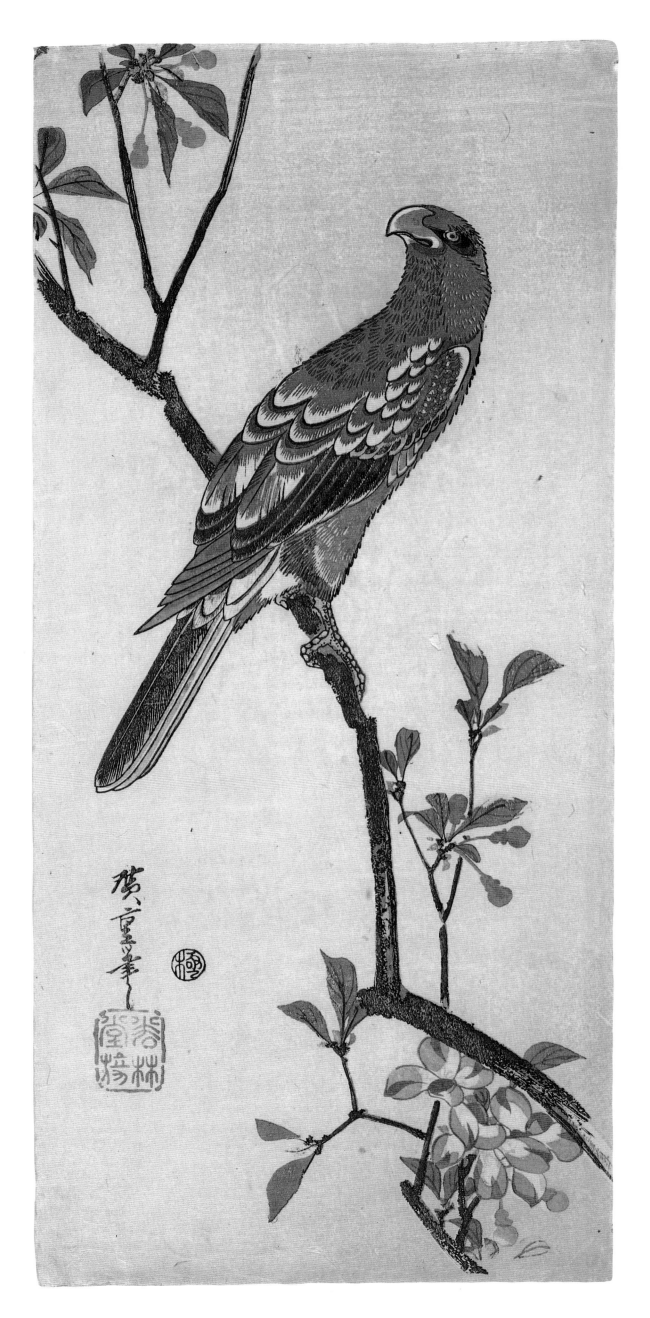

8. A Blue Bird on a Yellow-flowered Hibiscus

Autumn air washed by cool breezes,
Southern sun sweetening the dew on the
 hollyhocks,
The great heat has gone, and with it the
 cruel guards and officials.
When one is satisfied, what else is there
 to do?

Size: Medium Panel. 38.6 × 13.1 cm.
Date: early 1830s
Bird: Possibly a Musciapa *such as* Cyanoptila
 Cyanomelana, *blue fly-catcher*
Flower: Hibiscus manihot, hibiscus
Signed: Hiroshige hitsu
Artist's Seal: Ichiryūsai
Publisher's Mark: Kawashō (Kawaguchi Shōzō)
Censor's Seal: Kiwame
*Poem: Gogonzekku, or quatrain of five-character
 lines.*
Provenance: F. E. Church (November 1928)
References: Ledoux, 40; Vever, 913; Buhl, 43.
*From the Abby Aldrich Rockefeller Collection of Japanese Prints,
 Museum of Art, Rhode Island School of Design,
 accession number 34.215.*

The dramatic contrast in this print of the yellow flower with the blue bird exemplifies Hiroshige's brilliance as a colorist.

This excellent, unfaded, impression was originally in the Frederic E. Church collection as were nearly half the prints chosen for this book. Church formed an important collection of Japanese prints during the first half of this century and like other key American collectors of his generation – such as Frank Lloyd Wright, the Spaulding Brothers, Charles H. Chandler, Carl Schraubstadter, and Mary Ainsworth – was especially partial to Hiroshige *kachō-e*.

This impression was exhibited at the historic Grolier Club exhibition of Japanese prints in New York in 1924, as were many of the other Church *kachō-e* that were purchased as a group by Mrs. Rockefeller in 1928.

清風秋氣爽露裛日南葵
大暑去酷吏衛足亦何為

9. Five Swallows in Flight above a Branch of Cherry, the Blossoms Having Gone to Seed

Yama no ha[1] ni
tsubame wo kaesu
irihi kana.

At the mountain's edge,[1]
the swallows are sent to bed
by the setting sun.

Size: Medium Panel. 38.5 × 13.2 cm.
Date: early 1830s
Bird: Hirunda rustica Linnaeus, *house swallow*
Signed: Hiroshige hitsu
Artist's Seal: Ichiryūsai
Publisher's Mark: Kawashō (Kawaguchi Shōzō)
Censor's Seal: Kiwame
Poem: Haiku
Season word: tsubame, *"swallows" (spring)*
References: Ledoux, 39; TNM, 3529; Buhl 46.
From the Abby Aldrich Rockefeller Collection of Japanese Prints,
 Museum of Art, Rhode Island School of Design,
 accession number 34.226.

The playful flight of the five swallows is captured with great naturalism, and this print is one of Hiroshige's most charming bird and flower designs.

The noted collector and author Frederic W. Gookin, who served as an adviser to many important twentieth-century collectors (and who surely guided Mrs. Rockefeller), is reported in the museum's records to have described this impression as the finest he had ever seen.

A second edition published by Fujihiko is illustrated in Richard Lane's *Masters of the Japanese Print* (London, 1962), pl. 135.

1. This short phrase compresses the peculiar image often created by the Japanese mountain: not far away, with much of the semicircle of the outline defined against the sky by a single line of pines. It is a feature of life the Japanese take for granted, and those who have lived with mountain landscapes other than Hiroshige's may not understand.

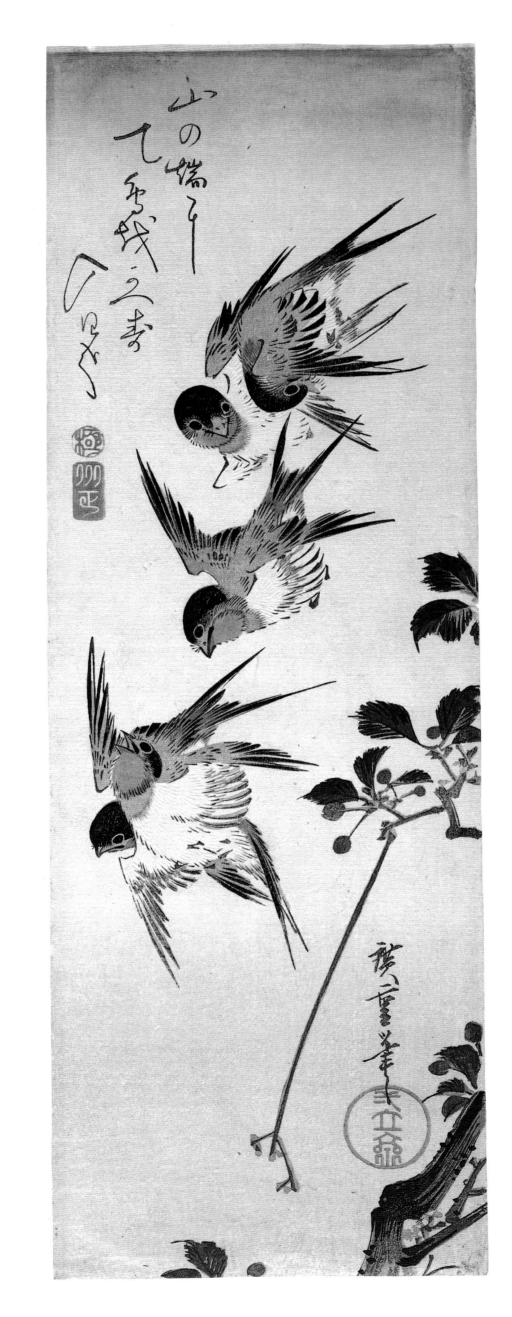

10. Sparrows and Camellia in Snow

> The crow fights with the kite over food;
> The sparrows dispute over nests.
> You stand alone beside the pond
> On a windy, snowy evening.

Size: Large Panel. 37 × 17.2 cm.
Date: early 1830s
Bird: Passer montanus (Linnaeus), tree sparrow
Flower: Camellia japonica, Camellia
Signed: Hiroshige hitsu
Artist's Seal: Utagawa
Publisher's Mark: Jakurindō (Wakasaya Yoichi)
Poem: Kambun. First two lines of a Shichi-gon-zekku.
 (Identified by Suzuki Jūzō as the first two lines
 of the poem "Inquiry of a Stork" by Pai Lo T'ien.)
Provenance: Hayashi, F. E. Church (November 1928)
References: TNM, 3495; Tamba, 841; Suzuki, 182;
 Vever, 863; UTK, vol. XI, pl. 91; Buhl, 47.
From the Abby Aldrich Rockefeller Collection of Japanese Prints,
 Museum of Art, Rhode Island School of Design,
 accession number 34.288.2.

Hiroshige, more than any other Japanese artist, is renowned for the depiction of snow, and this particular snow scene is one of the artist's supreme achievements in the genre of birds and flowers.

None of the standard Hiroshige reference works illustrates this exceedingly rare first state, which has a uniform gray ground and was pulled before the carving of the snowflakes onto the background block. The Rockefeller impression is printed on thick, heavy paper and has embossing in the wings of the sparrows. There is additional blind-printing around the edge of the camellias, which considerably enhances their tangible, snowy weight.

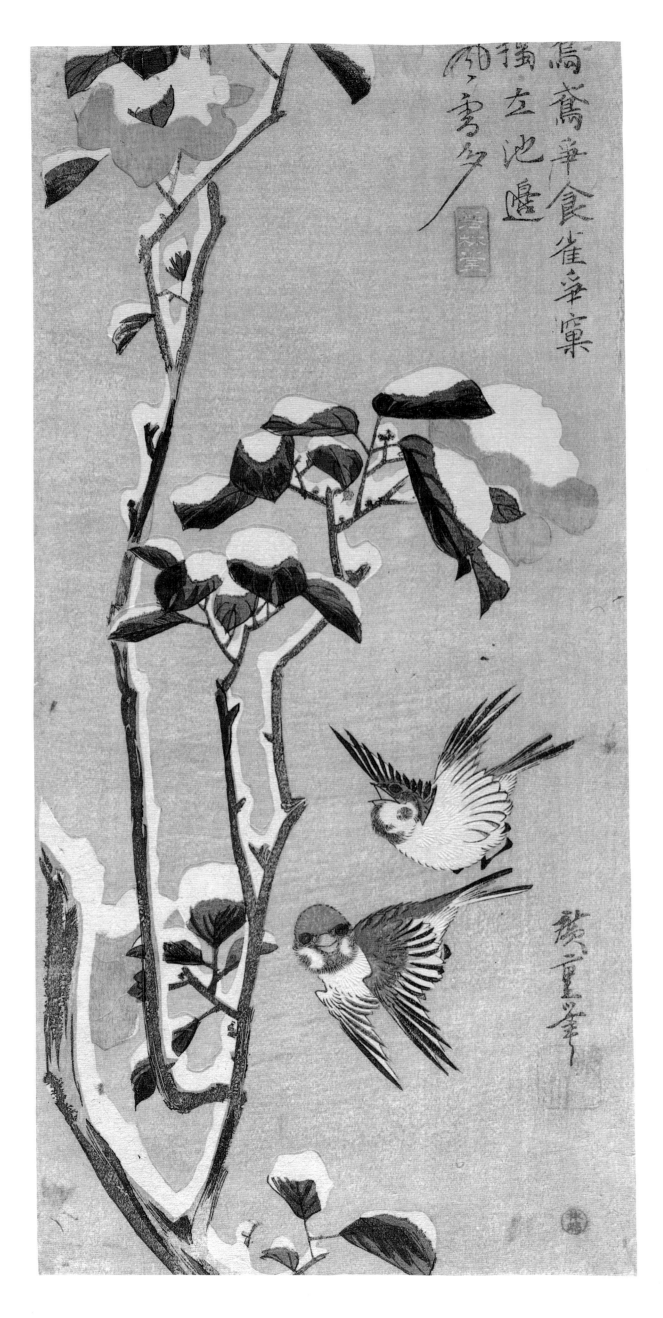

11. Sparrows and Camellia in Snow

The crow fights with the kite over food;
The sparrows dispute over nests.
You stand alone beside the pond
On a windy, snowy evening.

Size: Large Panel, 38.1 × 17 cm.
Date: early 1830s
Bird: Passer montanus (Linnaeus), *tree sparrow*
Flower: Camellia japonica, *Camellia*
Signed: Hiroshige hitsu
Artist's Seal: Utagawa
Publisher's Mark: Jakurindō (Wakasaya Yoichi)
Poem: Kambun. First two lines of a Shichigonzekku.
 (Identified by Suzuki Jūzō as the first two lines
 of the poem "Inquiry of a Stork" by Pai Lo
 T'ien.)
Provenance: Yamanaka & Co. (May 29, 1925)
References: TNM, 3495; Tamba, 841; Suzuki,
 182; Vever, 863; UTK, vol. XI, pl. 9; Buhl, 47.
From the Abby Aldrich Rockefeller Collection of Japanese Prints,
 Museum of Art, Rhode Island School of Design,
 accession number 34.288.1.

This is the second state of this superb design. Here, snowflakes have been carved into the background block and the color of the sky changed from a uniform gray ground to blue shading into gray. The flaw in the block to the right of the poetry confirms that the same block was used for both first and second states.

Like plate ten, this fine impression was printed on thick, heavy paper and has embossing in the outlines of the flowers and in the wings of the birds. Though some collectors might prefer this second state with the falling snow to the more subtle color harmonies of the previous plate, the large snowflakes carved on the background block are somewhat crudely drawn and may not have been conceived by Hiroshige himself.

Other second state impressions are illustrated in Vever, Suzuki, *Ukiyo-e Taikei,* and in the catalogue of the Tokyo National Museum. In the third state (Tamba and Buhl) the mark of the publisher Kikakudō replaces that of Jakurindō. It is interesting that this final state returns to the uniform gray ground of the first.

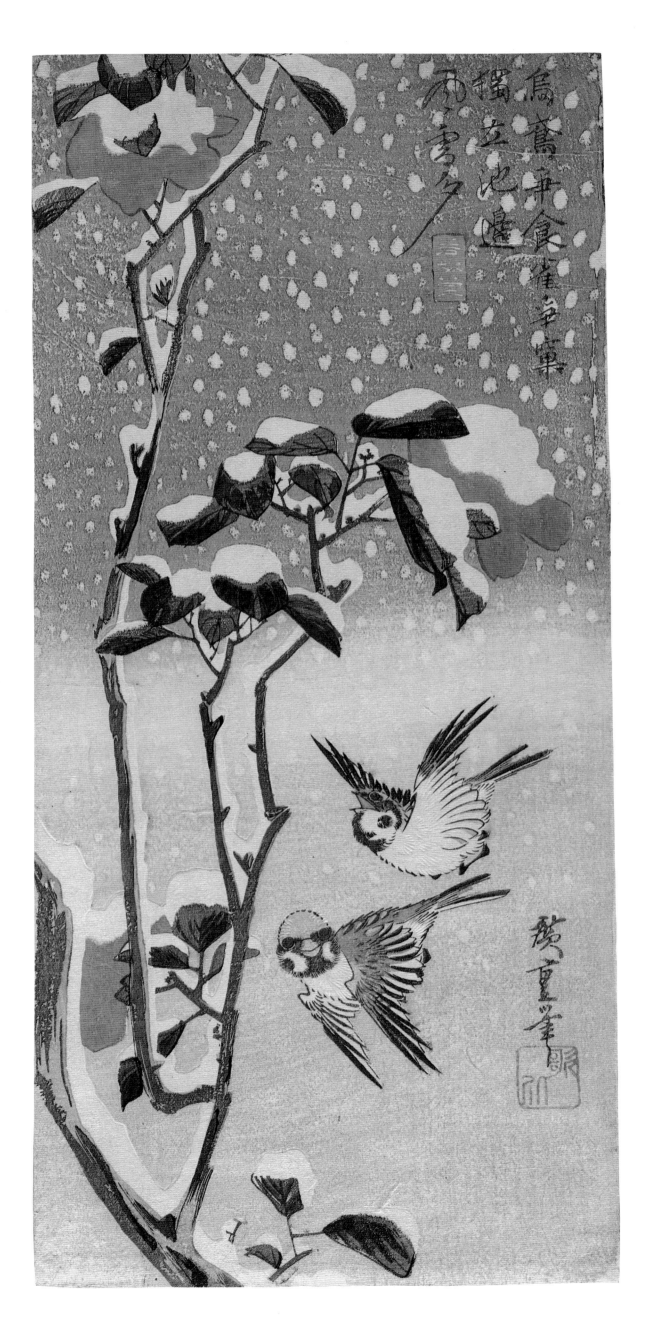

12. Morning Glory and Cricket

Asagao ya
akarenu sono hi
sono hi kana.

The morning glories
are out today! The morning
glories bloom today.

Size: Medium Panel. 38 × 13 cm.
Date: late 1830s
Flower: Pharbitis nil, morning glory.
Signed: Hiroshige hitsu
Publisher's Mark: Kawashō (Kawaguchi Shōzō)
Censor's Seal: Kiwame
Poem: Haiku
Season word: asagao; "morning glories" (autumn)
Provenance: William Lawrence Keane (Yokohama, 1921)
From the Abby Aldrich Rockefeller Collection of Japanese Prints,
* Museum of Art, Rhode Island School of Design*
* accession number 34.234.*

Like fireflies, crickets have traditionally been popular insects in Japan and depictions of them in cages kept as pets, as well as in their natural settings are often found in *Ukiyo-e* prints. A particularly graceful aspect of this elegant design is the way the placement of the poetry and the drawing of its characters echoes the stem of the morning glory.

As no other example of this print appears to have been recorded, it is fortunate that the impression and condition of the Rockefeller print are fine.

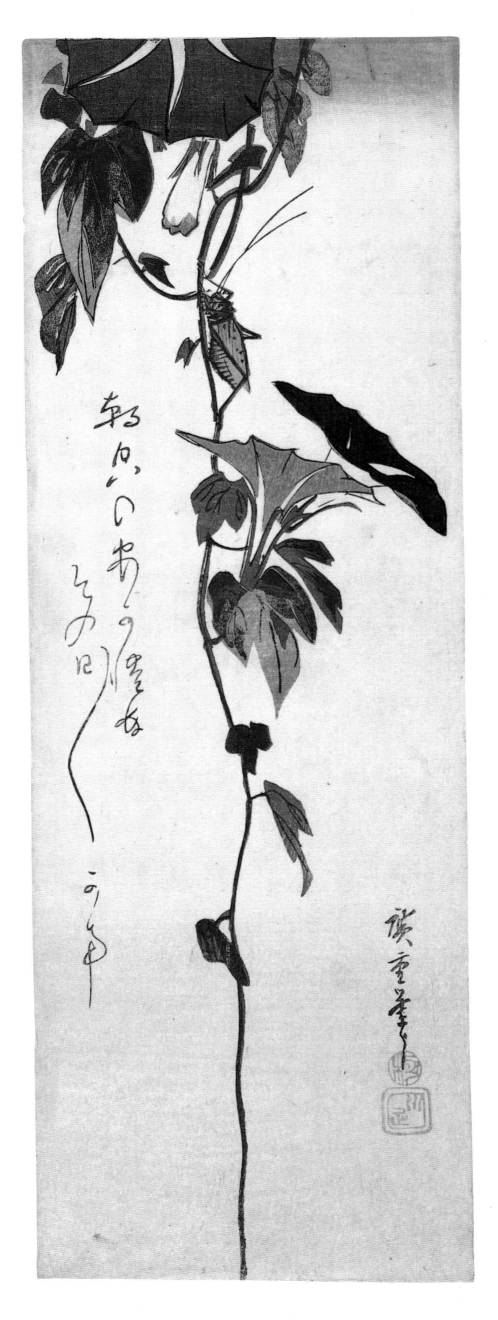

13. A Titmouse Hanging Head Downward on a Camellia Branch

Tsubaki kare
ochiru shite kara
haki jōsō.[1]

Withered camellias —
all the sweeping that goes on
after they've fallen!

Size: Large Panel. 38.2 × 17.6 cm.
Date: early 1830s
Bird: Parus major Linnaeus, great tit
Flower: Camellia japonica, camellia
Signed: Hiroshige hitsu
Artist's Seal: Ichiryūsai
Poem: Haiku
Season word: tsubaki, "camellia" (spring)
Provenance: F. E. Church (November 1928)
References: TNM, 3488; Vever, 871; Oberlin, 1300.
Museum of Art, Rhode Island School of Design,
accession number 34.284.1.

Japanese prints like most works of art on paper are extremely sensitive to the effects of light, and the delicate pink used for the background of this print is slightly faded. Although this is the second state of this very beautiful design, the quality of the impression is fine.

As with plate one and "Red-cheeked Bunting on a Branch of Cherry," another famous *kachō-e* (Vever, 865; TNM, 3492), the first state has the mark of the publisher Wakasaya Yoichi (Jakurindō). The Oberlin impression of this exceedingly rare first state has embossing in the outlines of the camellias, which is lacking in the Rockefeller print.

A duplicate impression of the second state in the collection is faded and damaged.

1. This poem uses the traditional practice known as "honkadori," or allusive variation, and scrambles a poem by Yaha, one of Bashō's principal disciples, to achieve a rather different meaning. That poem read: "Haki sōji shite kara tsubaki chirinikeri." It can be translated as:

The sweeping is done,
but the camellia blossoms
are falling again.

The variation, with its ingenious inversion of the two characters of *sōji,* meaning "cleaning," to create a word reading *jōsō,* or "ejecting broom," produces a very different haiku as given above.

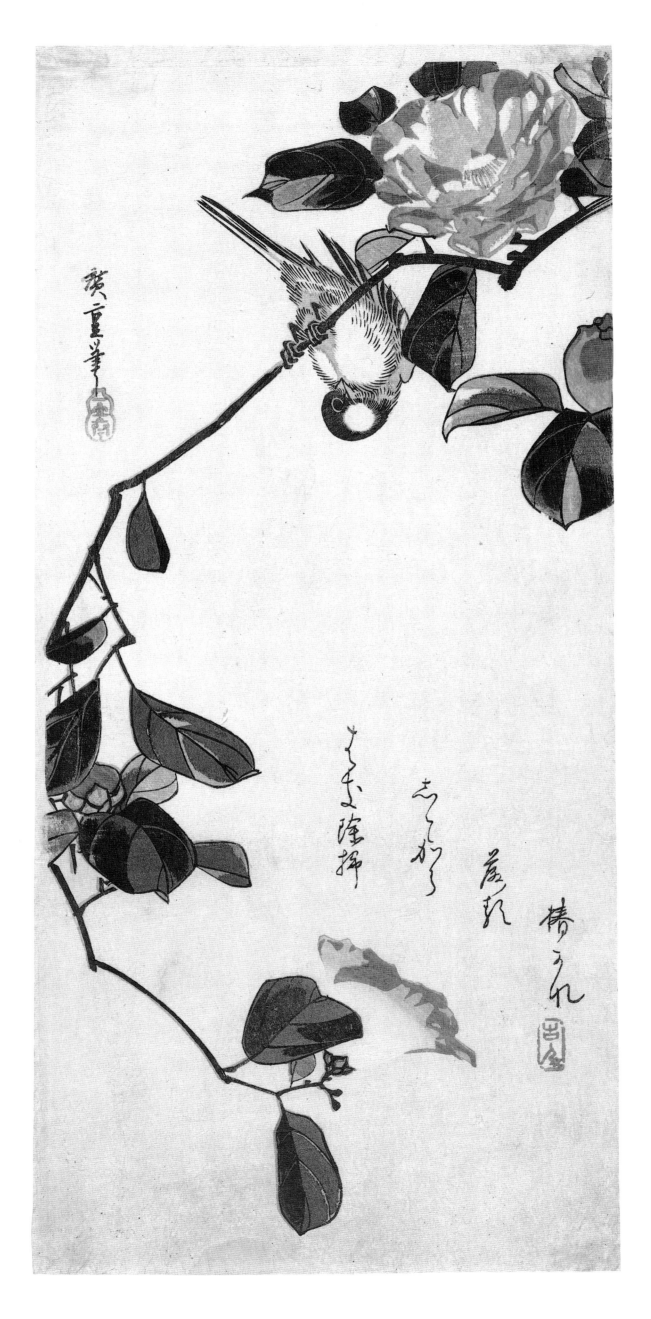

14. Dragonfly and Begonia

Shūkaidō[1]
sono ha a nani o
nani omoi.

Begonia flower —
tell us what, what in the world
are those leaves thinking?

Size: Medium Panel. 38.4 × 13 cm.
Date: early 1830s
Flower: Begonia evansiana, begonia
Signed: Hiroshige hitsu
Artist's Seal: Ichiryūsai
Poem: Haiku
Season Word: shūkaidō (autumn)
Provenance: Yamanaka & Co. (January 24, 1920)
From the Abby Aldrich Rockefeller Collection of Japanese Prints,
 Museum of Art, Rhode Island School of Design,
 accession number 34.225.

The transparency of the dragonfly's wings is beautifully portrayed, and the virtuoso use of blind-printing helps convey their delicate texture. In this print, as in many of his *kachō-e*, Hiroshige employs a fundamental aspect of the Shijō style: areas of variegated color printed to emulate the painterly strokes of a brush.

Another impression of this rare print is illustrated in the Frank Lloyd Wright sale catalogue (The Anderson Galleries [New York, 1927], lot 256).

This design was copied by the Osaka artist Hasegawa Sadanobu (1809–1879) in the 1850s. An impression of the copy is in the Honolulu Academy of Arts.

1. Chinese begonia, *Begonia evansiana,* or elephant's ear.

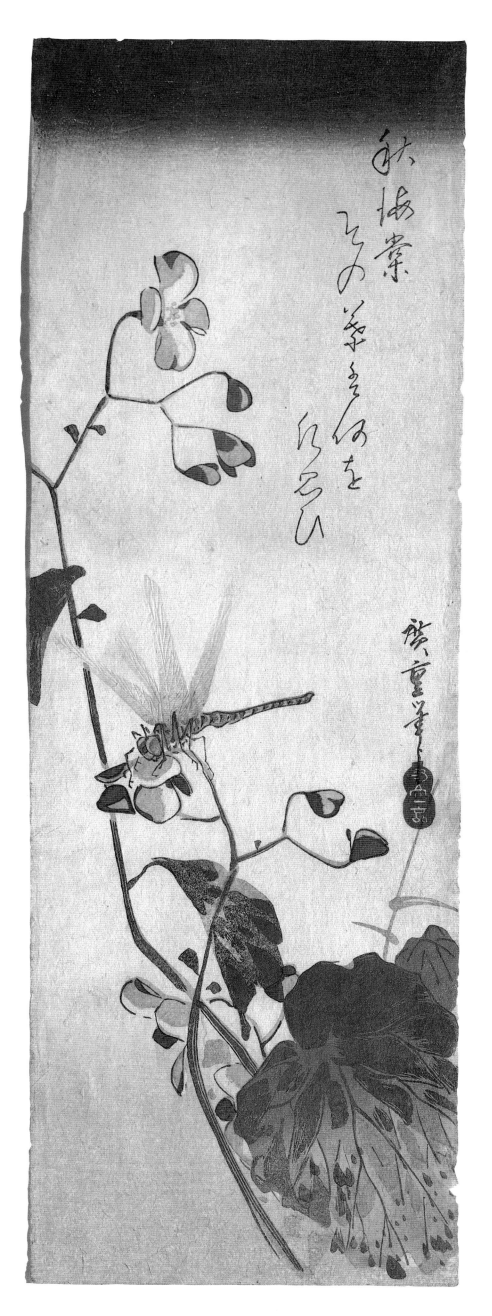

15. Parrot on a Branch of Pine

The pine tree,[1] after an eternity
of frosts followed by dews,
Shows a thousand years of color
deep in snow.

Size: Large Panel. 37.1 × 16.6 cm.
Date: early 1830s
Bird: Pennant's Rosella Platycercus elegans, *an*
inhabitant of Southeastern Australia. Only the
violet-blue spot on the chin is left out.
Flower: Pinus *spec. (probably* Pinus pariflora *or*
Pinus thunbergii), *pine*
Signed: Hiroshige hitsu
Artist's Seal: Yūsai
Publisher's Mark: Jakurindō (Wakasaya Yoichi)
Censor's Seal: Kiwame
Poem: Kambun. Two lines of seven characters each
Provenance: William Lawrence Keane (Yokohama,
September 1919)
References: UTK, vol. XI, pl.9.
From the Abby Aldrich Rockefeller Collection of Japanese Prints,
Museum of Art, Rhode Island School of Design,
accession number 34.276.

The *Ukiyo-e Taikei* impression is slightly earlier than the Rockefeller print and has a yellow ground. An impression in the catalogue of the Gale collection (Jack Hillier, *Catalogue of the Japanese Paintings and Prints in the Collection of Mr. and Mrs. Richard P. Gale* [London, 1970], vol. II, pl. 256) has a gradated blue ground and has significant block differences in the pine tree, although the poem and signature seem to have been printed from the same blocks as the Rockefeller and *Ukiyo-e Taikei* impressions.

1. The reference to the pine tree is expressed in a standard phrase meaning, literally, "eighteen lords." That substitution is based on breaking down the character for pine into its components. Thus the left side looks like the character for 10, the upper part of the right side like the character for 8, and the entire right side like the character for one of the higher ranks of Chinese nobility.

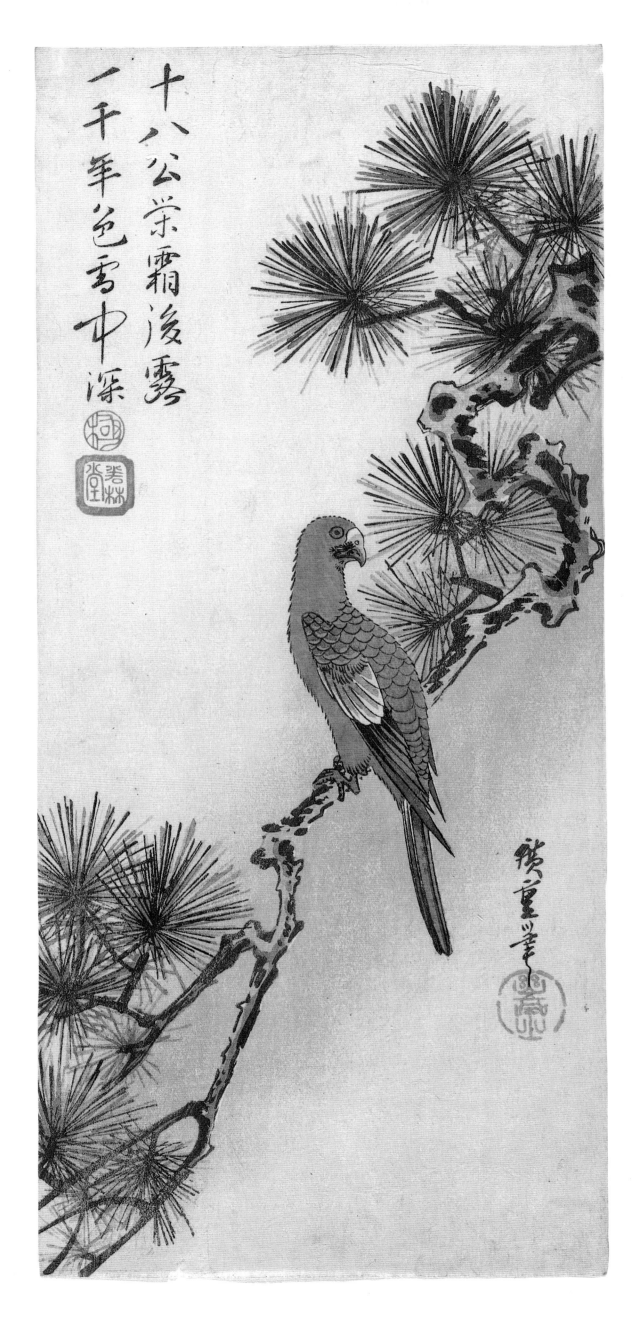

16. A Long-tailed Blue Bird on a Branch of Flowering Plum

Hito ume dokusen tenka haru.

One solitary early plum blossom,
And the whole world has spring.

Size: Large Panel. 37.8 × 18 cm.
Date: early 1830s
Bird: Cissa erythrorhyncha, crow family. (Does
not exist in Japan but is common in China)
Flower: Prunus mume, "plum" blossom
Signed: Hiroshige hitsu
Artist's Seal: Yūsai
Publisher's Mark: Jakurindō (Wakasaya Yoichi)
Censor's Seal: Kiwame
Poem: Kambun. One line of seven characters
Provenance: F. E. Church (November 1928)
References: TNM, 3484; Vever, 872; UTK, vol. XI,
pl. 10.
From the Abby Aldrich Rockefeller Collection of Japanese Prints,
Museum of Art, Rhode Island School of Design,
accession number 34. 290.

The subtlety of the printing in this marvelous design, particularly in the head and breast of the bird, approaches that of a *surimono:* those extraordinarily refined, private edition prints that are regarded as the pinnacle of the woodblock technique. This impression is the first state of the design.

The Rockefeller collection originally contained an impression of the second edition published by Kikakudō, which was exchanged in 1928 for the present print.

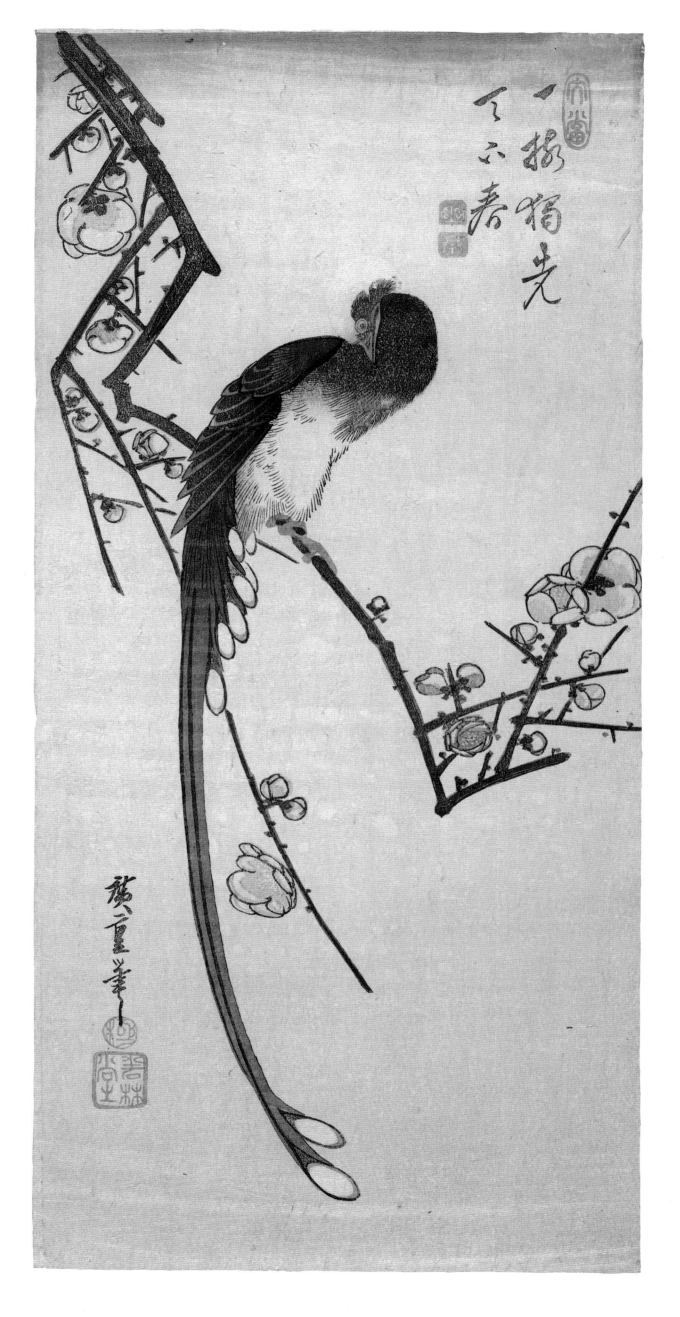

17. Crane and Rising Sun

Size: Large Panel. 39 × 17.7 cm.
Date: early 1830s
Bird: Grus japonicus Muller, Japanese crane
Signed: Hiroshige hitsu
Publisher's Mark: Jakurindō (Wakasaya Yoichi)
Censor's Seal: Kiwame
Provenance: F. E. Church (November 1928)
References: Tamba, 83; Amsterdam, 47; Buhl, 56.
From the Abby Aldrich Rockefeller Collection of Japanese Prints,
 Museum of Art, Rhode Island School of Design,
 accession number 34.297.

The crane is a traditional symbol of longevity, and both the crane and the rising sun have close associations with the new year.

There appear to be three states of this print. The first has a red band of color extending across the top of the print and, like the second state, is published by Jakurindō. In the second state (Rockefeller and Buhl), this band is replaced by the rising sun, increasing the new year associations. The third state, which retains the sun, is more coarsely printed and has the mark of the publisher Kikakudō. An impression of this last state is in Amsterdam.

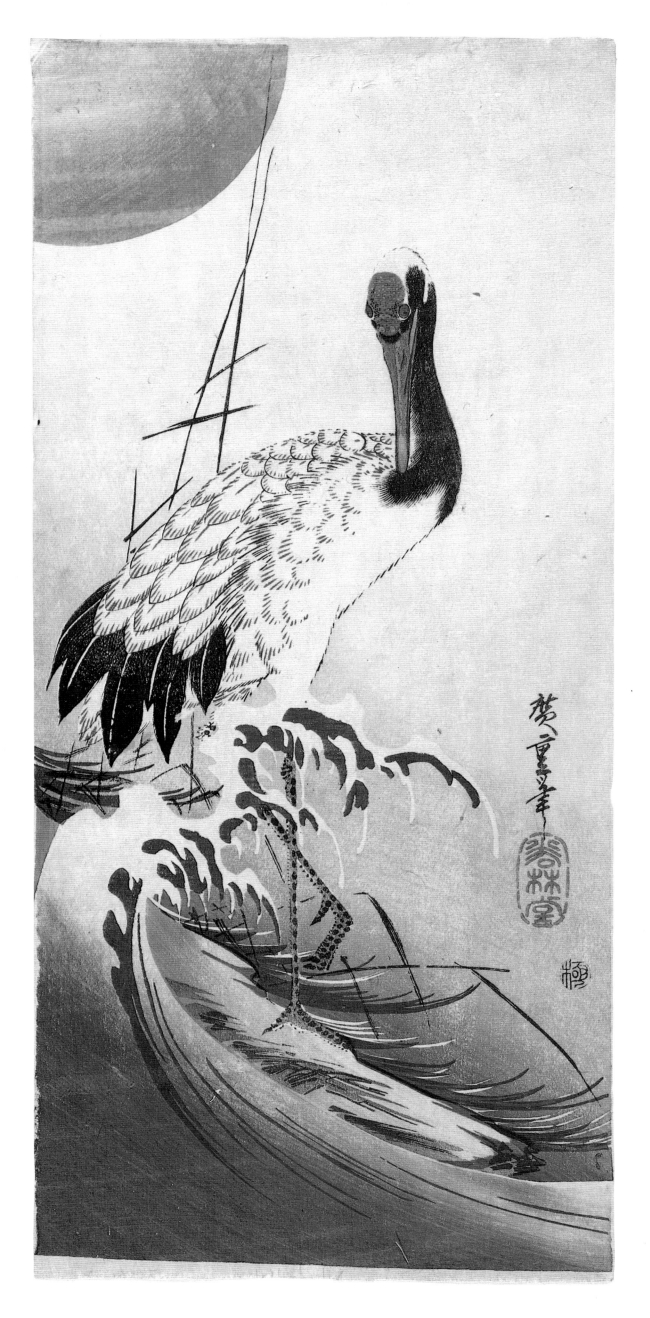

18. Sparrow and Bamboo

Kara[1] bito no
kuse o kononde
take ni made
akaki kokoro o
utsusu edakumi.

In admiration of
the ways of the Chinese,
this printing process
carries a feeling for red
even into the bamboo.

Size: Medium Panel. 37.6 × 13.1 cm.
Date: mid-1830s
Bird: Passer montanus Linnaeus (?), tree sparrow
Signed: Hiroshige hitsu; jussai Tonarime
Artist's Seal: Hiroshige
Publisher's Mark: Shōeidō han (Kawaguchi Shōzō)
Censor's Seal: Kiwame
Poem: Kyōka
Poem Signed: Hachijintei
Provenance: Yamanaka & Co. (1920)
References: Oberlin, 1312; Amsterdam, 9; Buhl, 45.
From the Abby Aldrich Rockefeller Collection of Japanese Prints,
 Museum of Art, Rhode Island School of Design,
 accession number 34.213.1.

This is the first of the two impressions of this design in the Rockefeller collection, with exquisite printing in the differently colored strands of bamboo.

It states on the print that the sparrow was designed by Tonarime, "a neighbor's girl," who was ten years old (Oberlin, p. 234). This unusual collaboration between an established artist and a child is by no means unique in Japanese art. *Kashin chō* of 1840, a book of poetry illustrated by Zeshin, Nanrei, and others, contains, for example, a print of flowers designed by the girl Sake at the age of eight. Yet Hiroshige's print provides a rare and endearing glimpse of his personality.

1. The word *kara*, using the character for the T'ang dynasty, is a common, rather archaic, way to refer to China. In this context, it has a strong association with the word *karakurenai*, or "Chinese red."

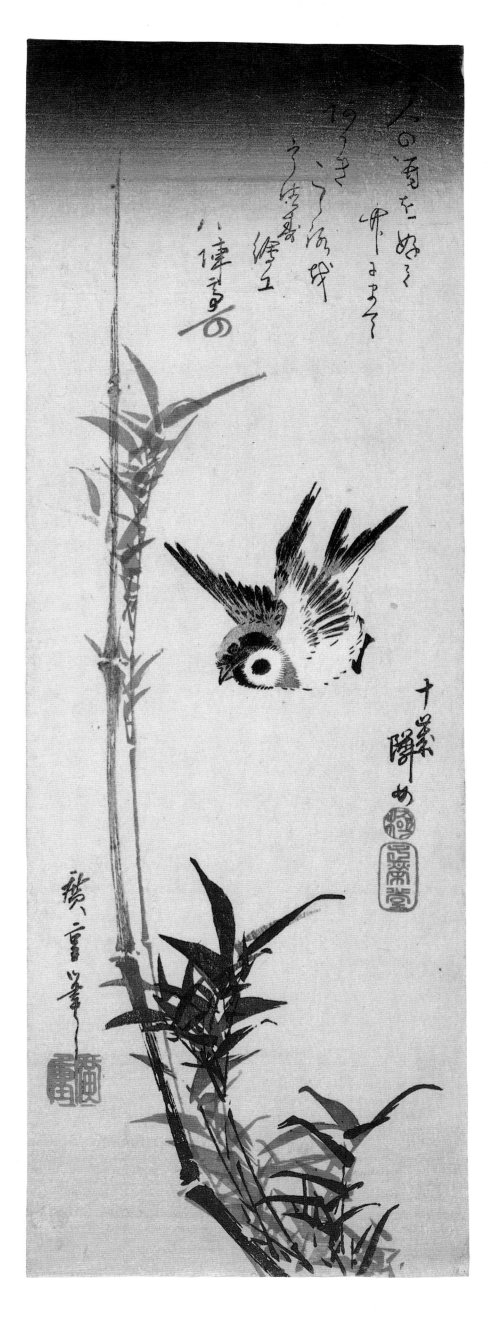

19. Pheasant and Chrysanthemum

Kiku no ka ya
fukumeru tsuyu no
chirutabi ni.

Chrysanthemum scent —
every time a drop of dew
drips down from inside!

Size: Large Panel. 38 × 17.5 cm.
Date: early 1830s
Bird: Phasianus (colchicus) versicolor Vieillot,
* common pheasant*
Flower: Chrysanthemum hort.; chrysanthemum
Signed: Hiroshige hitsu
Artist's Seal: Probably Shige
Publisher's Mark: Jakurindō (Wakasaya Yoichi)
Censor's Seal: Kiwame
Poem: Haiku
Season word: kiku, "chrysanthemum" (autumn)
References: TNM, 3490; Oberlin, 1296;
* Amsterdam, 34; Buhl, 66.*
From the Abby Aldrich Rockefeller Collection of Japanese Prints,
* Museum of Art, Rhode Island School of Design,*
* accession number 34.277.1.*

A first edition impression, the print has embossing in the feathers of the pheasant and in the chrysanthemums. The collection also contains an impression of the second edition published by Kikakudō that lacks the blind-printing and has a yellow ground, as well as a harsher overall color scheme. Another impression of this later state is in Amsterdam.

This is one of the Hiroshige bird and flower prints that was copied by the Osaka artist Hasegawa Sadanobu in the 1850s (see Christie's, London [March 1986], lot 115).

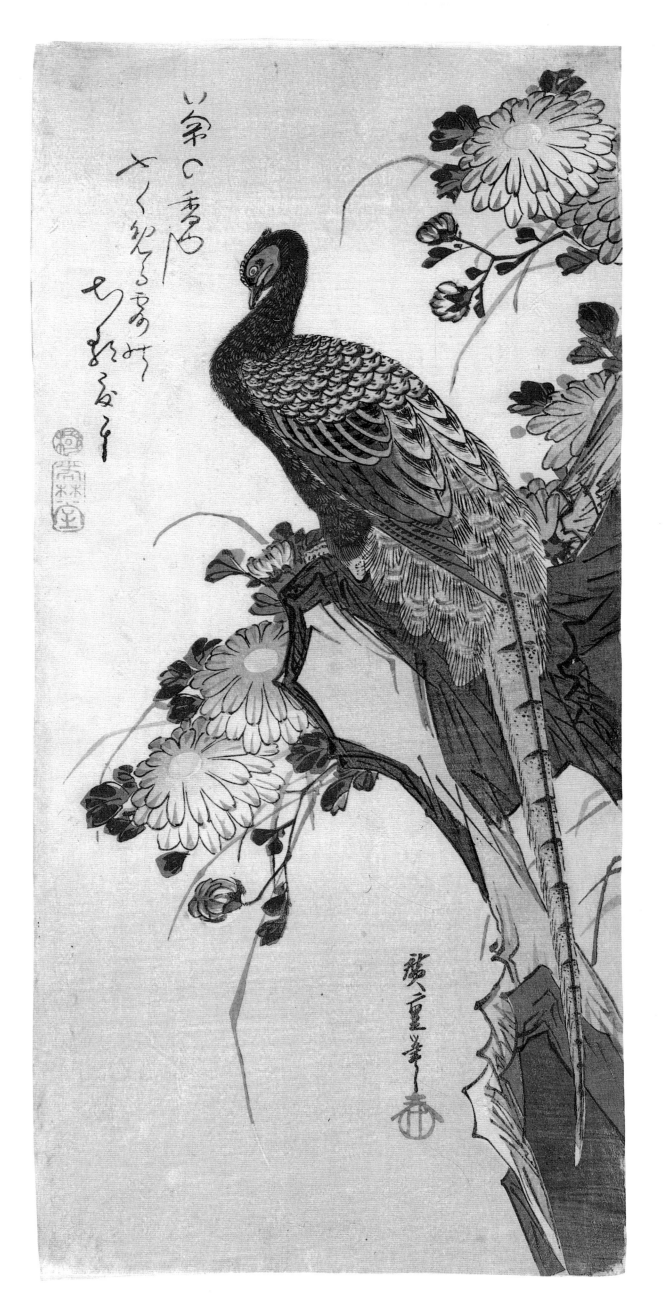

20. Cock, Umbrella, and Morning Glories

Nakeba[1] koso
wakere o oshime
tori no ne no
kikoenu sato no
akatsuki kana.

The cock starts to crow;
the time to part has come.[2]
Take me to a town
where the rooster is not heard;
that's the only place for dawn!

Size: Large Panel. 38.5 × 17.6 cm.
Date: early 1830s
Bird: Gallus gallus, *cock*
Flower: Pharbatis nil, *morning glory*
Signed: Hiroshige hitsu
Artist's Seal: Ichiryūsai
Poem: Kyōka, written in manyōgana
Provenance: F. E. Church (November 1928)
References: Suzuki, 57; Vever, 870; UTK, vol. XI,
* pl. 96.*
From the Abby Aldrich Rockefeller Collection of Japanese Prints,
* Museum of Art, Rhode Island School of Design,*
* accession number 34.281.*

This is the first edition of the print and has Hiroshige's Ichiryūsai seal beneath his signature. In the second edition (Vever and *Ukiyo-e Taikei* impressions), this seal is replaced by that of the publisher Kikakudō.

The cock is a sacred bird in Japan, largely because of its ability to forecast weather changes and to tell time (Volker, p. 73). It is also the symbol of virility and of male beauty.

1. Again the verb *naku* is used for a bird's call. Whether the bird quacks, crows, or warbles, the same verb expresses the action.

2. The parting at dawn, after which the lover escapes with none of the world aware of his visit, is a standard feature of the classical Japanese love affair. Often the period between the first streaks of dawn and the escape is protracted by the lover, partly to show the lady his reluctance to part with her and partly as a devil-may-care toying with the dangers of his position.

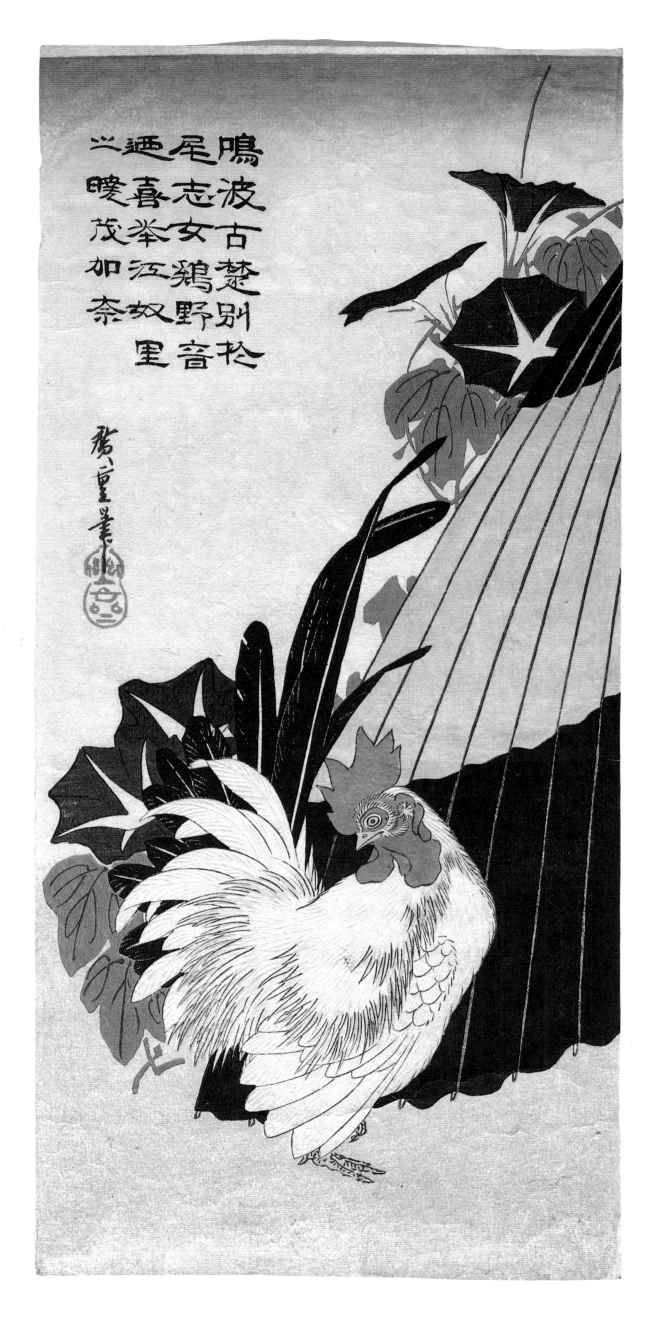

21. An Egret among Rushes

Size: Medium Panel. 36.8 × 12.2 cm.
Date: early 1830s
Bird: Egretta garzetta Linnaeus, *little egret*
Flower: Juncus spec., *rush*
Signed: Hiroshige hitsu
Artist's Seal: Ichiryūsai
Publisher's Mark: Kawashō (Kawaguchi Shōzō)
Censor's Seal: Kiwame
Poem: Kambun. Gogonzekku. Text filled with
 archaic characters and therefore unreadable
Provenance: William Lawrence Keane (Yokohama,
 1921)
References: TNM, 3530; Vever, 907; UTK, vol. XI.
 pl. 89.
From the Abby Aldrich Rockefeller Collection of Japanese Prints,
 Museum of Art, Rhode Island School of Design,
 accession number 34.219.

To Hillier this is "one of the most admired of the artist's *kachō-e*" (Vever, p. 931). This must also have been a popular print in Hiroshige's time as late impressions are known where the lines of the reeds have broken down due to excessive wear on the blocks.

The Rockefeller print is a fine, early impression with attractive shading in the blue water, but sadly, the rubbing in the center of the print has gone into the embossing of the heron's feathers.

22. Sparrow and Bamboo

Size: Large Panel. 37.2 × 17.2 cm.
Date: 1847–52.
Bird: Passer Montanus (Linnaeus), tree sparrow
Signed: Hiroshige ga.
Artist's Seal: Ichiryūsai
Publisher's Mark: Tsujiyasu (Tsujiya Yasubei)
Censors' Seals: Muramatsu; Mera.
Provenance: Wakai; Arthur D. Ficke (American Art
* Galleries, New York, 1920, lot 737).*
From the Abby Aldrich Rockefeller Collection of Japanese Prints,
* Museum of Art, Rhode Island School of Design,*
* accession number 34.283.*

Bamboo in Japanese art is invariably painted with broad, flat strokes of the brush that alternate with delicate, transparent washes for the leaves. In this print, using many varied shades of gray, Hiroshige's engravers and printers have created a fine example of the emulation of brushstrokes in woodblock printing.

This is a particularly rare print and much later in date than most Hiroshige large panel *kachō-e*. There seems to be no record of another impression.

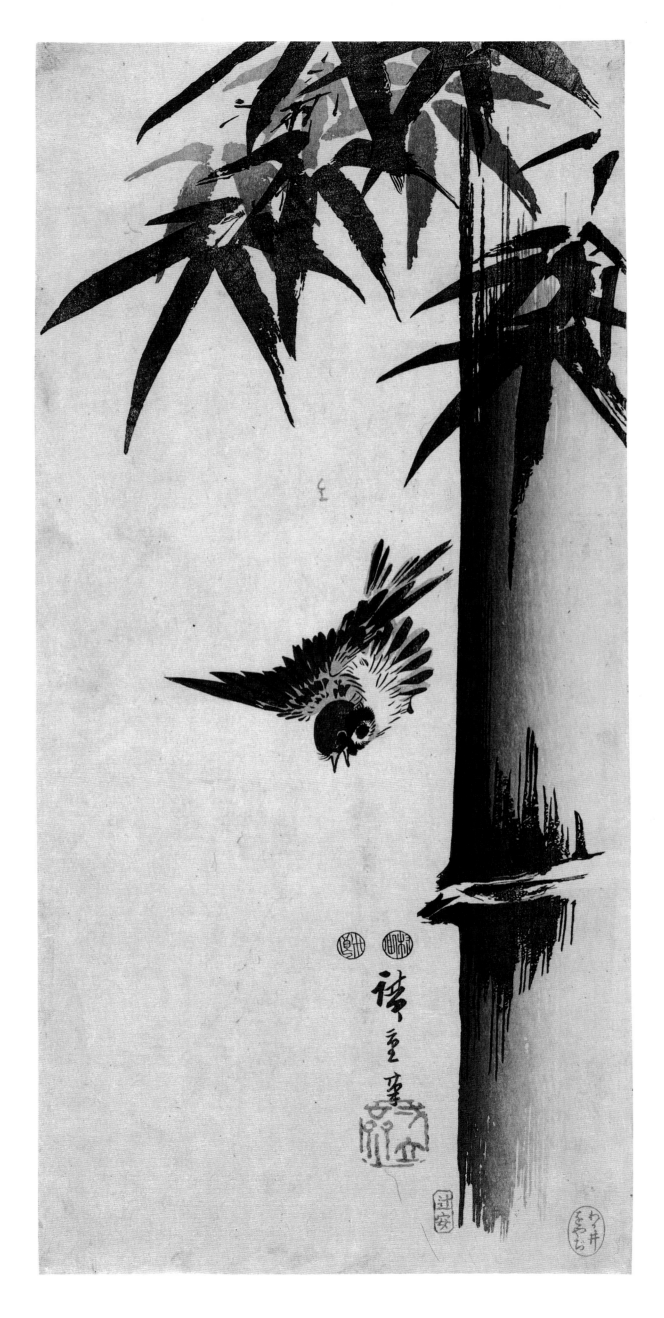

23. Falcon on a Pine Tree with the Rising Sun

Hatsu hi no de
kuni ni sakai a
nakari keri.

As New Year's Day dawns,
all the border gates are down
throughout the nation.

Size: Large Panel, 38.5 × 17.7 cm.
Date: early 1830s
Bird: Falco peregrinus Tunstall, *peregrine falcon*
Signed: Hiroshige hitsu
Artist's Seal: Ichiryūsai
Poem: Haiku
Season word: hatsu hi, *"New Year's dawn" (New*
Year)
Provenance: Probably Hirakawa (American Art
Association [New York, 1917], lot 57).
Reference: Amsterdam, 32.
From the Abby Aldrich Rockefeller Collection of Japanese Prints,
Museum of Art, Rhode Island School of Design,
accession number 34.277.2

The falcon, like the rising sun, is closely associated with the New Year and features with the eggplant and Mt. Fuji in one of the traditional "three lucky dreams." Dreaming of a falcon at New Year's would ensure happiness in the year to come.

A second state of this print was published by Sanoya Kihei. In an impression of this later state in Amsterdam, the sun is printed as a solid tone and lacks the gradation of color in the Rockefeller print.

A hawk on a pine was a popular Hiroshige subject and was repeated a number of times, most notably in three impressive *kakemono-e*.

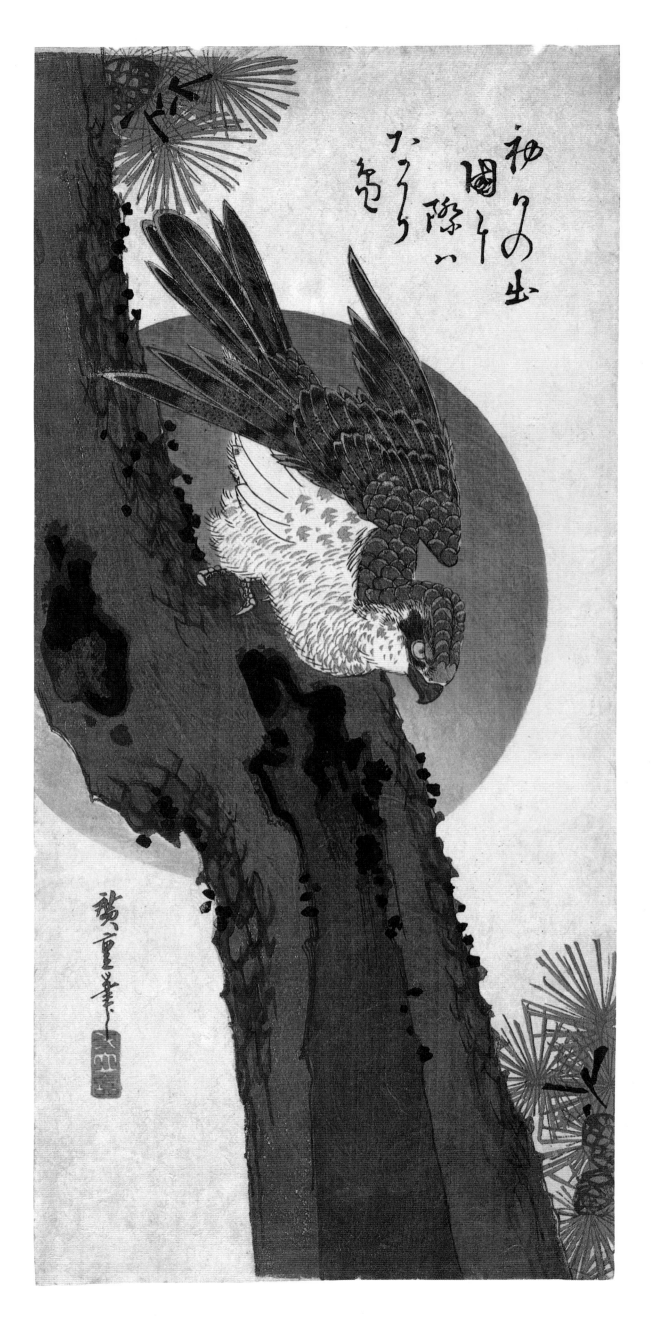

24. Bird in a Tree

Ryoku gaku jun o hete rō o hiraku
 no hi.
Ohgon ko ni michite hako ni iruru no
 toki.

The day green sepals burst from confinement
 in bamboo shoots.
The time when gold fills the trees and is
 placed in the basket.

Size: Large Panel. 38 × 17.3 cm.
Date: early 1830s
Flower: Diospyros Kaki, *persimmon*
Signed: Hiroshige hitsu
Publisher's Mark: Kikakudō (Sanoya Kihei)
Censor's Seal: Kiwame
Poem: Kambun. Shichigonkoshi. Two lines of seven
 characters each
Provenance: Yamanaka & Co. (January 1920)
Reference: Oberlin, 1301.
From the Abby Aldrich Rockefeller Collection of Japanese Prints,
 Museum of Art, Rhode Island School of Design,
 accession number 34.282.

Hiroshige designed a number of prints engraved in reverse that emulate Chinese stone rub-
bings. These prints were mostly *harimaze* or *ōban* sheets composed of several different designs,
and judging by the late impressions that one usually encounters, they must have been rather
popular in Hiroshige's day. The Rockefeller design is perhaps the most important example of
these Chinese-style prints, and as the artist's *kachō-e* are nearly always engraved in the paint-
erly manner of the *Shijō* style, this design provides an interesting comparison in style.

 Another edition, published by Jakurindō, is in Oberlin.

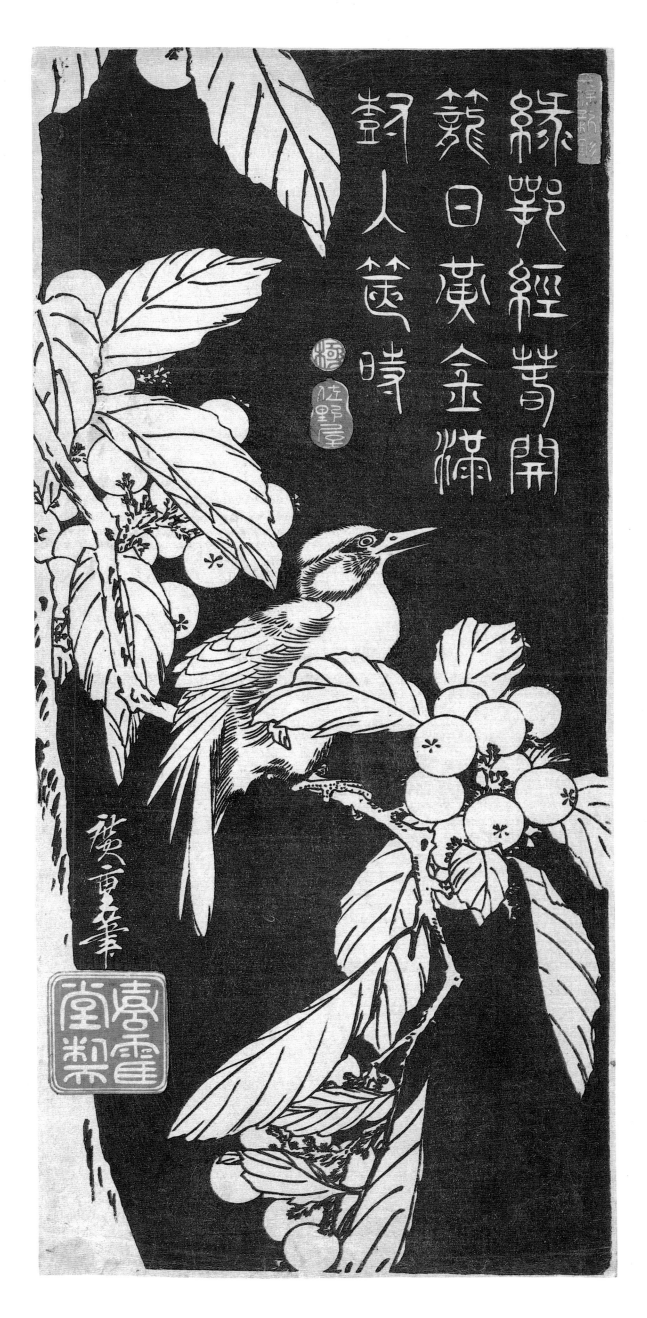

25. Peacock and Peonies

Size: Kakemono-e *(vertical* ōban *diptych).*
 72.2 × 24.6 cm.
Date: early 1840s
Bird: Pavo cristatus, *peacock*
Flower: Paeonia suffructicosa, *tree peony*
Signed: Hiroshige hitsu
Provenance: William Lawrence Keane (Yokohama,
 January 1920)
Reference: Suzuki, 197.
From the Abby Aldrich Rockefeller Collection of Japanese Prints,
 Museum of Art, Rhode Island School of Design,
 accession number 34.633.

Japanese prints were often kept in albums to be viewed at their owner's leisure. *Kakemono-e,* in contrast, were frequently displayed on the walls of the Japanese home as inexpensive substitutes for scroll paintings and, as a result, are usually found faded and damaged. Many were originally backed with cheap paper mounts in imitation of more costly silk mounts. Considering that the Rockefeller *kakemono-e* was mounted and hung in such a manner (the signs of mounting can be seen along the edge of the print), it is in excellent condition.

A peacock with peonies was one of Hiroshige's favorite *kachō-e* subjects.

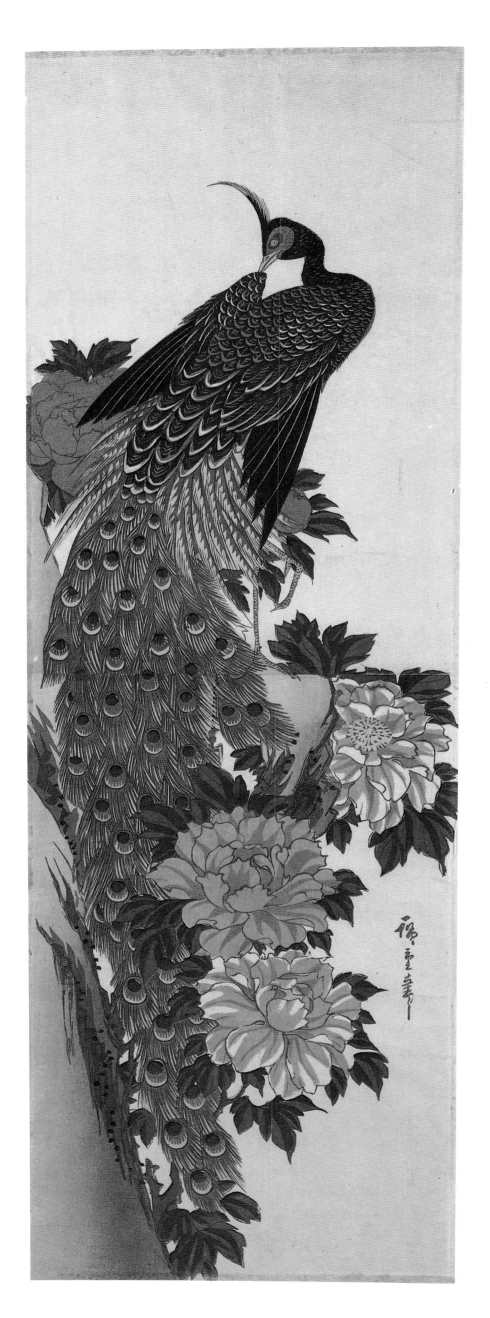

26. Kingfisher above a Yellow-flowered Water Plant

Fune niguru
kishi no koebi ya
natsu no tsuki.

Small shrimp by the shore
fleeing as the boat comes in
under summer's moon.

Size: Medium Panel. 35.1 × 11.2 cm.
Date: Third month of 1853 (Ox/III)
Bird: Alcedo atthis Linnaeus, Kingfisher
Flower: Nuphar japonicum
Signed: Hiroshige hitsu
Artist's Seal: Hiro
Publisher's Mark: Tsujiyasu (Tsujiya Yasubei)
Censors' Seals: Watanabe; Mera.
Poem: Haiku
Season Word: natsu, "summer"
Poem Signed: Kōsui
Provenance: Wakai; Charles Jacquin (Walpole
* Galleries [New York, 1921], lot 531).*
From the Abby Aldrich Rockefeller Collection of Japanese Prints,
* Museum of Art, Rhode Island School of Design,*
* accession number 34.156.1.*

27. Kingfisher and Moon above a Yellow-flowered Water Plant

Size: Medium Panel. 35.1 × 11.2 cm.
Date: Third month of 1853 (Ox/III)
Bird: Alcedo atthis Linnaeus, Kingfisher
Flower: Nuphar japonicum
Signed: Hiroshige hitsu
Artist's Seal: Hiro
Publisher's Mark: Tsujiyasu (Tsujiya Yasubei)
Censors' Seals: Watanabe, Mera
Poem: Haiku
Poem Signed: Kōsui
Season word: natsu, "summer"
References: F. E. Church (November 1928)
From the Abby Aldrich Rockefeller Collection of Japanese Prints,
* Museum of Art, Rhode Island School of Design,*
* accession number 34.156.2.*

Both impressions are fine, and the colors are fresh and unfaded. The moonlit nightscene lacks the woodgrain in the water of plate twenty-six and thus seems to have been printed from a different background block. Otherwise, the blocks for the two prints are the same.

There is slightly less wear on the publisher's seal in plate 27 and this, along with the mention of the moon in the poem, confirms that the print is the earlier state.

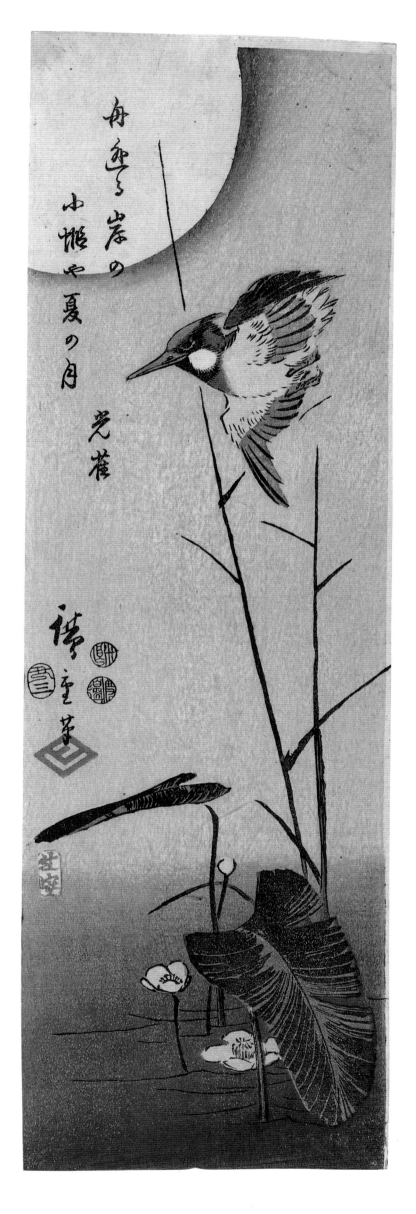

28. Mandarin Ducks on an Icy Pond with Brown Leaves Falling

Oshidori no
sakazuki to chiyo[1]
usukōri.

For mandarin ducks
thin ice is a wedding cup
for a thousand years.

Size: Medium Panel. 37.9 × 13.1 cm.
Date: mid-1830s
Bird: Aix galericulata (Linnaeus), Mandarin Ducks
Signed: Hiroshige hitsu
Poem: Haiku
Season words: oshidori, *"mandarin duck"*; kōri,
"ice" (winter)
Provenance: F. E. Church (November 1928)
References: TNM, 3527.
From the Abby Aldrich Rockefeller Collection of Japanese Prints,
Museum of Art, Rhode Island School of Design,
accession number 34.131.

1. *Sakazuki* is the word for the tiny Japanese sake cup, which has an important place in the wedding ceremony as bride and groom drink from the same cup and pledge eternal love. *Chiyo,* "a thousand years," and the familiar *banzai,* for "ten thousand years" — though they are most directly connected with the emperor and his reign — are common terms connected with personal well-wishes.

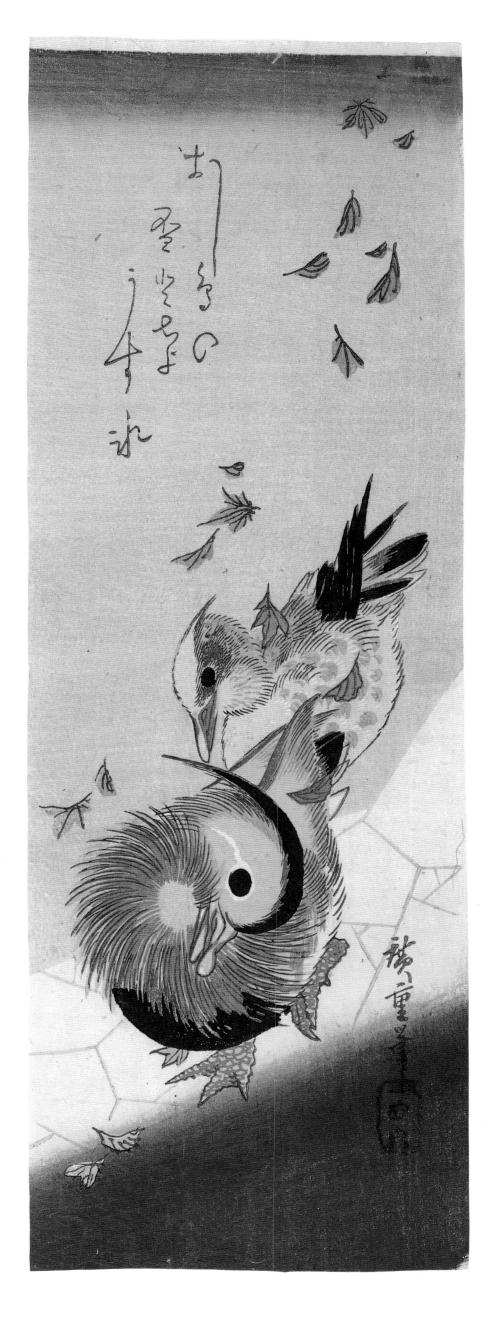

29. A Little Bird Amidst Chrysanthemum

Kichō omou

Taihō no
takaki kokoro no
kimi yue ni
ukimi o sasai
yori mo tsukarezu.[1]

Thoughts on an Exotic Bird

He is a great lord,
with a mind that flies as high
as that of the roc,
so he will have none of me,
who dare not fly very high.

Size: Medium Panel. 37.6 × 12.9 cm.
Date: early 1830s
Bird: Linnaeus bucephalus Temminck & Schlegal,
 bullheaded shrike
Flower: Chrysanthemum hort., chrysanthemum
Signed: Hiroshige hitsu
Artist's Seal: Ichiryūsai
Publisher's Mark: Kawashō (Kawaguchi Shōzō)
Poem: Kyōka, with title
Provenance: William Lawrence Keane (Yokohama,
 1921)
Reference: Buhl, 44.
From the Abby Aldrich Rockefeller Collection of Japanese Prints,
 Museum of Art, Rhode Island School of Design,
 accession number 34.217.1.

The collection contains a duplicate impression of this print with small areas of damage and with woodgrain in the blue shading at lower left.

1. *Tsukarezu* can mean either "cannot climb high," "does not get tired," or, if read *tsugarezu,* "cannot enter into entanglements." It seems to be used in all three senses in this poem.

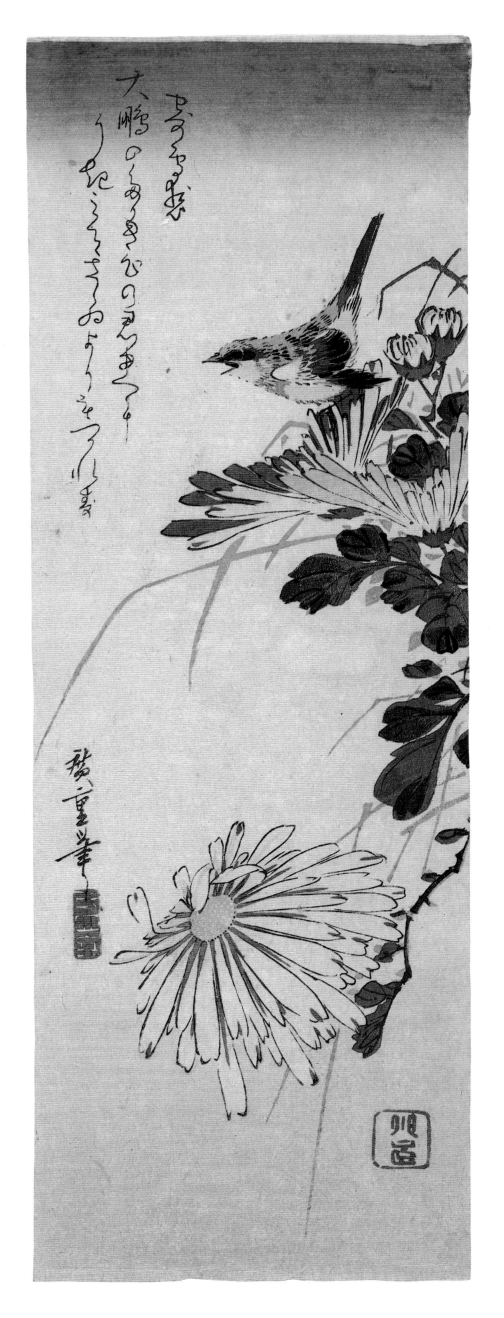

30. Sparrow and Bamboo

Take no haru
momiji no aki no
mamire kana.

The bamboo in spring —
tinted with the crimson stains
of fall's maple leaves.

Size: Medium Panel. 33.8 × 11 cm.
Date: ca. 1845
Bird: Passer montanus Linnaeus, *tree sparrow*
Signed: Hiroshige hitsu
Artist's Seal: Ichiryūsai
Poem: Haiku, signed
Season word: haru, *spring*
Poet: Isōan
Censor's Seal: Tanaka
Provenance: William Lawrence Keane (Yokahoma,
* January 1920)*
From the Abby Aldrich Rockefeller Collection of Japanese Prints,
* Museum of Art, Rhode Island School of Design*
* accession number 34.166*

Although the blue of the sky would have been printed with far greater intensity in earlier impressions of this print, the skillful printer has achieved considerable atmosphere and a soft pastel-like quality, particularly in the inking of the green bamboo, which is very attractive.

Another impression of this print is illustrated in the F. E. Church sale catalogue (Parke-Bernet Galleries [New York, 1946], lot 190).

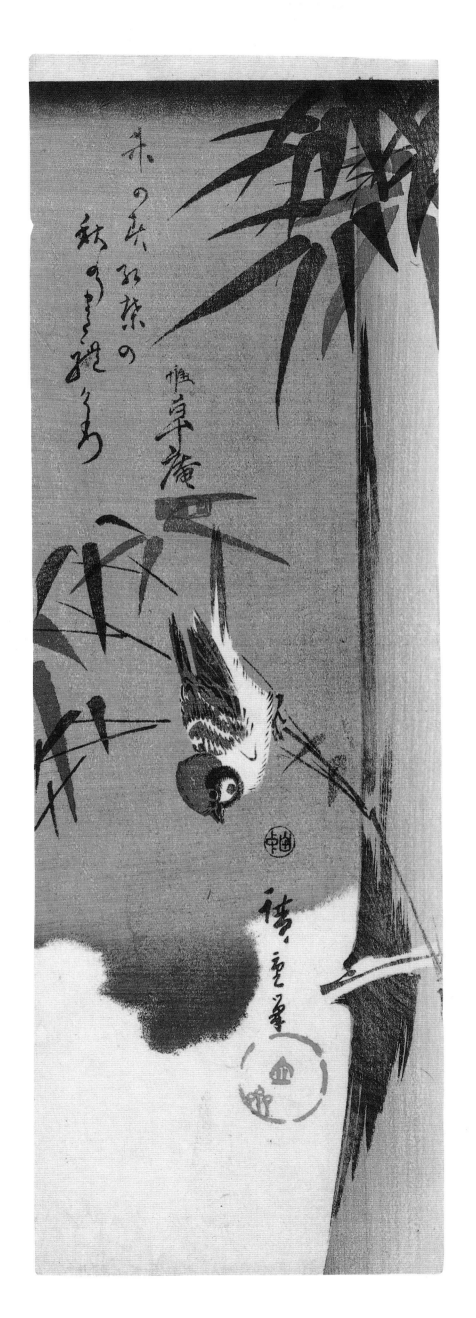

31. A Mandarin Duck on a Snowy Bank

Oshidori no
wakare o mitari
asa arashi.

The morning tempest
sees even mandarin ducks
go separate ways.

Size: Medium Panel. 34.7 × 11.5 cm.
Date: 1830s
Bird: Aix galericulata (Linnaeus), mandarin duck
Signed: Hiroshige hitsu
Artist's Seal: Ichiryūsai
Poem: Haiku
Season word: oshidori, "mandarin duck" (winter)
Poet: Sakushōken Riho
References: Vever, 912; Oberlin, 1314.
From the Abby Aldrich Rockefeller Collection of Japanese Prints,
 Museum of Art, Rhode Island School of Design,
 accession number 34.133.

An impression illustrated in a Christie's sale catalogue (New York [April 1987], lot 254) has yellow, not brown shading at the top of the print and a square Ichiryūsai seal after the signature rather than the gourd-shaped seal of the Rockefeller and Vever prints. The Oberlin impression lacks either seal.

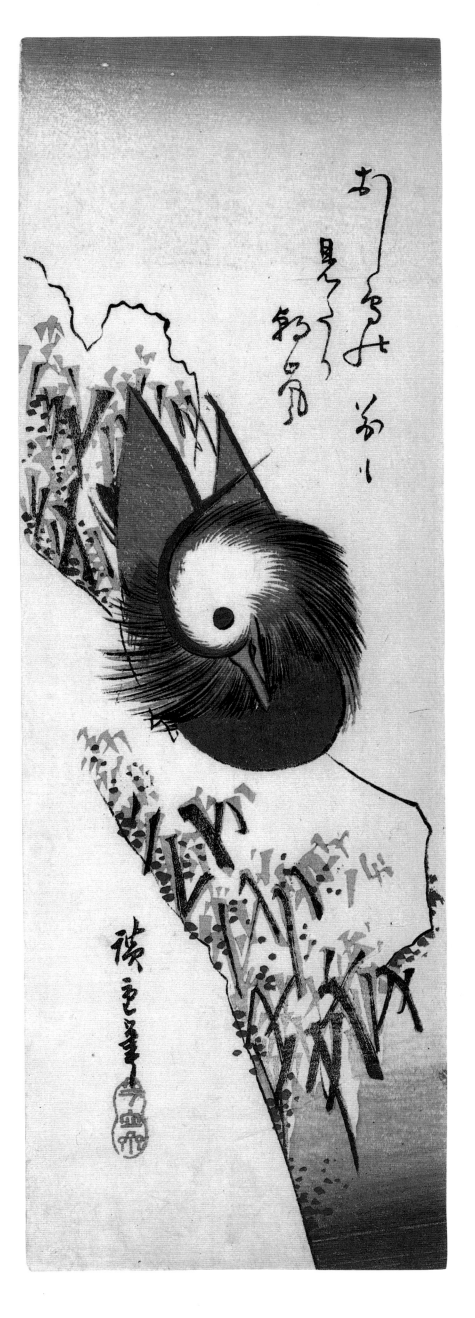

32. Birds Flying over Waves

Futa takumu
yowa ya chidori no
shikiri naku.

Conniving in pairs,
at midnight hear the plovers
piping endlessly.

Size: Medium Panel. 34.1 × 11.4 cm.
Date: late 1830s
Signed: Hiroshige hitsu
Poem: Haiku
Season word: chidori, "plover" (winter)
Poem signed: Uomori
Provenance: Alexis Rouart (American Art Galleries
[New York, 1922], lot 925).
From the Abby Aldrich Rockefeller Collection of Japanese Prints,
Museum of Art, Rhode Island School of Design,
accession number 34.138.

In addition to the Rockefeller print, there are at least two other versions of this design. A version published by Sanoki with birds flying across a small round moon is illustrated in Tamba (plate 411). Another version with a larger moon is illustrated in a Sotheby's sale catalogue (London [January 1978], lot 117). These three versions are from completely different blocks, though each appears genuine and bears every sign of having been printed during Hiroshige's lifetime.

This example of the contemporary reengraving of a Hiroshige *kachō-e* is not an isolated one and indicates their great popularity among the print-buying Edo public of the mid-nineteenth century. Roger Keyes (Oberlin, p. 119) has questioned whether these multiple versions, which are often executed in different engraving styles and which often lack publisher's and censor's seals, were redesigned by Hiroshige himself or copied from existing designs. This complicated connoisseurship issue requires careful study.

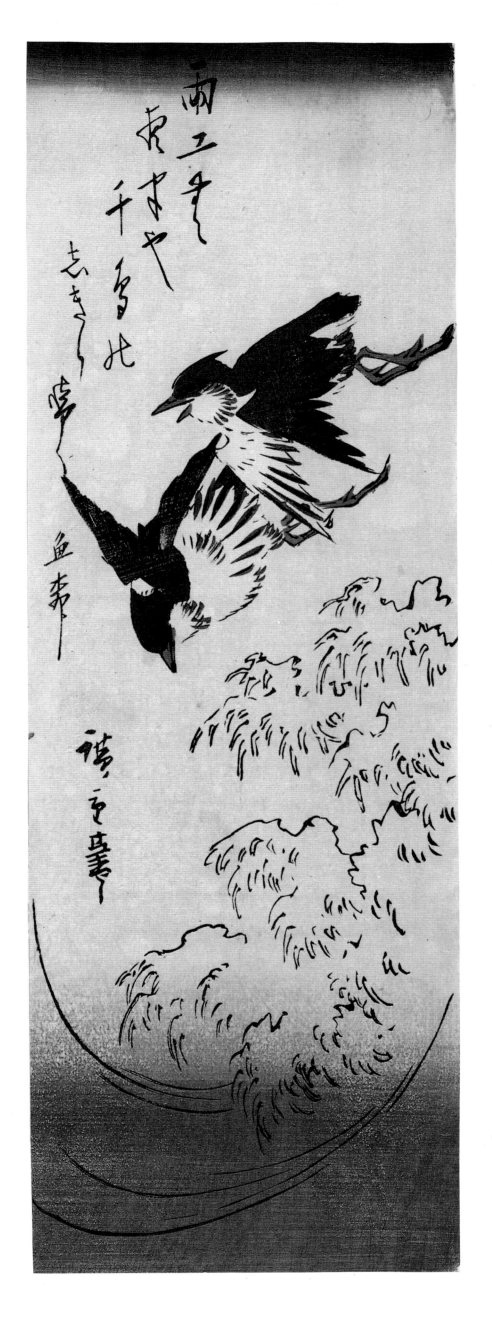

33. Blossoming Plum Tree

Nodokasa ni
yasuraka ni naru
chikara kobu.

Gently nurtured
in complete tranquillity —
bundles of muscle.

Size: Medium Panel. 37.7 × 13 cm.
Date: ca. 1847
Flower: Prunus mume, "plum" blossom
Signed: Hiroshige hitsu
Censor's Seal: Mera
Poem: Haiku
Season word: nodokasa, "tranquillity" (spring)
Poem signed: Arimatsu
Provenance: Frank Lloyd Wright (Purchased
* through F. W. Gookin, May 1923)*
Reference: TNM, 3536.
From the Abby Aldrich Rockefeller Collection of Japanese Prints,
* Museum of Art, Rhode Island School of Design,*
* accession number 34.170.*

34. Blossoming Plum Tree with Full Moon

Size: Medium Panel. 33.5 × 11.1 cm.
Date: ca. 1847
Flower: Prunus mume, "plum" blossom
Signed: Hiroshige hitsu
Publisher's Mark: probably Kawashō (Kawaguchi
* shōzō)*
Censor's Seal: Mera
Poem: Haiku
Season word: nodokasa, "tranquillity" (spring)
Poem signed: Arimatsu
Provenance: Yamanaka & Co.
From the Abby Aldrich Rockefeller Collection of Japanese Prints,
* Museum of Art, Rhode Island School of Design,*
* accession number 34.171.*

As with plates twenty-six and twenty-seven, the addition of a moon to a Hiroshige *kachō-e* effectively changes the mood and tone of the design.

The character to the right of the middle plum branch of plate thirty-three has been shortened — otherwise, it would have extended below the top edge of the moon. Although plate thirty-four has been trimmed at left, both prints are untrimmed at top, and the design in the later state (plate 34) has been concentrated by shortening the sky block. This probably occurred because the moon had to lie below the line of poetry; and if the sky had not been cut down, the design might have become unbalanced. The highest plum branch in plate thirty-four has also been shortened so as not to extend above the line formed by the poetry.

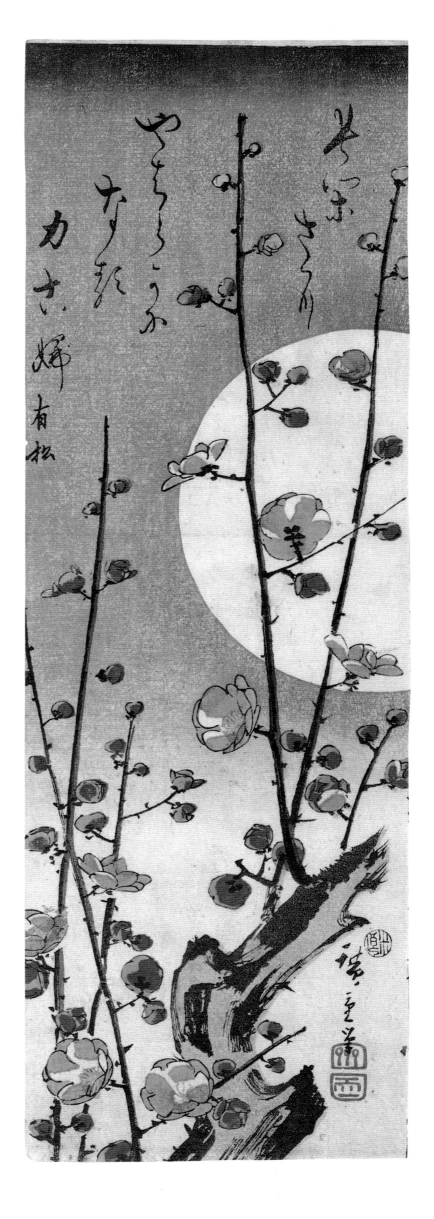

35. Three Wild Geese Flying Downward across the Moon

Komu na yo ga[1]
mata mo arō ka
tsuki ni kari.

Will it come again —
another night like this one?
Wild geese and the moon.

Size: Medium Panel. 34.2 × 12.4 cm.
Date: late 1830s
Bird: Anser fabalis Latham, bean goose
Signed: Hiroshige hitsu
Artist's Seal: Ichiryūsai
Poem: Haiku
Season word: kari, "wild geese" (autumn)
Provenance: F. E. Church (November 1928)
From the Abby Aldrich Rockefeller Collection of Japanese Prints,
* Museum of Art, Rhode Island School of Design,*
* accession number 34.153.*

Three geese flying across the moon is one of the traditional symbols of autumn in Japan (Volker, p. 91).

As with plates three and four, Hiroshige has contrasted the angle of the descending geese with the sharp curvature of the moon to form an exciting and dramatic composition.

Earlier impressions lack the dark blue band at the top of the Rockefeller print and have additional shading around the moon.

1. Pun on *Yo,* meaning "world."

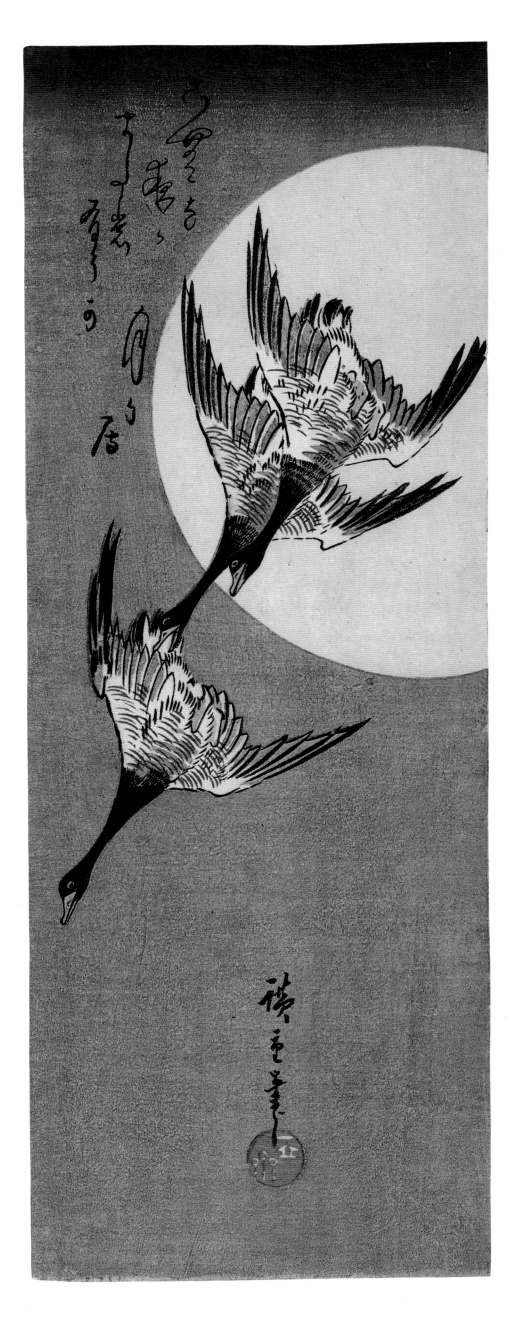

36. A Japanese White-eye on a Persimmon Branch

Tsukimi tote
mukau sangen[1]
morawarete
shibu mo nokoranu
yado no edagaki.

They said, "Moon viewing" —
the three neighbors over there —
and then accepted
all persimmons[2] on my tree,
even those that weren't ripe.

Size: Medium Panel. 35.9 × 12.6 cm.
Date: mid-1830s
Bird: Zosterops japonica Temminck & Schlegel,
 Japanese white-eye
Flower: Diospyros Kaki, persimmon
Signed: Hiroshige hitsu
Artist's Seal: Ichiryūsai
Poem: Kyōka
Poem signed: Jintei (disciple of Hachijintei?)
Provenance: F. E. Church (November 1928)
From the Abby Aldrich Rockefeller Collection of Japanese Prints,
 Museum of Art, Rhode Island School of Design,
 accession number 34.218.

This print is very similar in style and subject to a plate from Chinnen's *Sōnan Gafu* (1834) — one of the masterpieces of *Shijō* book design — which shows two small green birds on a persimmon.

Other impressions of this Hiroshige *kachō-e* are illustrated in the Arthur D. Ficke sale catalogue (American Art Association [New York, 1920], lot 741) and, more recently, in a Sotheby's sale catalogue (London [May 1982], lot 103).

1. "Mukou sangen ryōdonari," or "the three houses across the way and the two next door," is a common expression, even today.

2. Persimmons, along with a spread of fifteen dumplings, pampas-grass and chestnuts, are an important part of moon-viewing on October 15th.

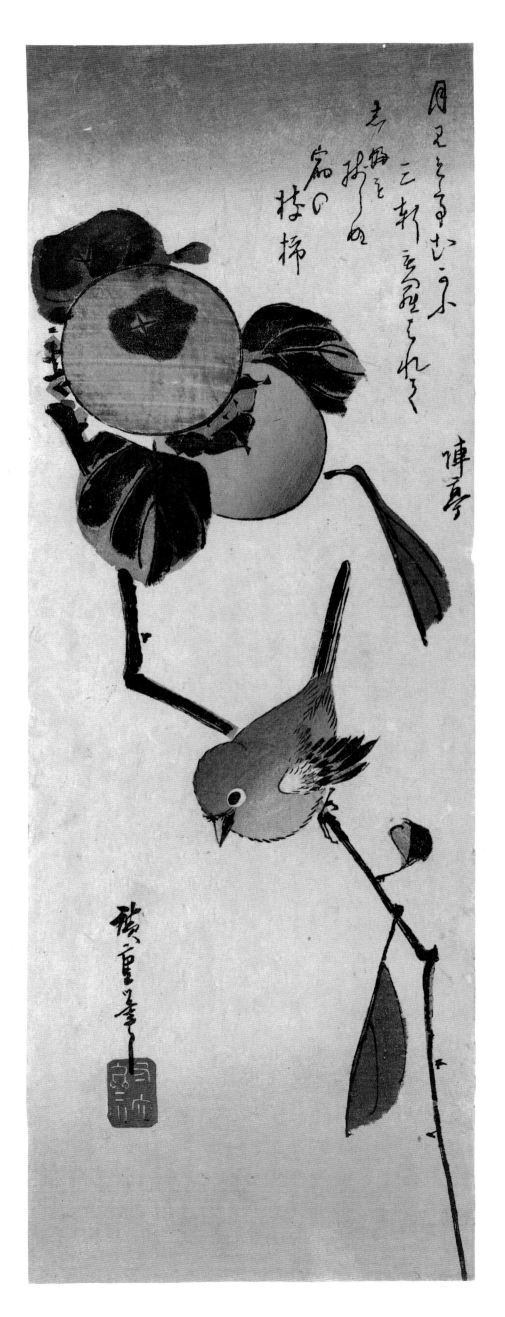

37. Sparrow and Wild Rose

Size: One Third Block. 25.6 × 12.3 cm.
Date: early 1830s
Bird: Passer montanus Linnaeus, tree sparrow
Signed: Hiroshige hitsu
Provenance: F. E. Church (November 1928)
From the Abby Aldrich Rockefeller Collection of Japanese Prints,
 Museum of Art, Rhode Island School of Design,
 accession number 34.262.

No other impression of this particularly rare Hiroshige *kachō-e* appears to be recorded.

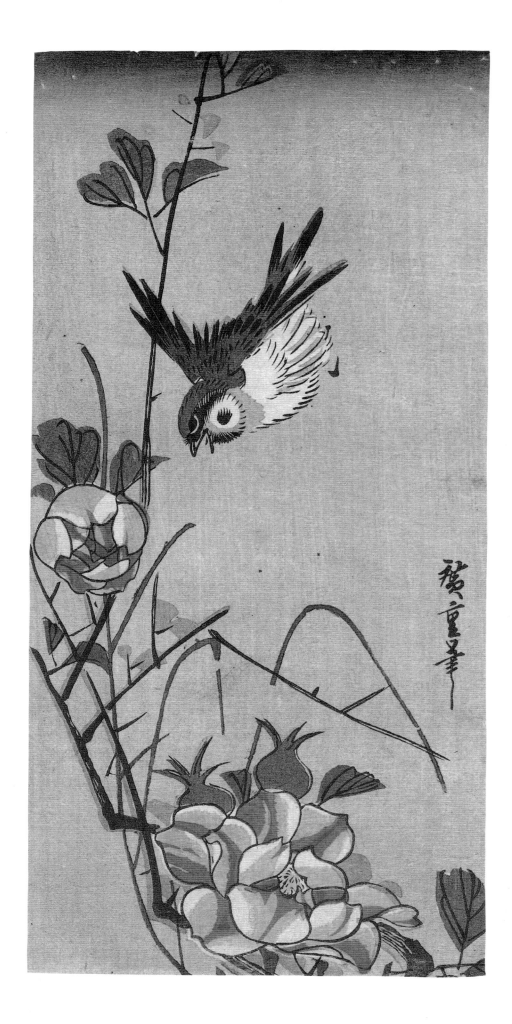

38. Two Ducks Swimming among Reeds

Kamo naki ya
kaze fukishiwamu
mizu no omo.

A duck calls softly;
a breeze starts ripples moving
over the water.

Size: Medium Panel
Date: mid-1830s
Birds: Bird at bottom: Anas formosa Georgi,
 Baikal teal; *Bird at top:* Anas platyrhynchos
 Linnaeus, *mallard*
Flower: Phragmites, *reeds*
Signed: Hiroshige hitsu
Artist's Seal: Yūsai
Publisher's Mark: Kawashō (Kawaguchi Shōzō)
Poem: Haiku, written in manyōgana
Season word: kamo, "duck" (winter)
Provenance: Hayashi; F. E. Church (November
 1928).
References: TNM, 3521; Oberlin, 311; Amsterdam,
 31.
From the Abby Aldrich Rockefeller Collection of Japanese Prints,
 Museum of Art, Rhode Island School of Design,
 accession number 34.130.2.

The collection contains another, somewhat later, impression with less subtle printing grada-
tions and the water printed in a harsher tone of blue.

Impressions of the second edition with the publisher's mark changed from Kawashō to
Fujihiko are illustrated in *Ukiyo-e Taisei*, vol XI, no. 47 and Sotheby's sale catalogue (London
[May 1978], lot 185). Both of these later impressions lack the strong shading in the water
beneath the ducks that is present in plate thirty-eight.

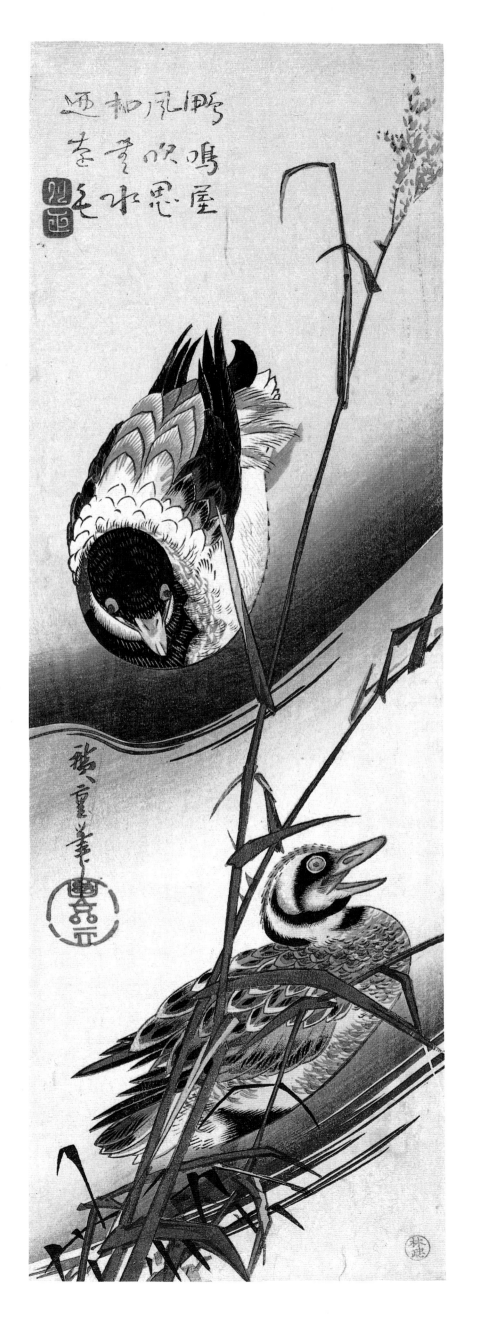

39. A Group of Cranes in Flight

Size: Letter Writing Paper? 17.6 × 48.7 cm.
Date: late 1830s
Birds: (with white wings) Grus japonicus Muller,
* Japanese crane; (with gray wings) Grus vipio*
* Pallas, white-naped crane*
Signed: Hiroshige ga
Artist's Seal: Ryūsai
Provenance: Charles B. Eddy (purchased from
* Yamanaka & Co., January 1927)*
From the Abby Aldrich Rockefeller Collection of Japanese Prints,
* Museum of Art, Rhode Island School of Design,*
* accession number 34.481.*

This long, *surimono*-like print, which seems to have been intended for use as letter writing paper, is similar in format and muted color scheme to the rare landscape series known as "Thirteen Views of the Environs of Edo" (Suzuki, plates 212 and 215). Like the Rockefeller *kachō-e*, prints from this set lack a censor's seal and a publisher's mark, though Roger Keyes believes that the landscape series was probably a commissioned *surimono*-style set and (contrary to what has sometimes been suggested) never intended for use as letter-writing paper.

It is not surprising given the ephemeral nature of this *kachō-e* that only one other impression (in the Honolulu Academy of Arts) appears to be extant.

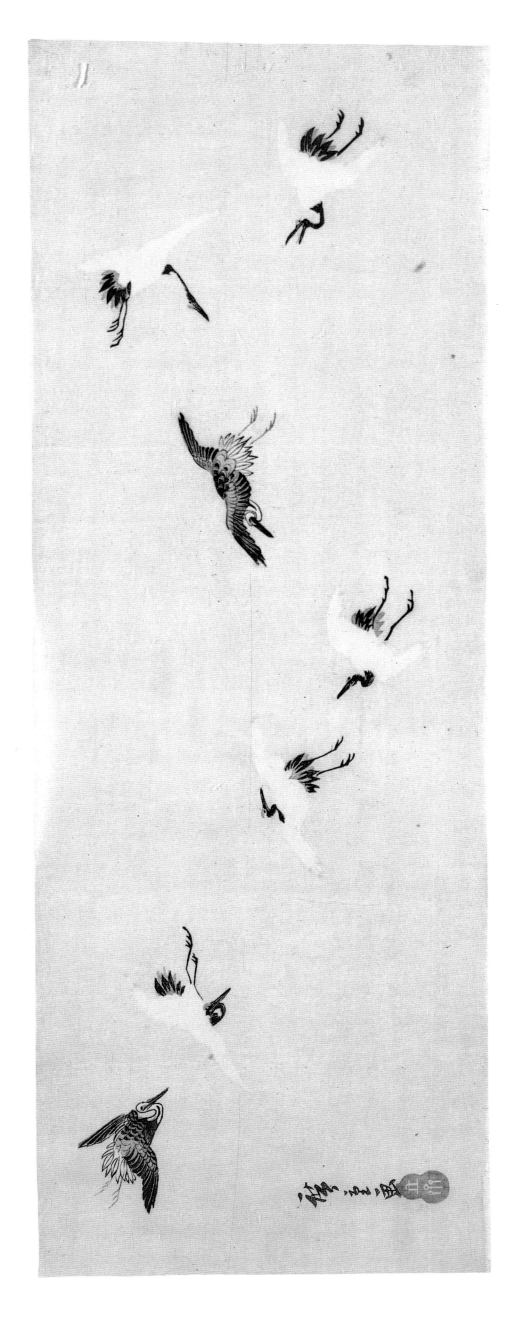

40. Autumn Flowers in Front of the Full Moon

Size: Fan Print. 22.8 × 29.4 cm.
Date: First month of 1853 (Ox/I)
Flower: Begonia evansiana, begonia, Gentiana
 triflora, Ixeris stolonifera
Signed: Ryūsai
Artist's Seal: Hiro
Publisher's Mark: Marusei (Maruya Seijiro)
Provenance: F. E. Church (November 1928)
From the Abby Aldrich Rockefeller Collection of Japanese Prints,
 Museum of Art, Rhode Island School of Design,
 accession number 34.329.

There are two standard types of Japanese fans: the elongated folding fan, the *ōgi-e,* and the more rounded *uchiwa-e. Ukiyo-e* artists rarely used the *ōgi-e* format for print design, although several examples by Hiroshige are known.

Hiroshige's fan prints are among the most beautiful designs in his entire oeuvre, and they are among the Hiroshige prints most coveted by today's collectors; but because they were intended for use, relatively few have survived. This print, of autumnal flowers set against a full moon echoing the shape of the fan, appears to be unique. Fortunately, a large number of the fan prints that have survived come from the sample books of the original fan sellers, and, as here, they are usually early impressions with unfaded colors.

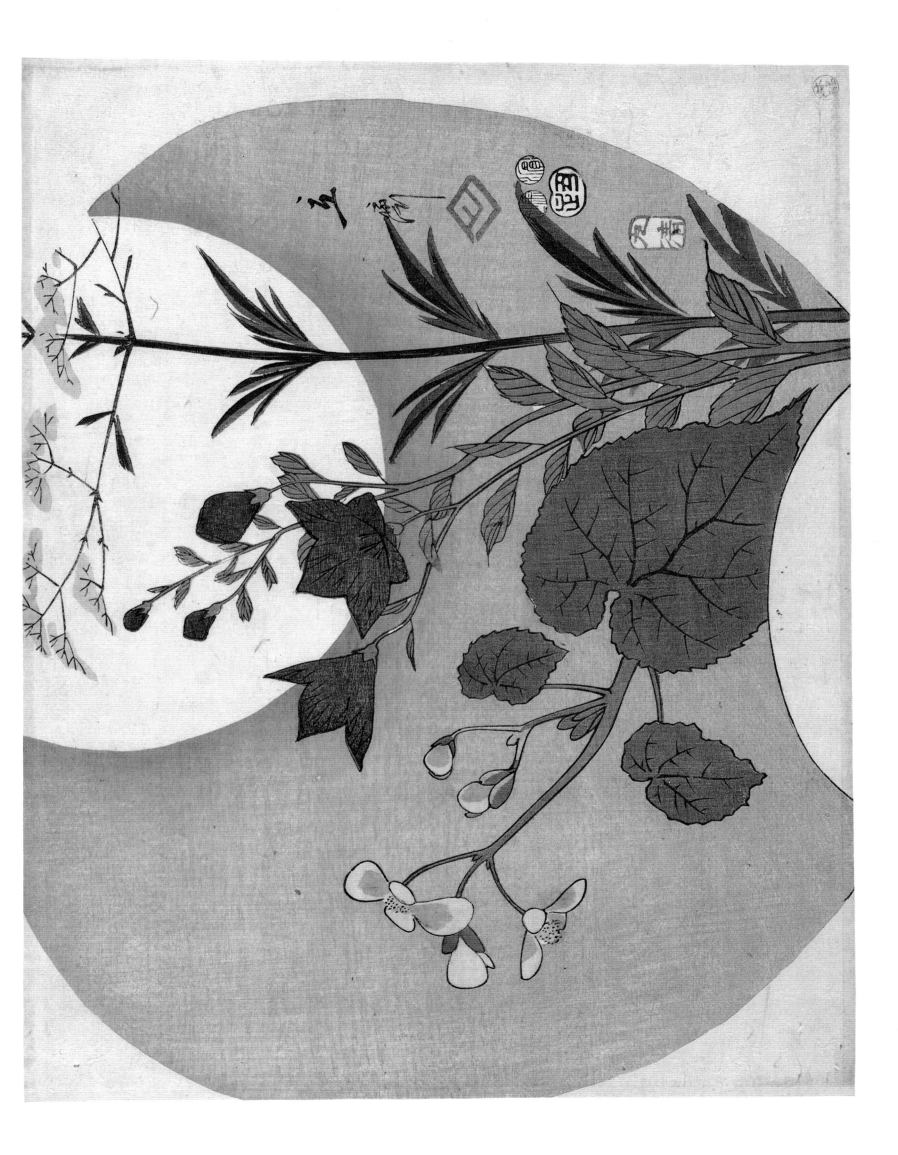

41. Dancing Swallows

Size: Fan Print. 22.7 × 29.2 cm.
Date: ca. early 1840s
Bird: Hirundo rustica Linnaeus, house swallow
Signed: Hiroshige gi[hitsu]
Artist's seal: Tōkaidō
References: Tamba 109
Provenance: F. E. Church (November 1928)
From the Abby Aldrich Rockefeller Collection of Japanese Prints,
 Museum of Art, Rhode Island School of Design,
 accession number 34.333.

This marvelous fan print of a "ballet master" conducting a troop of dancers is among the wittiest of Hiroshige's designs. In the Shijō tradition, the human figures in a number of Hiroshige's landscape prints are also intentionally humorous, though this is sometimes less than obvious to Western audiences.

The Rockefeller impression of "Dancing Swallows" is quite late. The swallows in the Tamba impression are printed with greater intensity, a differently colored background, and with the mark of the publisher Kitamago. The Tamba print is signed *gihitsu*, or "painted for fun." The Rockefeller impression is missing the character for *hitsu* ("painted"): either the character was mistakenly uninked, or it was removed from the signature block.

Tamba illustrates two other humorous *kachō-e* fan prints (plates 10 and 499), which are also signed *gihitsu*. Titled "Floral Personifications of the Six Famous Poets," these prints parody a traditional subject by depicting the poets as composites of various types of flowers.

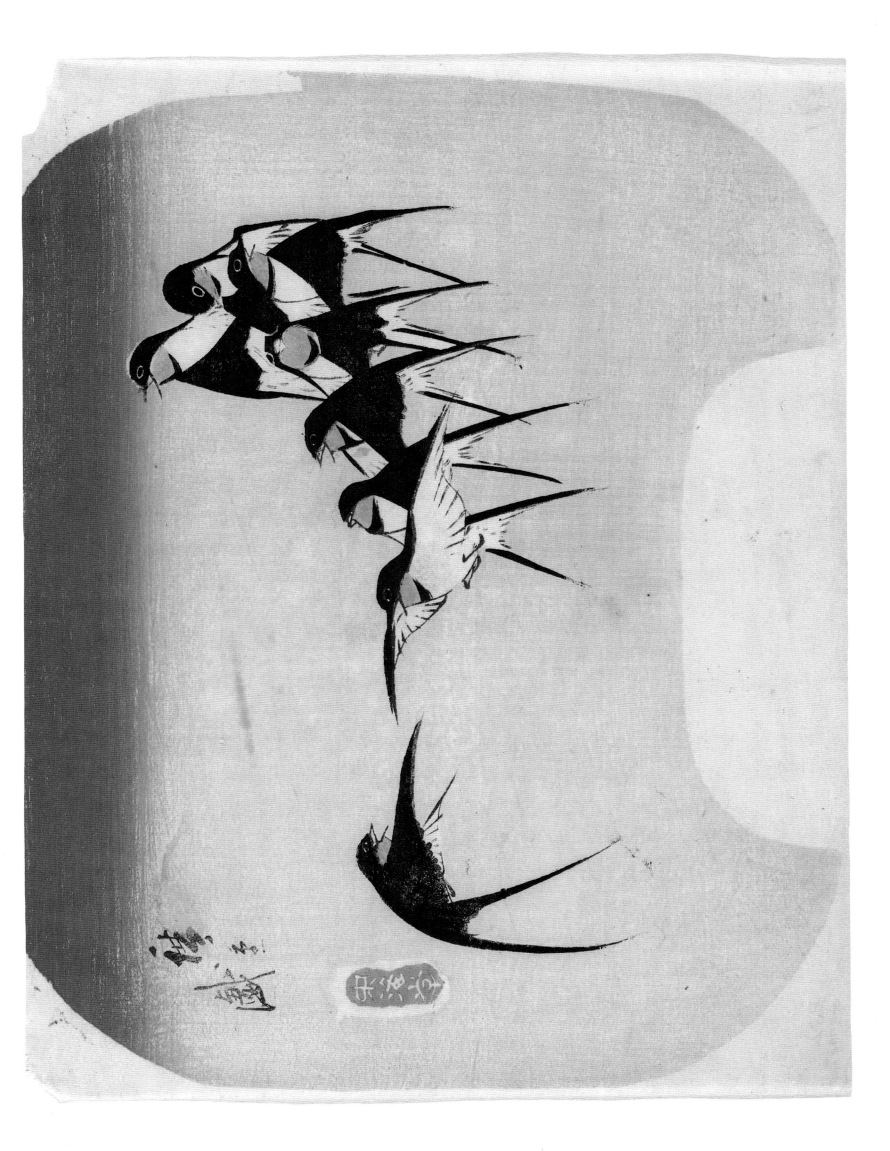

42. "Autumn" (*Aki*): from the series *Kodai Meiyō Shiki no hana*
("Flowers of the Four Seasons with Historical Associations")
Subtitle: *Kando Yūkoku Judō no Kiku,*
("Judōs Chrysanthemums in a Deep Ravine in China")

Size: Fan print. 23.7 × 30.9 cm.
Date: 1844–46.
Flower: Chrysanthemum hort., chrysanthemum
Signed: Hiroshige ga
Publisher's Mark: Surugaya Sakujirō
Censor's Seal: Murata
Provenance: F. E. Church (November 1928)
From the Abby Aldrich Rockefeller Collection of Japanese Prints,
 Museum of Art, Rhode Island School of Design,
 accession number 34.332.

The boy in the yellow cartouche is Judō, better known as Kikujidō ("the Chrysanthemum Boy"), who is often depicted in Japanese and Chinese art. In autumn in Japan, the old tradition of displaying wire models of Kikujidō composed of various types of chrysanthemums is still popular.

An additional impression of this print is in the Honolulu Academy of Arts. Another print from the series shows irises and the poet Ariwara no Narahira (see Sebastian Izzard, *Hiroshige,* New York, 1983, plate 52).

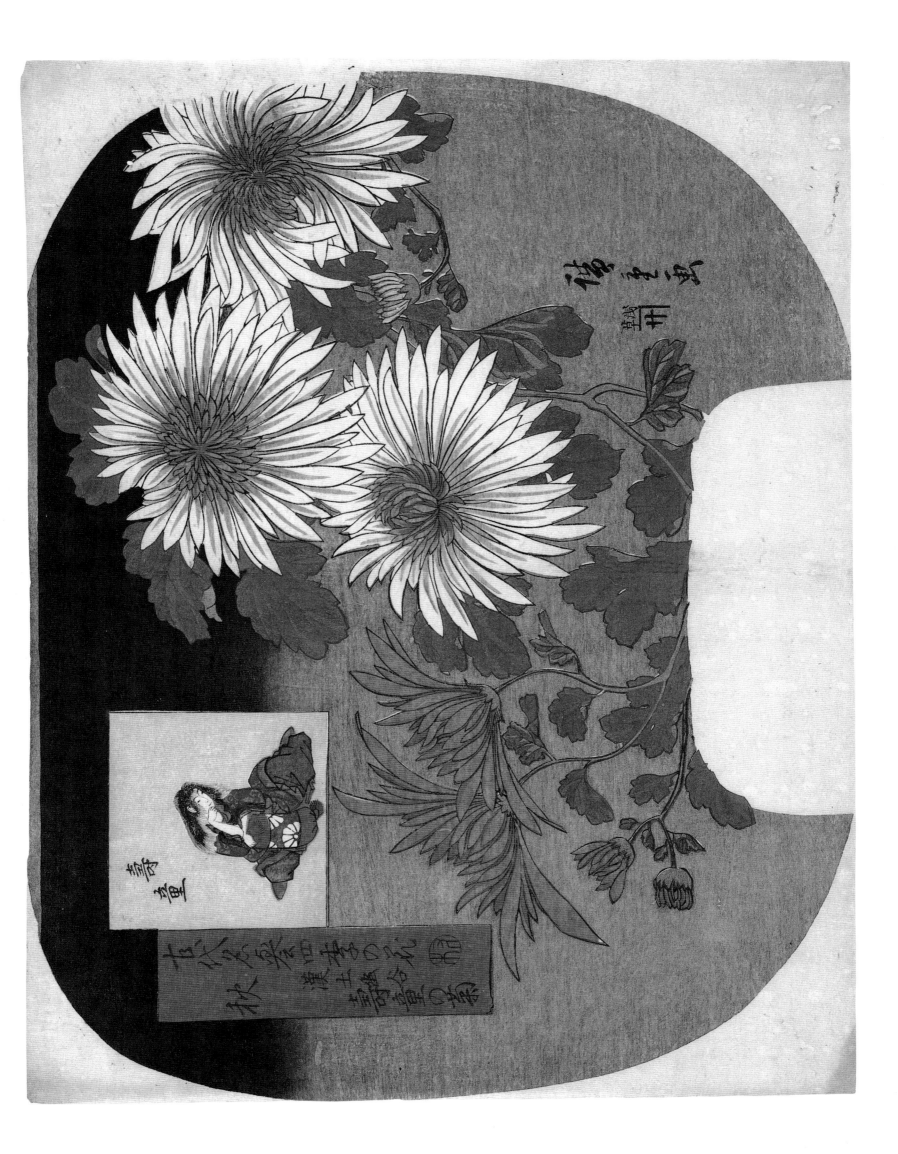

43. Sparrow and Bamboo

Size: Fan Print. 23.4 × 29.9 cm.
Date: Mid-1840s
Bird: Passer montanus Linnaeus, *tree sparrow*
Signed: Hiroshige hitsu
Artist's Seal: Ichiryūsai
Publisher's Mark: Surugaya Sakujirō
Censor's Seal: Watanabe
Provenance: F. E. Church (November 1928)
From the Abby Aldrich Rockefeller Collection of Japanese Prints,
* Museum of Art, Rhode Island School of Design,*
* accession number 34.331.*

This print is related in style, subject matter, and muted color scheme to plates twenty-two and thirty, which date from the same period. The three prints show how Hiroshige utilized the different formats of the Japanese print to lend variety to a similar theme.

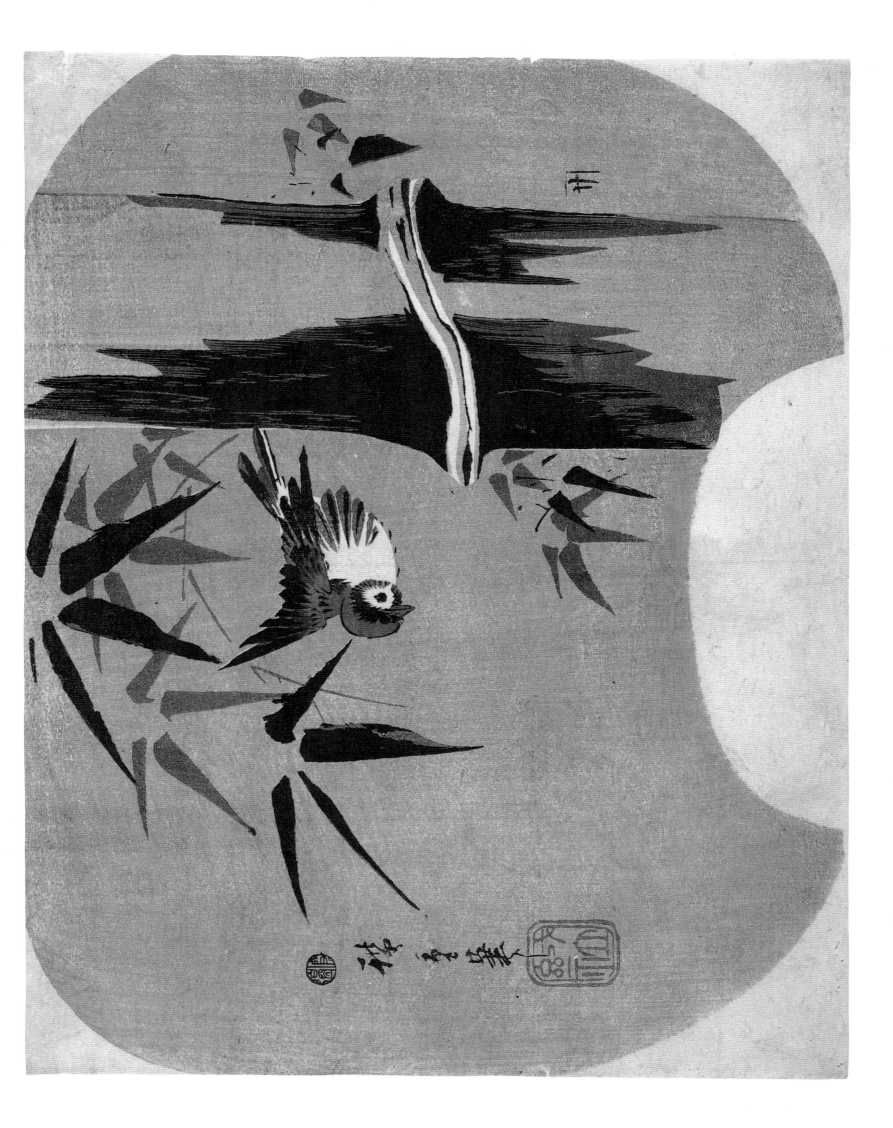

44. Yellow Bird and Cotton Rose

Size: Fan Print. 17.5 × 22.8 cm.
Date: Second month of 1852 (Rat/II)
Bird: Streptopelia risoria(?), *dove*
Signed: Hiroshige hitsu
Flower: Hibiscus mutabilis, *cotton rose*
Publisher's Mark: Sanoya Kihei
Censors' Seals: Watanabe; Mera.
From the Abby Aldrich Rockefeller Collection of Japanese Prints,
* Museum of Art, Rhode Island School of Design,*
* accession number 34.300.*

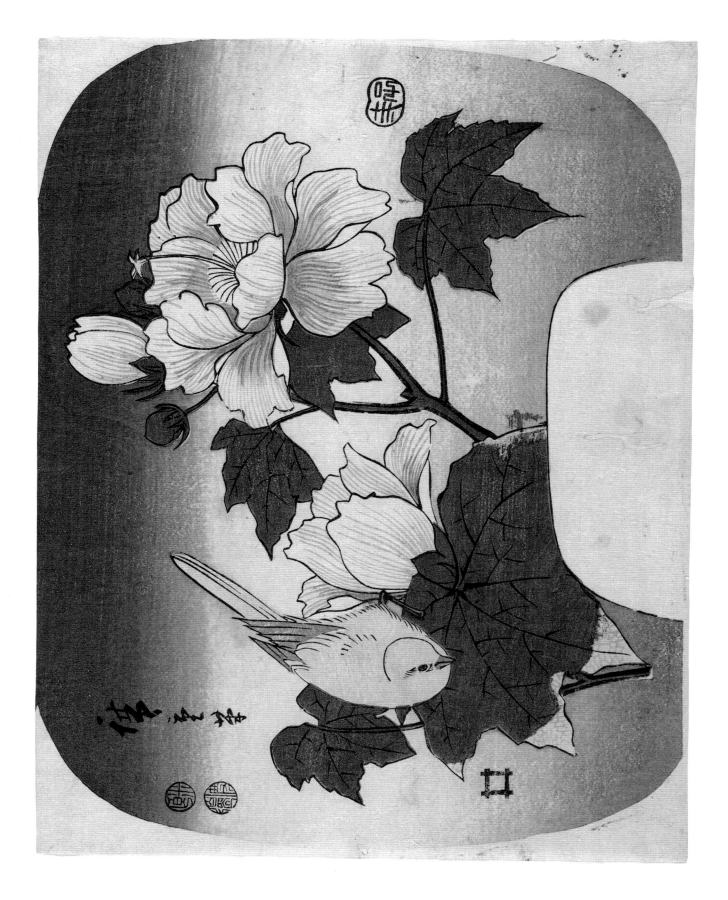

45. "Iris" (*Kakitsubata*): from the series *Rokkasen no Uchi* ("Six Flowers")

Size: Fan Print. 22.6×28.2 cm.
Date: Fourth month of 1856 (Dragon/IV)
Flower: Iris ensata, iris
Signed: Hiroshige ga
Censor's Seal: Aratame
Provenance: F. E. Church (November 1928)
From the Abby Aldrich Rockefeller Collection of Japanese Prints,
* Museum of Art, Rhode Island School of Design,*
* accession number 34.328.*

This print shows the influence of the Rimpa School and its leading proponent, Ogata Kōrin, who is famous for his depiction of irises.

The Rockefeller collection contains two other prints from this series: one of hydrangeas and the other of peonies. Another impression of the iris subject is in the Honolulu Academy of Arts.

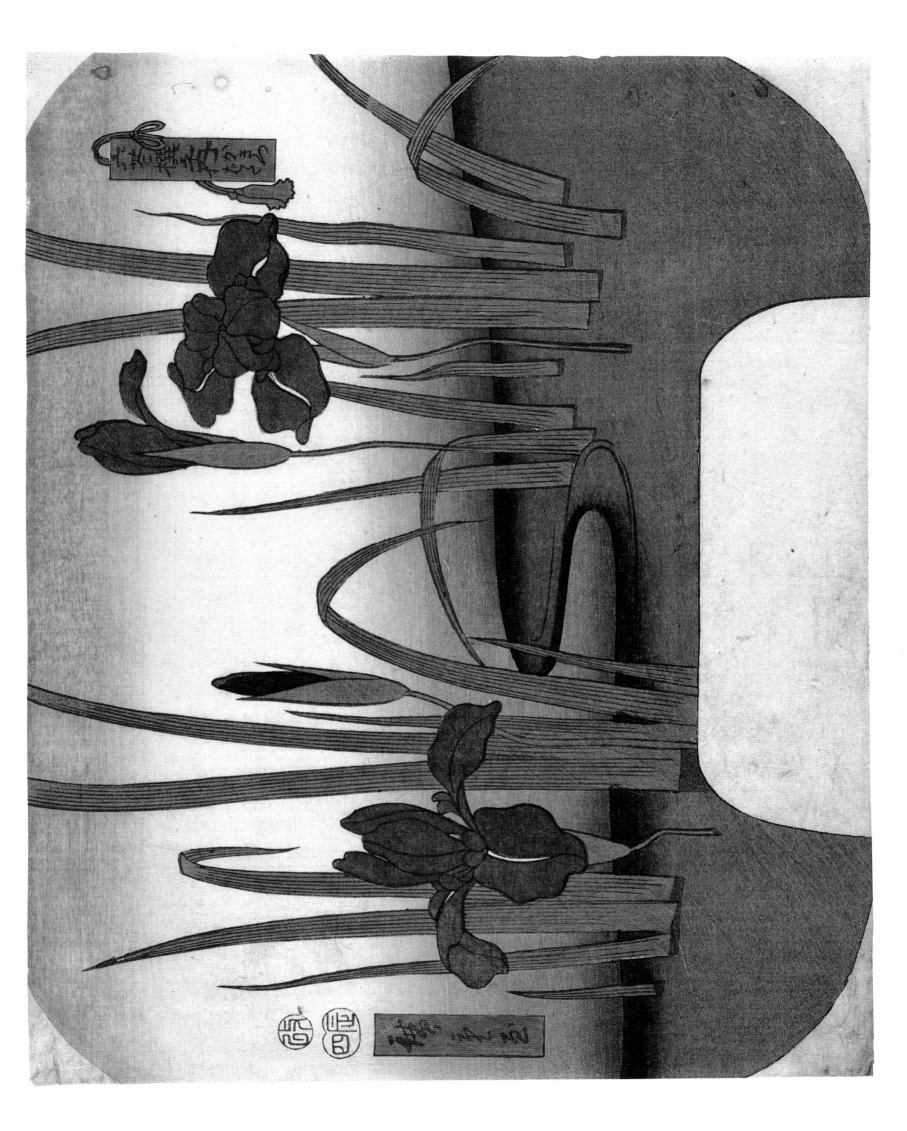

46. Morning Glories

Omokage no
tsuyu wasurarenu
wakareji ni
midarete mo saku
asagao no hana.

I cannot forget
your dear face for one moment,
though my path is strewn
with morning glories blooming
in spite of their confusion.

Size: Fan Print. 22.9 × 29.3 cm.
Date: Second month of 1854 (Tiger/II)
Flower: Pharbitis nil, *morning glory*
Signed: Ryūsai
Artist's Seal: Hiroshige
Publisher's Mark: Sanoya Kihei
Censor's Seal: Aratame
Poem: Kyōka
Poem Signed: Yūroku
References: F. E. Church (November 1928)
From the Abby Aldrich Rockefeller Collection of Japanese Prints,
* Museum of Art, Rhode Island School of Design,*
* accession number 34.442.*

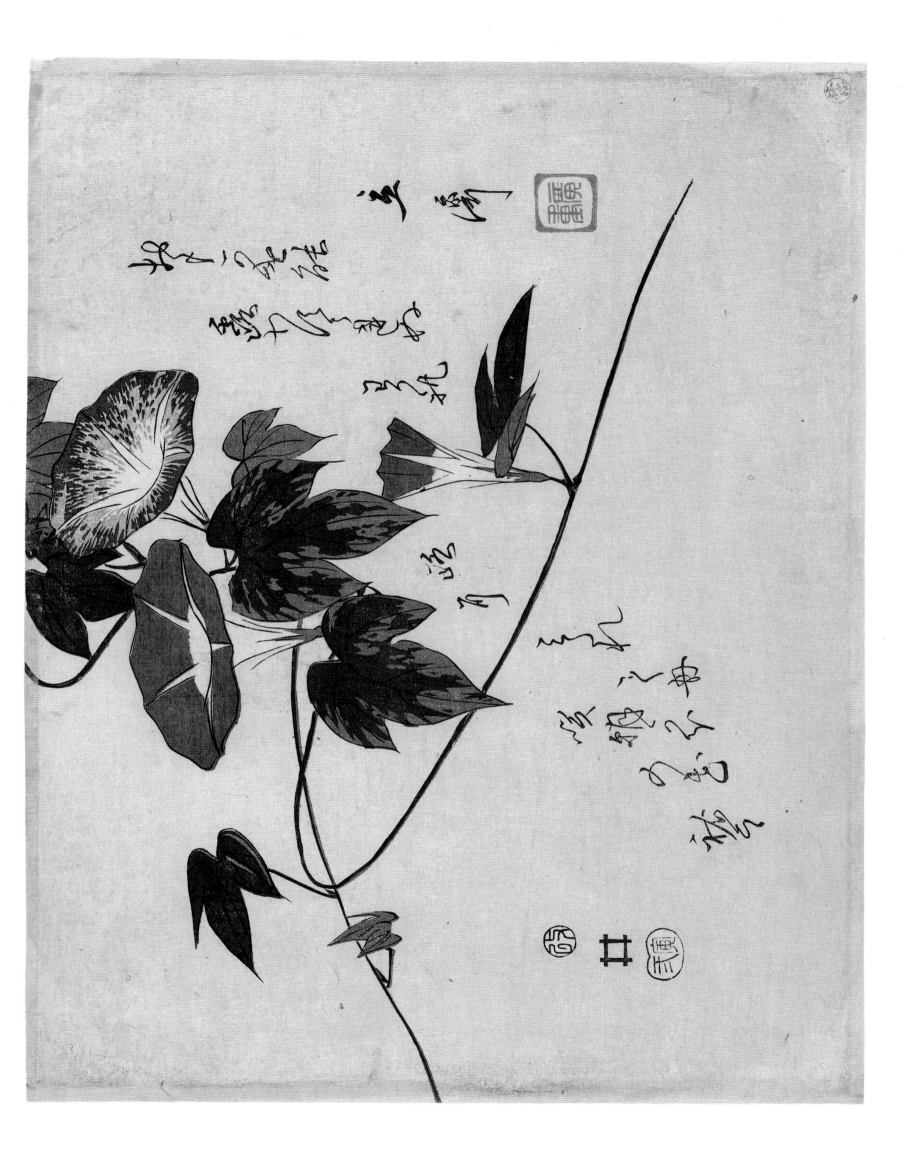

47. *Fūyo* ("Hibiscus"): from the series *Fūryu Natsu no Hanazono* ("Elegant Summer Flower Gardens")

Size: Fan Print. 22 × 30 cm.
Date: ca. 1845
Flower: Hibiscus mutabilis, *cotton rose*
Signed: Hiroshige hitsu
Publisher's Mark: Aritaya Seiemon
Censor's Seal: Yoshimura
Provenance: Shiba (Hakone, Japan)
From the Abby Aldrich Rockefeller Collection of Japanese Prints,
* Museum of Art, Rhode Island School of Design,*
* accession number 34.299.*

Another design from the series showing hollyhocks also has a gray ground printed with attractive woodgrain. An impression is illustrated in a Sotheby's sale catalogue (London [July 1976], lot 71).

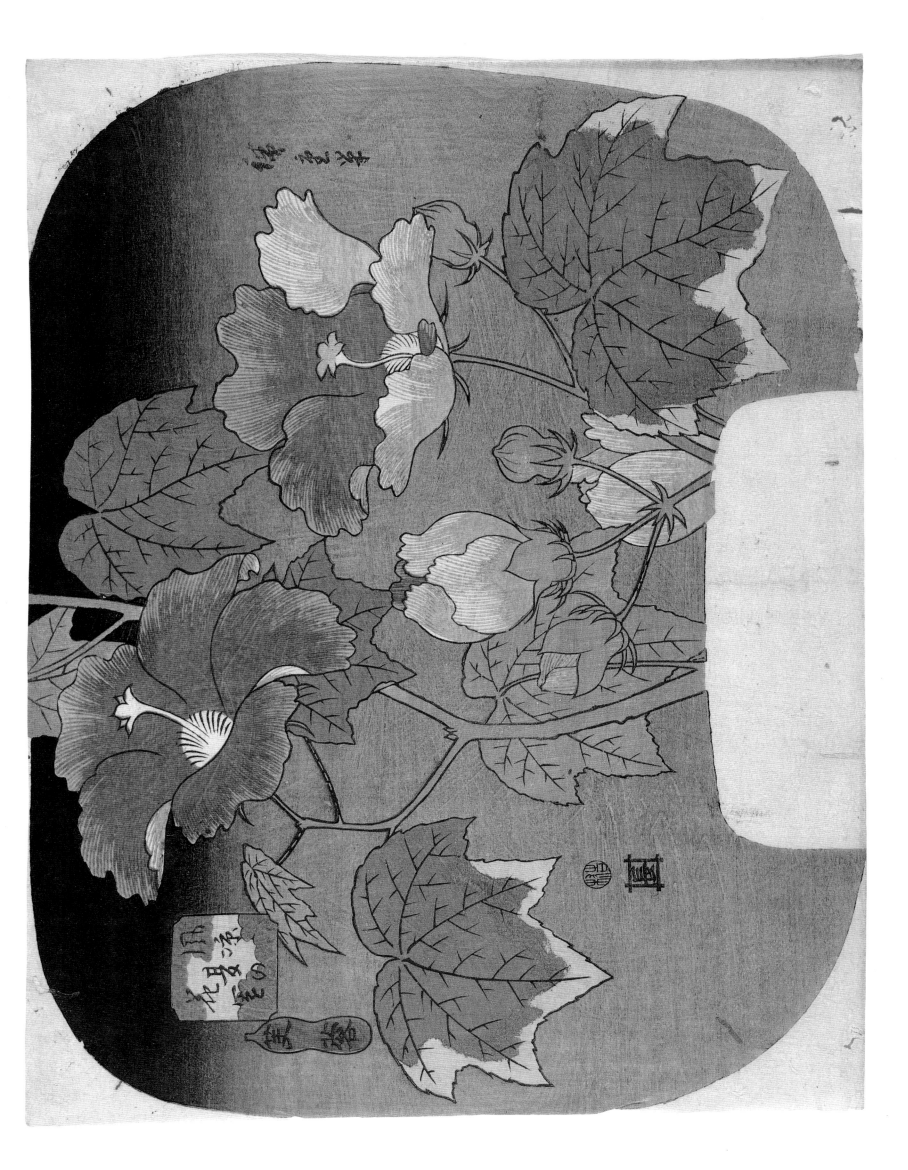

48. Parrot on a Pine Branch

Kiyo taki ya
nami ni ochitaru
haru matsuba.

Pristine waterfall —
and springtime's pine needles
falling in torrents.

Size: Half-block. 22.9 × 17.4 cm.
Date: ca. 1830
Bird: Pennant's Rosella Platycercus elegans
Flower: Pinus spec., pine
Signed: Hiroshige ga
Artist's Seal: Yūsai
Poem: Haiku
Season word: haru, "spring"
Poem signed: (in kana): Bashō
Provenance: F. E. Church (November 1928)
References: Tamba, 394; Suzuki, 178.
From the Abby Aldrich Rockefeller Collection of Japanese Prints,
Museum of Art, Rhode Island School of Design,
accession number 34.365.

These two designs, like most *chūban,* or "half-block" prints, were originally printed together on an *ōban* sheet and then separated. The two Rockefeller prints were bought at different times and from different sources, yet by a fortunate coincidence, they are so consistent in quality that they might have come from the very same *ōban* sheet.

Suzuki illustrates an impression of the uncut *ōban* that is later than the Rockefeller prints. The Suzuki impression lacks the artist's seal on the print of the parrot. It is printed without the gray block at top and also lacks the light blue block. Moreover, the signature and poem blocks on the left-hand portion of the Suzuki print seem to differ from the Rockefeller impression, although otherwise the key-block corresponds.

49. Mandarin Ducks in a Stream

Hara[1] no tatsu
hito ni misebaya
oshi futatsu.

Take an angry man
and show him mandarin ducks
— they never break up.

Size: Half-block. 23.2 × 16.9 cm.
Date: ca. 1830
Bird: Aix galericulata (Linnaeus), mandarin duck
Signed: Hiroshige ga
Artist's Seal: Yūsai
Poem: Haiku
Season word: oshidori, "mandarin ducks," fuyu
(winter)
Provenance: Frank Lloyd Wright (Purchased
through F. W. Gookin, May 1923)
References: Suzuki, 178.
From the Abby Aldrich Rockefeller Collection of Japanese Prints,
Museum of Art, Rhode Island School of Design,
accession number 34.348.

1. The work *hara,* meaning "stomach," is the first half of the familiar word *harakiri. Hara* is not a pleasant word for the Japanese, on a scale of unpleasantness about equal with the English "belly." The phrase *hara no tatsu* means "to be angry," and the association of this with the sedate mandarin ducks is certainly unpoetic. The pun, however, on *futatsu,* meaning both "don't get angry" and the number two, peculiarly applicable to the inseparable ducks, is delightful to Japanese, who have none of the inhibitions about puns common to speakers of English.

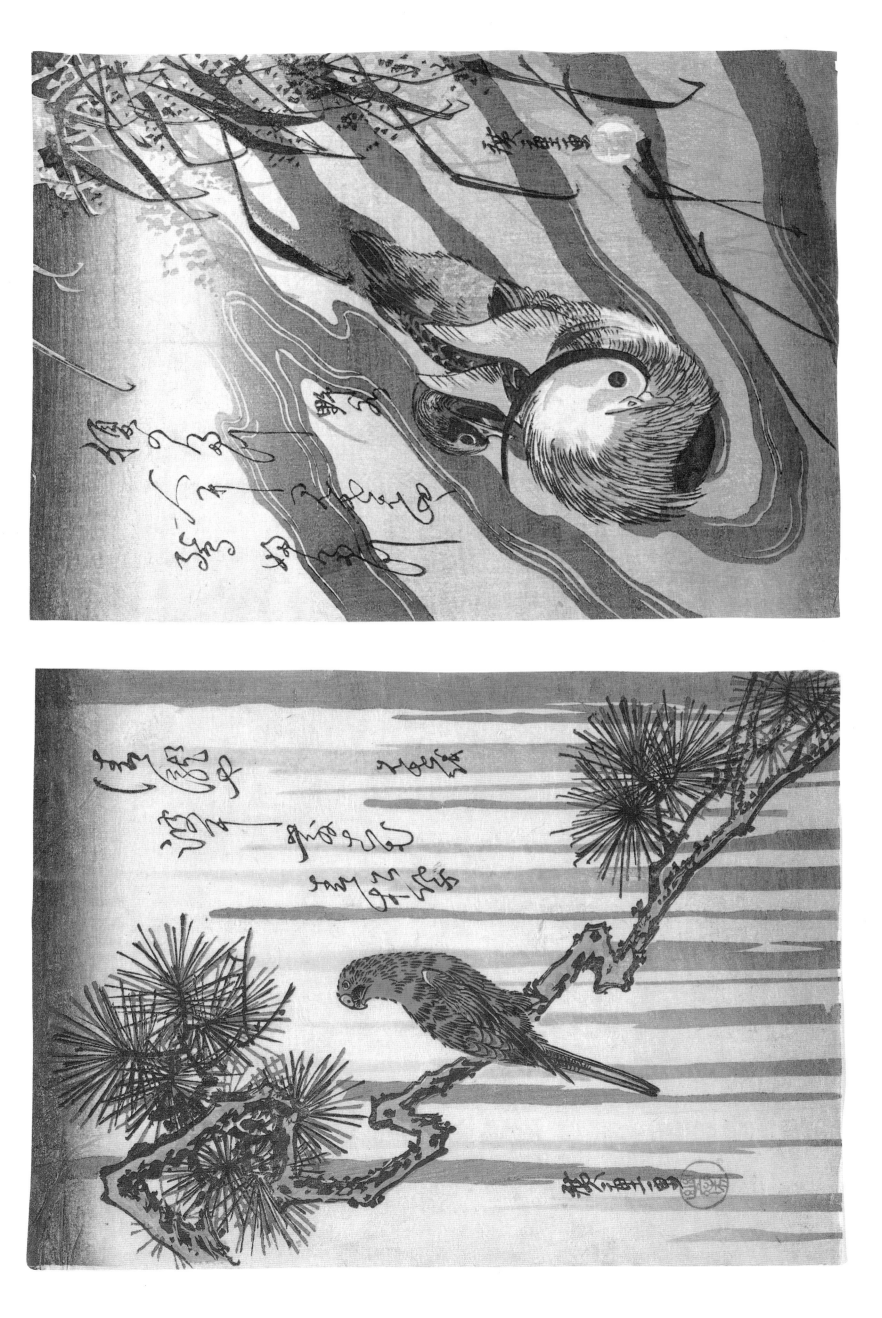

50. Sparrows and Camellia in Snow

Size: Medium Panel. 34.4 × 11.5 cm.
Date: late 1830s
Bird: Passer montanus, tree sparrow
Flower: Camellia japonica, camellia
Signed: Hiroshige hitsu
Artist's Seal: Hiro
Publisher's Mark: Kawashō (Kawaguchi Shōzō)
Provenance: Frank Lloyd Wright (Purchased
* through F. W. Gookin, May 1923)*
From the Abby Aldrich Rockefeller Collection of Japanese Prints,
* Museum of Art, Rhode Island School of Design,*
* accession number 34.167.2.*

This delightful print was certainly well-received in Hiroshige's day, as the design was reengraved in the mid-1840s. An impression of this 1840s edition, which lacks the publisher's mark and has a censor's seal to the left of the sparrows, is illustrated in the Lilly S. Perry sale catalogue (Sotheby's [London, 1966], lot 131).

Another Hiroshige print, similar in format, subject matter, and composition to the Rockefeller design, may be found in the Tokyo National Museum Catalogue (Vol. III, no. 3496).

Other impressions of this print are illustrated in the catalogue of the Gale Collection (Jack Hillier, *Catalogue of the Japanese Paintings and Prints in the Collection of Mr. and Mrs. Richard P. Gale* [London, 1970] vol. II, pl. 277), and in the Ficke sale catalogue (American Art Association [New York, 1920], lot 751).

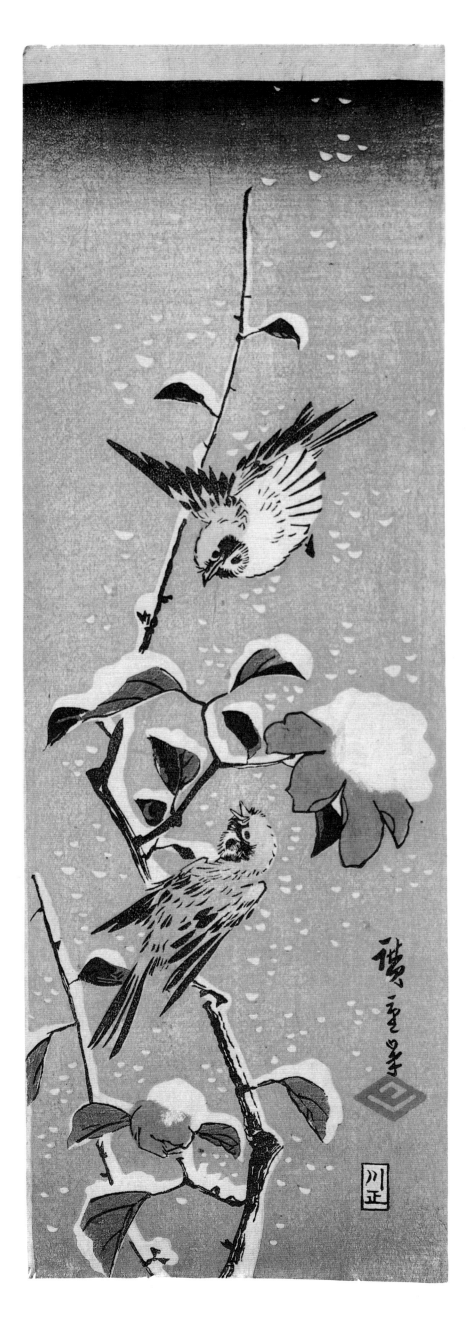

51. Kingfisher and Iris

Kawasemi no
hane o yosoute
mizu kagami.

Preening his feathers
in a watery mirror —
kingfisher in flight.

Size: Half-block. 22.2 × 16.5 cm.
Date: late 1830s
Bird: Alcedo atthis Linnaeus, kingfisher
Flower: Iris ensata, iris
Signed: Hiroshige hitsu
Artist's Seal: Ichiryūsai
Censor's Seal: Kiwame
Poem: Haiku
Season word: semi, normally "cicada" but
* here part of the name of Kingfisher, literally*
* "river-cicada" (summer)*
Provenance: Frank Lloyd Wright (Purchased
* through F. W. Gookin, May 1923)*
From the Abby Aldrich Rockefeller Collection of Japanese Prints,
* Museum of Art, Rhode Island School of Design,*
* accession number 34.344.*

Another impression of this print is located in the Honolulu Academy of Arts.

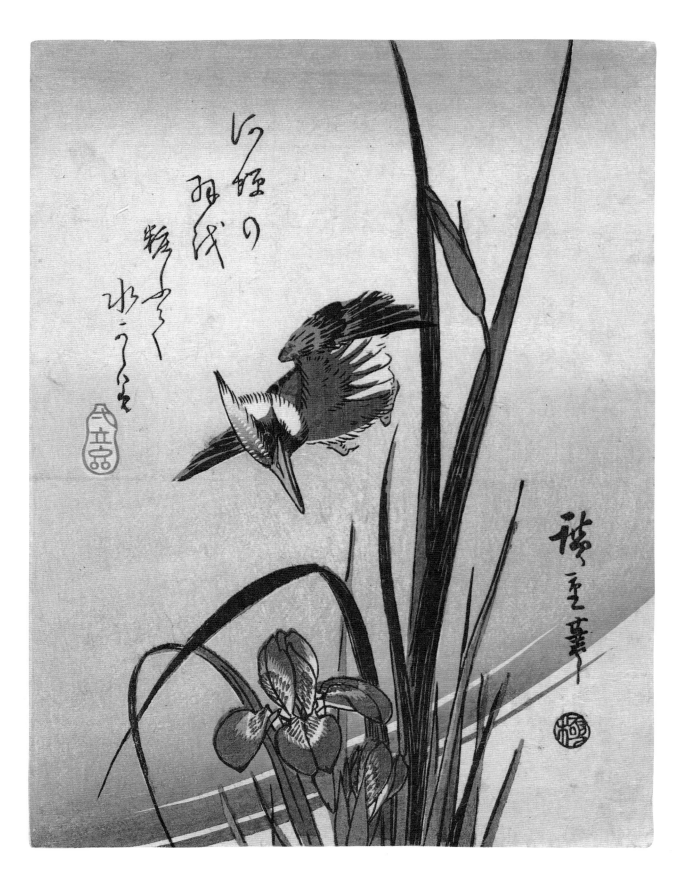

52. A Japanese White-Eye on a Branch of Maple

Size: Medium Panel. 34.2 × 11.1 cm.
Date: Second month of 1854 (Tiger/II)
Bird: Zosterops japonica Temminck & Schlegel,
* Japanese white-eye*
Flower: Acer nipponicum?, maple
Signed: Hiroshige hitsu
Artist's Seal: Ichiryūsai
Publisher's Mark: Tsutaya Kichizō
Censor's Seal: Aratame
Provenance: F. E. Church
From the Abby Aldrich Rockefeller Collection of Japanese Prints,
* Museum of Art, Rhode Island School of Design,*
* accession number 34.148.2.*

The reddish brown pigment chosen for the maple leaves has oxidized, making them appear more naturalistic and three-dimensional. The Rockefeller collection contains a later, duplicate impression without the oxidization on the leaves that appears boring and flat by comparison. This later print also lacks the Ichiryūsai seal of the illustrated impression.

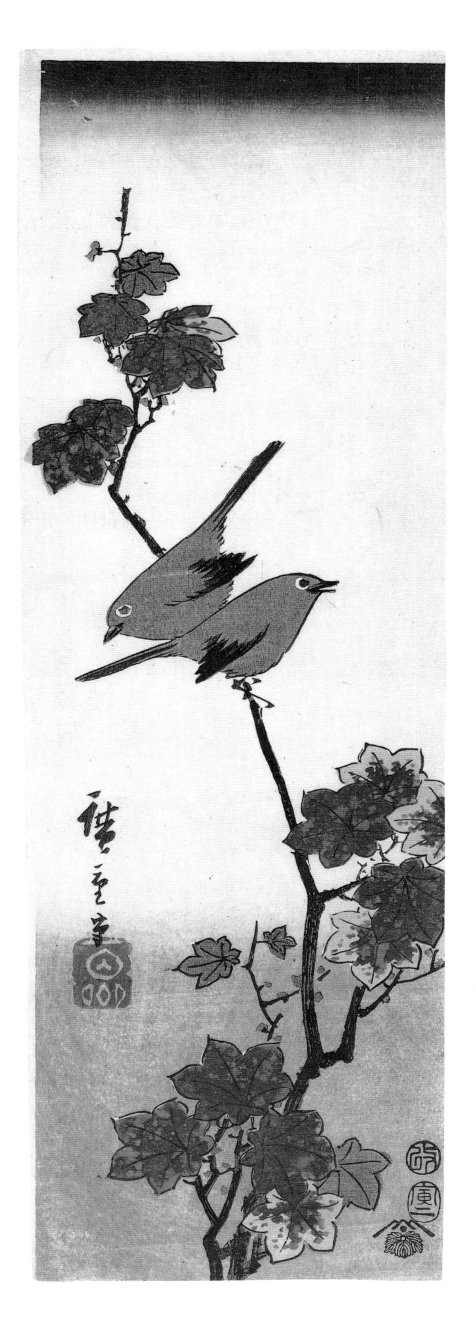

53. Butterfly and Peony

Botanka fūokisha nari. The Peony is a Person of Wealth and
 Station.

Size: Half-block. 22.9 × 16.8 cm.
Date: late 1830s
Flower: Paeonia suffructicosa, tree peony
Signed: Hiroshige ga
Artist's Seal: Yūeido
Publisher's Mark: Aritaya Seiemon
Poem: Kambun. Seven character sentence, written
 in reisho (ancient square characters)
Provenance: Frank Lloyd Wright (Purchased
 through F. W. Gookin, May 1923)
From the Abby Aldrich Rockefeller Collection of Japanese Prints,
 Museum of Art, Rhode Island School of Design,
 accession number 34.345.1.

A butterfly hovering above flowering peonies was a popular *kachō-e* subject among Japanese print artists, and Hiroshige designed several variations of this theme including a horizontal *ōban* that is also in the collection. The Rockefeller collection contains another impression of this half-block print that is considerably later and is printed in black ink only.

Hiroshige's pupil and adopted son, Shigenobu (1826–69), better known as Hiroshige II, continued the tradition of landscape design and *kachō-e* established by his father. Just how closely the pupil followed the master can be seen by comparing the Rockefeller print with Hiroshige II's half-block design of butterfly and peonies that is illustrated in *Ukiyo-e Taikei,* vol. XI, pl. 61.

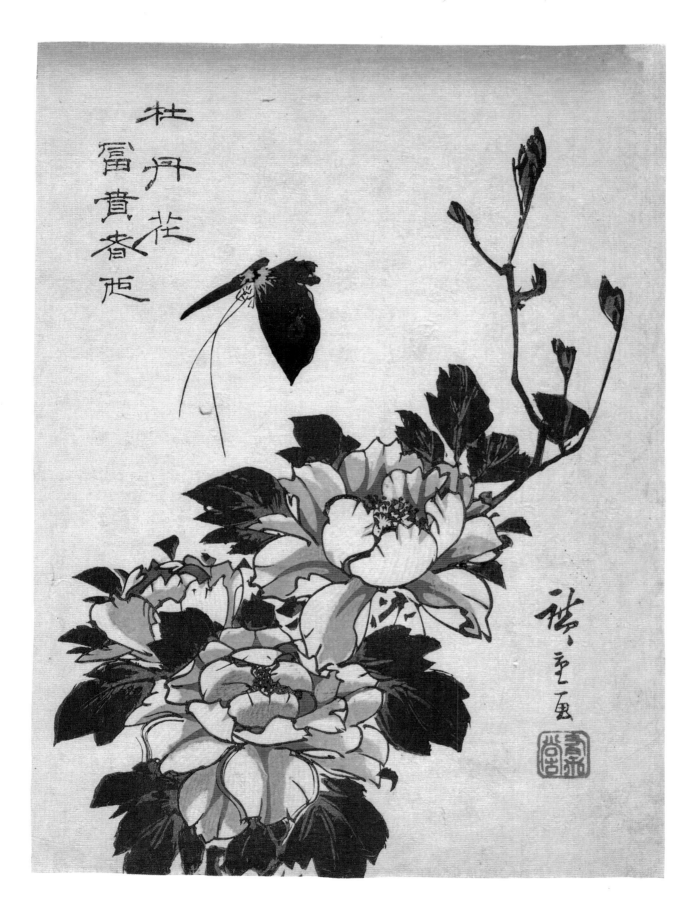

54. Wagtail and Roses

Yo no naka wa
sekirei mo o no
hima mo nashi

In this busy world,
there is no leisure time
for a wagtail's tail.

Size: Medium Panel. 35.3 × 13 cm.
Date: mid-1830s
Bird: Motacilla cinerea (?), gray wagtail
Flower: Rosa multiflora
Signed: Hiroshige hitsu
Publisher's Mark: Kawashō (Kawaguchi Shōzō)
Poem: Haiku
Season word: sekirei, "wagtail" (summer)
Poet: Bonchō
Provenance: F. E. Church (November 1928)
References: TNM, 3499; Oberlin, 1316.
From the Abby Aldrich Rockefeller Collection of Japanese Prints,
 Museum of Art, Rhode Island School of Design,
 accession number 34.221.

This print lacks the area of blue shading behind the bird that is present in the Oberlin impression. However, it has an area of brown shading at the top and a blue area at the bottom that are absent in the Oberlin print.

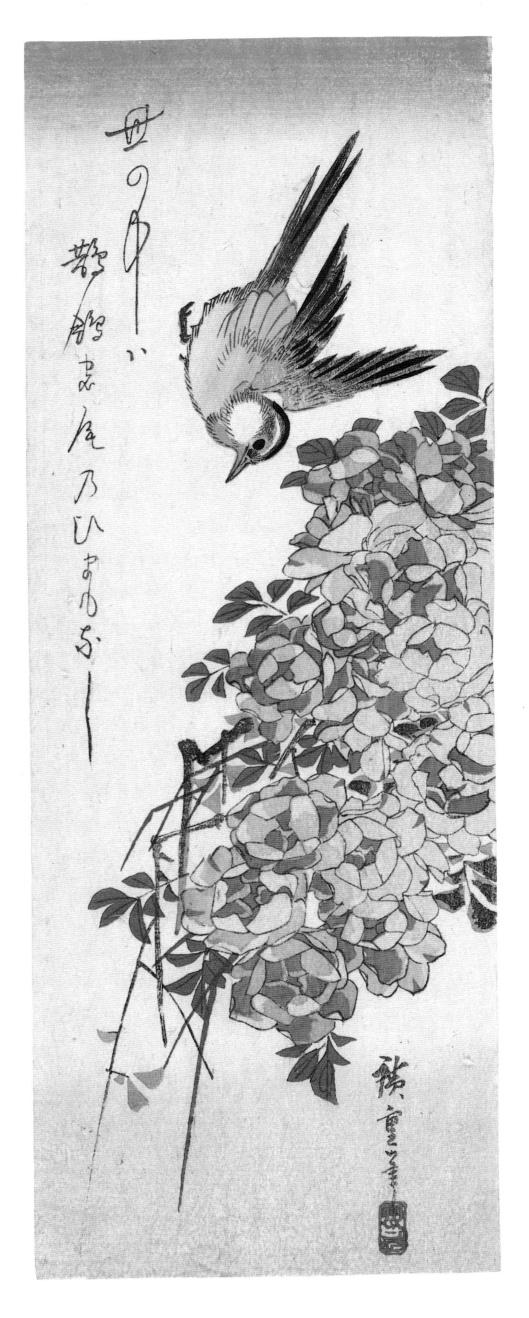

55. Java Sparrow and Magnolia

Omoshiroki
sakura no ato ya
mokurenge.

Extraordinary!
After the cherry blossoms,
the magnolias bloom.

Size: Medium Panel. 37.7 × 12.9 cm.
Date: 1830s
Bird: Padda oryziuora, *Java sparrow*
Flower: Magnolia liliiflora, *magnolia*
Signed: Hiroshige
Artist's Seal: Ichiryūsai
Publisher's Mark: Kawashō (Kawaguchi Shōzō)
Censor's Seal: Kiwame
Poem: Haiku
Season word: sakura, *"cherry blossom" (spring)*
References: Buhl, 41.
From the Abby Aldrich Rockefeller Collection of Japanese Prints,
 Museum of Art, Rhode Island School of Design,
 accession number 34.222.2.

The collection contains another impression, which though equally early, has some fading in the purple of the flowers.

 Another example of this print is illustrated in the Hiroshige Memorial Catalogue ("Catalogue of the Memorial Exhibition of Hiroshige's Works on the Sixtieth Anniversary of His Death" [Tokyo, 1917], pl. 44).

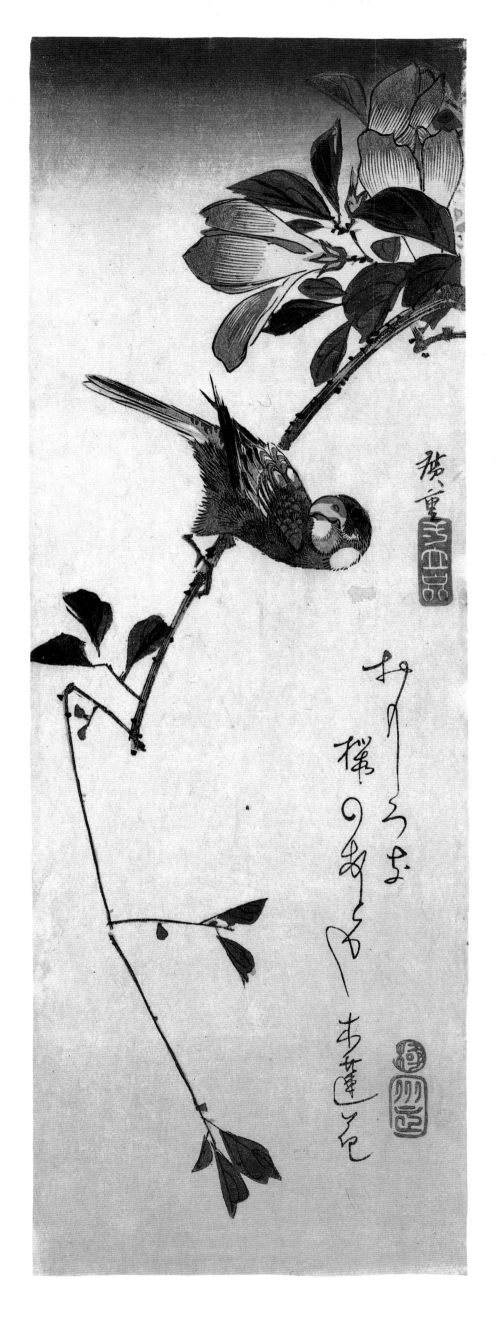

56. Parrot on a Grapevine

Boku myō onozukara shiru yoku sei wo
　　hiraku koto o
Suiyo no kisai wa sei ni masarazu.
Ikansen sakan ni kinbanjō o uru to
　　iedomo.
Kamikudakete suisui kokusui no sei.

Calligraphy has its own way of determining
　　sobriety.
One who is drunk cannot make the brush
　　run clean.
It matters not if you use golden sheets,
It is, in short, the soul of black water.

Size: Medium Panel. 37.5 × 12.7 cm.
Date: mid-1830s
Bird: A parrot showing no direct resemblance to
　　any specific species
Flower: Vitis vinifera, grape
Signed: Hiroshige hitsu
Publisher's Mark: Kawashō (Kawaguchi Shōzō)
Poem: Kambun. Shichi-gon-zekku.
Provenance: S. Nomura (Kyoto, 1921)
References: TNM, 3526; Tamba, 401.
From the Abby Aldrich Rockefeller Collection of Japanese Prints,
　　Museum of Art, Rhode Island School of Design,
　　accession number 34.223.

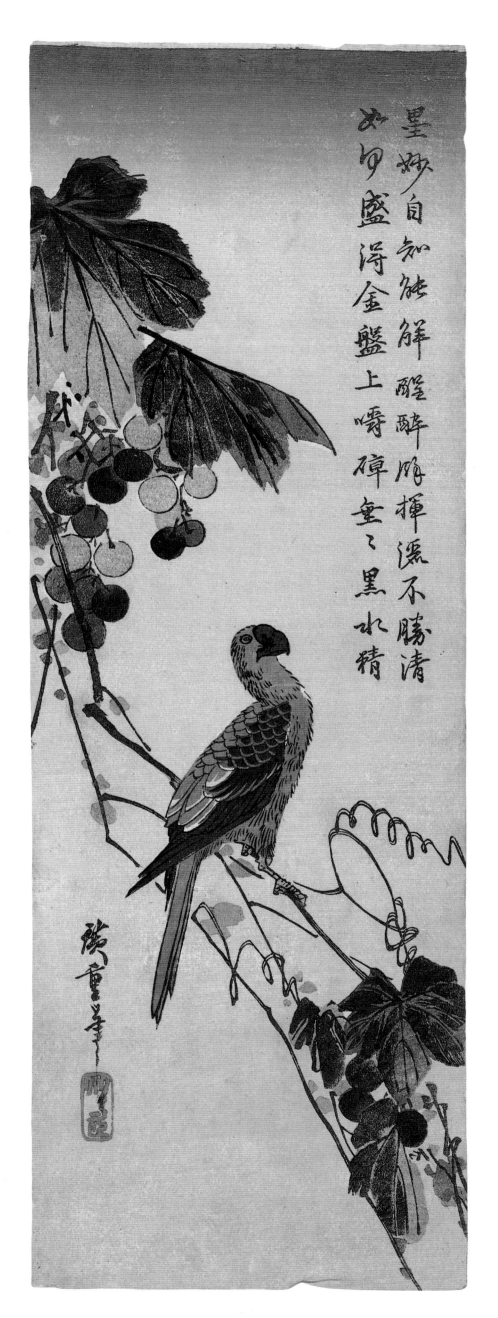

57. A Cock in the Snow

Kinuginu[1] no
hanashi mo imada
tsumoranu[2] ni
tokekau[3] to naku
naku yuki no tori.

The hour of parting,
with all its deep feelings,
in drifts about them,
they hear the melting tones
of the rooster in the snow.

Size: Medium Panel. 36.5 × 12.2 cm.
Date: mid-1830s
Bird: Phasianus (colchicus) versicolor Vieillot,
* common pheasant*
Signed: Hiroshige ga
Artist's Seal: Ichiryūsai
Poem: Kyōka
Poem signed: Hachijintei
Provenance: J. S. Happer (March 4, 1920)
References: Buhl, 53.
From the Abby Aldrich Rockefeller Collection of Japanese Prints,
* Museum of Art, Rhode Island School of Design,*
* accession number 34.229.*

This impression is fine and early, but to make the print look fresher and less faded, the rooster's head and the seals of Hiroshige and the poet Hachijintei have been touched-in with red watercolor by a later hand. The areas of green in the snow beneath the cock have been similarly painted-in, although the subtle blending of gray and green pigments for the bank of grass is as printed.

1. Means "go, don't go" and also "silk against silk."

2. Means "piled up," referring to the things the lovers have to say, but having an association, of course, with the snow.

3. The Japanese equivalent of "cock-a-doodle-doo." The first two syllables, however, are part of the verb *tokeru*, which means "to melt."

58. A Pheasant and Bracken

Fumitagau
michi ya warabi no
take takashi.

Blundering into
a path where tasty grasses
manage to grow tall.

Size: Medium Panel. 35.9 × 12.7 cm.
Date: mid-1830s
Bird: Grisolophus pictus, *golden pheasant*
Flower: Equisetum *spec., ferns*
Signed: Hiroshige hitsu
Artist's Seal: Ichiryūsai
Poem: Haiku
Season word: warabi, *"marshgrass" (spring)*
Provenance: Alexis Rouart (American Art
Association [New York, 1922], lot 705).
References: Oberlin, 1306.
From the Abby Aldrich Rockefeller Collection of Japanese Prints,
Museum of Art, Rhode Island School of Design,
accession number 34.231.

Other impressions are illustrated in the Spaulding sale catalogue (American Art Association [New York, 1921], lot 381), the third Vever sale (Sotheby's [London, 1978], lot 340), and in Narazaki (*Studies in Nature. Hokusai–Hiroshige* [Tokyo, 1970], figs. 38–39).

59. Kingfisher and Iris

Amadare ni
sode mo ayame ni
nioi keri.

In the dripping rain,
with sleeves slowly soaking
in iris fragrance.

Size: Medium Panel. 37.6 × 12.8 cm.
Date: early 1830s
Bird: Alcedo atthis Linnaeus, kingfisher
Flower: Iris ensata, iris
Signed: Hiroshige hitsu
Artist's Seal: Hiroshige
Publisher's Mark: Kawashō (Kawaguchi Shōzō)
Censor's Seal: Kiwame
Poem: Haiku
Season word: ayame, "iris" (summer)
Poet: Shūshoku
Provenance: F. E. Church (November 1928)
References: Buhl, 61.
From the Abby Aldrich Rockefeller Collection of Japanese Prints,
 Museum of Art, Rhode Island School of Design,
 accession number 34.257.

This is perhaps the finest of the many Hiroshige designs showing a kingfisher with an iris. Another impression is illustrated in Kikuchi, *A Treasury of Japanese Wood Block Prints* (New York, 1969), no. 1478.

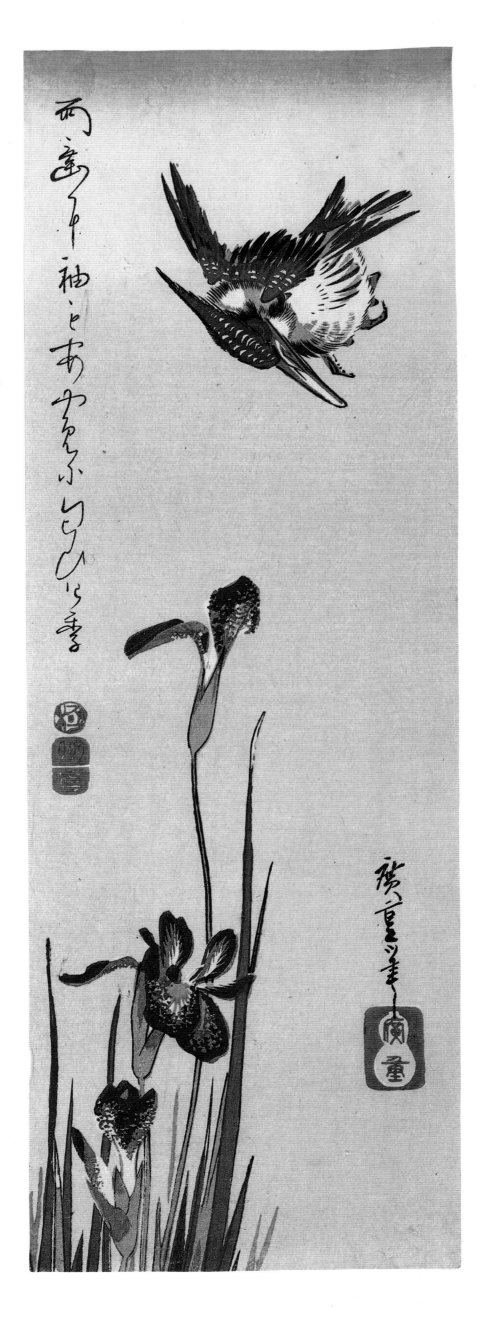

60. A Tethered Falcon Eyeing a Sparrow

Samuki yo no
negura no tori no
yakume tori
on[1] o shiranu wa
hito koso arikeri.

Passing the cold night
watching over little ones
asleep in the nest —
ingratitude is something
only human beings know.

Size: Medium Panel. 37.5 × 13 cm.
Date: mid-1830s
Birds: Falco peregrinus Tunstall *peregrine falcon;*
 Hayabusa *and* Passer montanus Linnaeus,
 tree sparrow
Flower: Narcissus tazetta *L. var.* Chinensis *Roem.*
Signed: Hiroshige hitsu
Publisher's Mark: Shōeidō han (Kawaguchi Shōzō)
Poem: Kyōka
Provenance: Yamanaka & Co. (January 24, 1920)
References: TNM, 3531; Vever, 917.
From the Abby Aldrich Rockefeller Collection of Japanese Prints,
 Museum of Art, Rhode Island School of Design,
 accession number 34.232.

Falconry seems to have been a popular sport in Edo period Japan (Volker, p. 69), and there are some notable *kachō-e* showing hawks or falcons by a number of eighteenth-century masters including Koryūsai, Eishin, and Utamaro and his pupils.

Hiroshige has realistically captured the tension between the sparrow who flies up in terror and the tethered bird with its unflinching eye and menacing claw. However, Volker (p. 70) recounts a traditional folktale that shows a more sympathetic relationship between the falcon and its prey. He writes that in the winter, the wild falcons keep a small bird to warm their claws in the cold of a winter night. When morning comes, the falcon releases the bird and out of gratitude refuses to hunt in the direction of the bird's flight.

1. Knowing *on* — meaning one's debts to parents, teachers, and a few other important people in one's life — is a basic value of Japanese society. Ruth Benedict has much to say about *on* and the entire phrase *on o shiranu* in *Chrysanthemum and the Sword.*

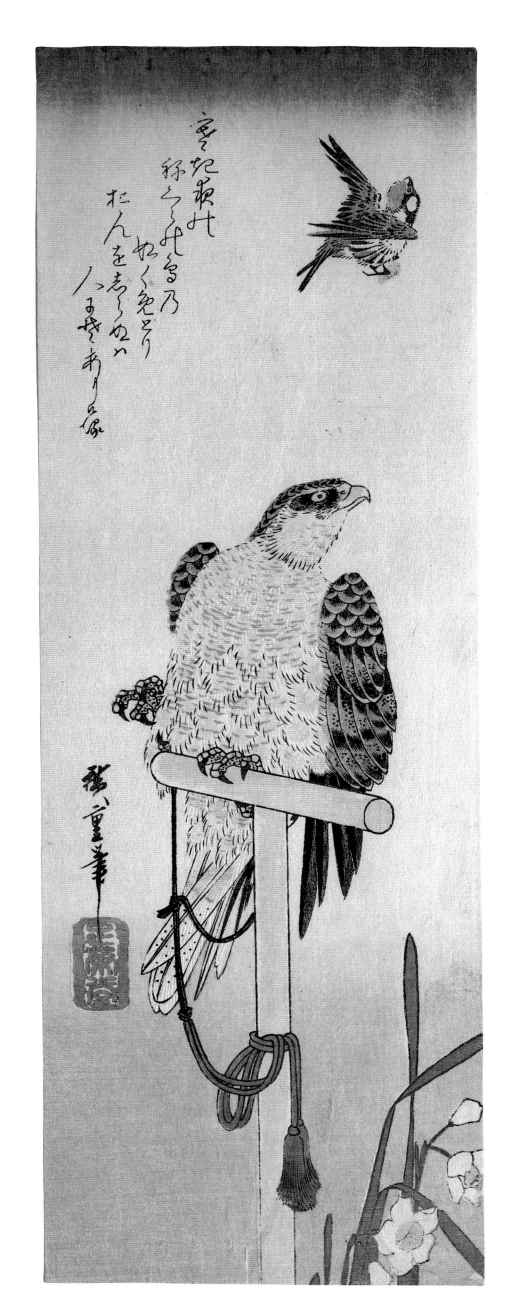

61. Chinese Bellflowers and Miscanthus

Wakihira mo
mizu ni saki chiru
kikyō kana.

Chinese bellflower —
at my side if I don't watch,
you bloom and scatter.

Size: Medium Panel. 37.8 × 13.2 cm.
Date: 1830s
Flower: Phragmitis, spec., reeds
Signed: Hiroshige hitsu
Artist's Seal: Ichiryūsai
Poem: Haiku
Season word: kikyō, "Chinese bellflower" (autumn)
Poet: Rosen
Provenance: Arthur D. Ficke (American Art
Galleries [New York, 1920], lot 746).
From the Abby Aldrich Rockefeller Collection of Japanese Prints,
Museum of Art, Rhode Island School of Design,
accession number 34.233.

The grass at the top of the print is cleverly printed in reverse. The flowers, though, are slightly faded and would originally have been a more intense shade of purple.

Other impressions of the print are illustrated in the Frank Lloyd Wright sale catalogue (Anderson Galleries [New York, 1927], lot 248) and in Kikuchi, *A Treasury of Japanese Wood Block Prints* (New York, 1969), no. 1481.

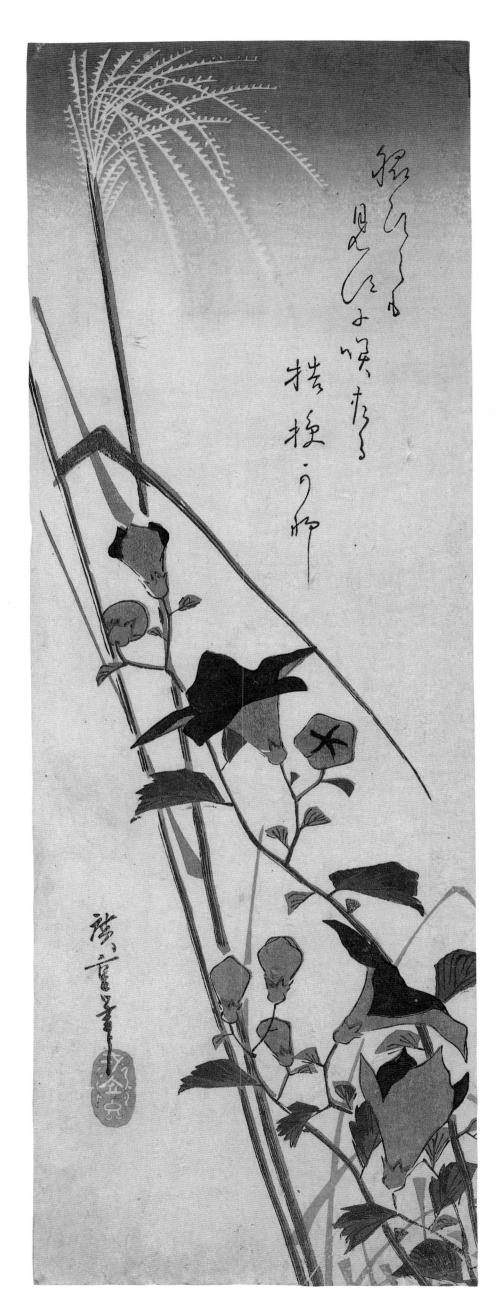

62. A Java Sparrow on a Magnolia Branch

Wakasama ni
mizukobu shigeri
hana tsubaki.

Brimming with youth,
you splash out all your water —
camellia flower!

Size: Medium Panel. 38.6 × 13.1 cm.
Date: early 1830s
Bird: Padda oryziuora, *Java sparrow*
Flower: Magnolia liliiflora, *magnolia*
Signed: Hiroshige hitsu
Artist's Seal: Ichiryūsai
Publisher's Mark: Kawashō (Kawaguchi Shōzō)
Poem: Haiku
Season word: tsubaki, "camellia" (spring)
Provenance: F. E. Church (November 1928)
From the Abby Aldrich Rockefeller Collection of Japanese Prints,
 Museum of Art, Rhode Island School of Design,
 accession number 34.237.

Other impressions are illustrated in the Happer sale catalogue (Sotheby's [London, 1909], lot 287) and in Kikuchi, *A Treasury of Japanese Wood Block Prints* (New York, 1969), no. 1477.

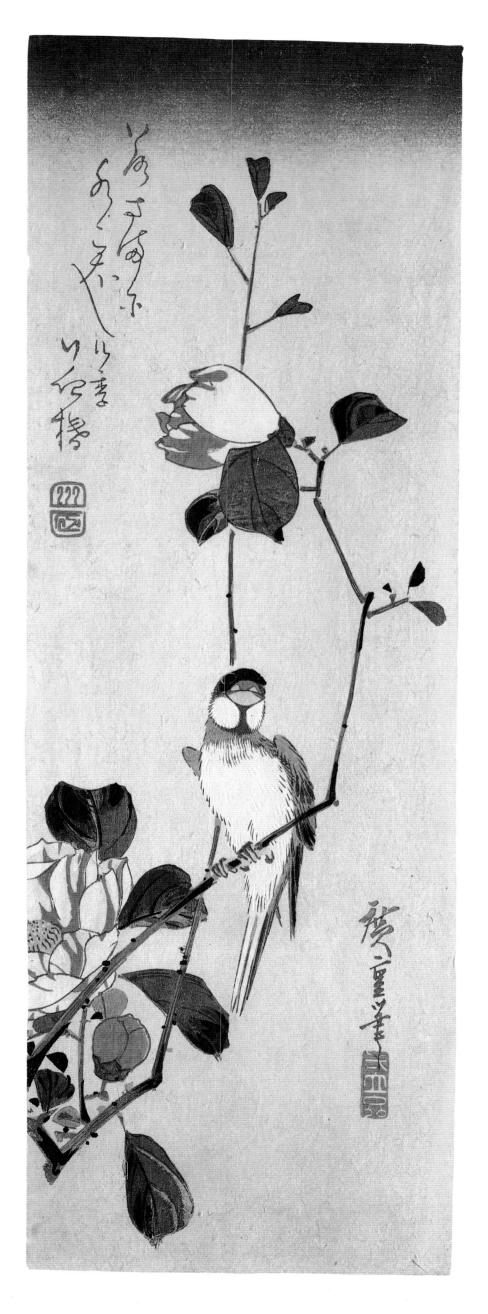

63. Peonies

Mizu utte
shibaraku tsuki o
matare keri.

It struck the water;
then for a time the moon
kept me waiting.

Size: Medium Panel. 36.4 × 12.3 cm.
Date: ca. 1847
Flower: Paeonia lactiflora, *herbaceous peony*
Signed: Hiroshige hitsu
Censor's Seal: Mera
Poem: Haiku
Season word: tsuki, "moon" (autumn, moon-
 viewing season)
Provenance: Frank Lloyd Wright (Purchased
 through F. W. Gookin, May 1923)
References: TNM, 3516.
From the Abby Aldrich Rockefeller Collection of Japanese Prints,
 Museum of Art, Rhode Island School of Design,
 accession number 34.189.

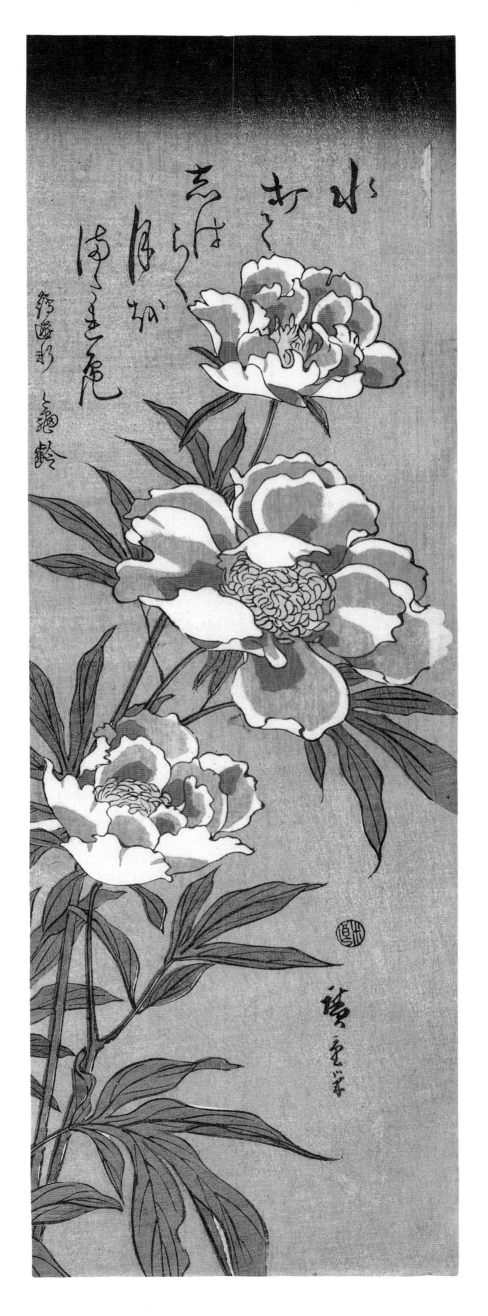

64. A Black-Naped Oriole Perched on a Stem of Rose Mallow

Ariake no
nurete ochitaru
fuyō[1] kana.

In the moonlight at dawn,
see the fuyō damp with dew
and blossoms falling.

Size: Medium Panel. 38.4 × 12.9 cm.
Date: mid-1830s
Bird: Oriolus chinensis Linnaeus, *black-naped*
 oriole
Flower: Hibiscus mutabilis L., *rose mallow*
Signed: Hiroshige hitsu
Artist's Seal: Ichiryūsai
Poem: Haiku
Season word: fuyō, "rose mallow" (summer)
Provenance: F. E. Church (November 1928)
References: TNM, 3524; Suzuki, 184; Vever, 906;
 UTK, vol. XI, pl.7; Oberlin, 1310.
From the Abby Aldrich Rockefeller Collection of Japanese Prints,
 Museum of Art, Rhode Island School of Design,
 accession number 34.238.

This is among the finest extant impressions of this well-known print and is in exemplary condition.

1. A variety of rose mallow according to *Kenkyūsha's New Japanese English Dictionary.*

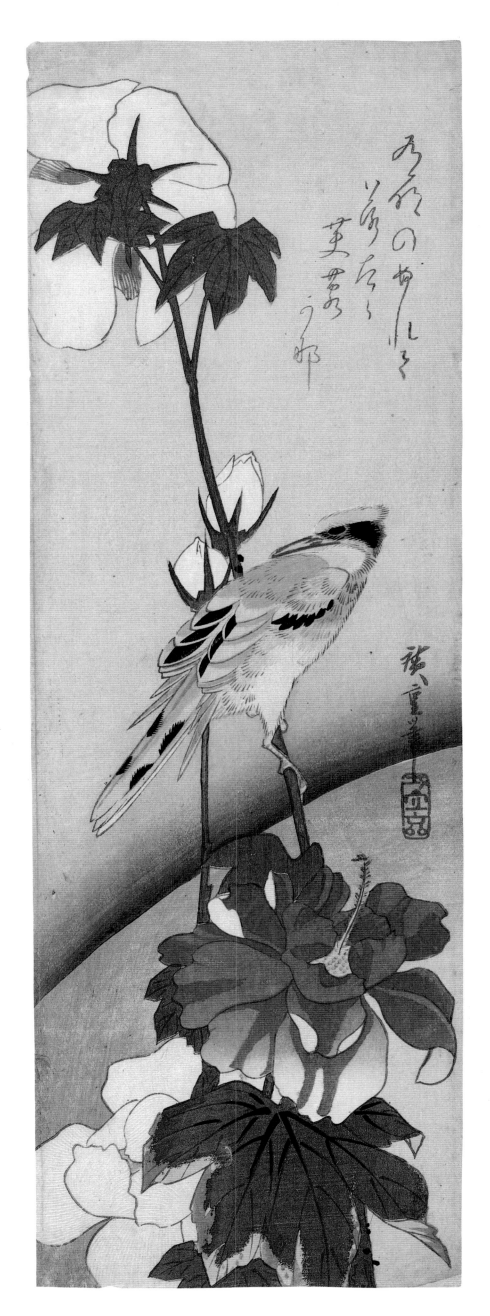

65. A Pheasant on a Snow-covered Pine

The pine tree,[1] after an eternity of frosts
 followed by dews,
Shows a thousand years of color deep in
 snow.

Size: Medium Panel. 38.1 × 13.1 cm.
Date: mid-1830s
Flower: Pinus, spec., pine
Signed: Hiroshige hitsu
Artist's Seal: Ichiryūsai
Publisher's Mark: Kawashō (Kawaguchi Shōzō)
Censor's Seal: Kiwame
Poem: Kambun. Shichi-gon-koshi. Two lines of
 seven characters each.
Provenance: F. E. Church (November 1928)
References: Suzuki, 185; Vever, 916; Oberlin, 1304;
 Buhl, 68.
From the Abby Aldrich Rockefeller Collection of Japanese Prints,
 Museum of Art, Rhode Island School of Design,
 accession number 34.258.

1. See note, Plate #15.

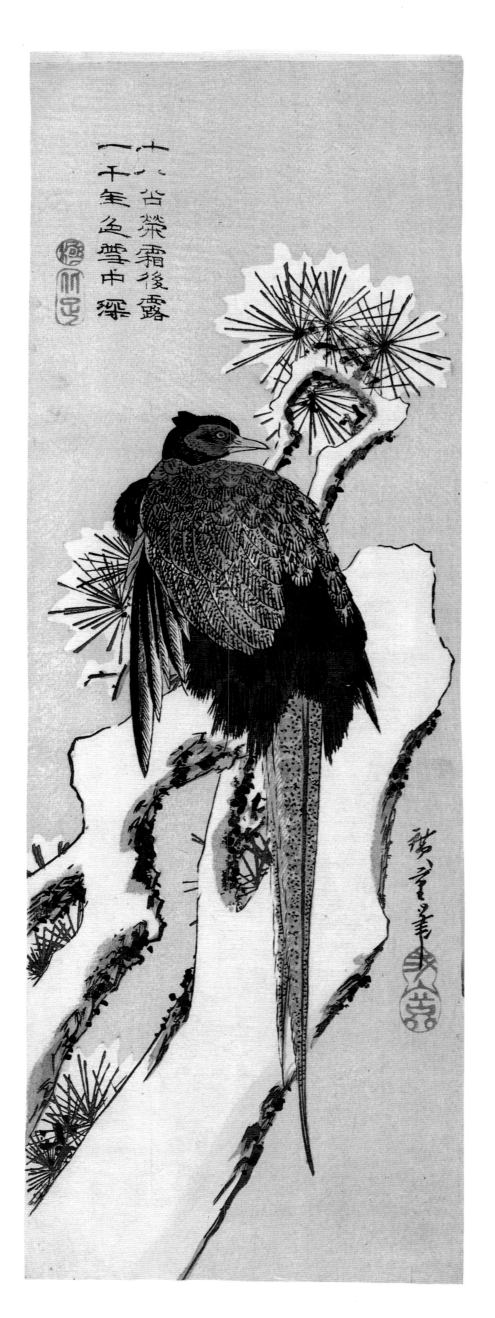

66. A Cuckoo Flying through the Rain

Futa goe a
Gomosaki koezu
hototogisu.[1]

Two voices crossing
high over Gomosaki —
a cuckoo and rain.

Size: Medium Panel. 37.7 × 12.7 cm.
Date: early 1830s
Bird: Cuculuys poliocephalus Latham, *little cuckoo*
Signed: Hiroshige hitsu
Publisher's Mark: Shōeidō han (Kawaguchi Shōzō)
Censor's Seal: Kiwame
Poem: Haiku
Season word: hototogisu, *"cuckoo" (summer)*
Provenance: Yamanaka & Co. (April 3, 1926)
References: Oberlin, 1305.
From the Abby Aldrich Rockefeller Collection of Japanese Prints,
 Museum of Art, Rhode Island School of Design,
 accession number 34.247.

The Japanese cuckoo, or *hototogisu,* is famous in poetry, paintings, and prints and is usually associated with the moon and rain. To farmers, its plaintive cry serves as a springtime reminder to plant rice; but to poets, it is a lament for unrequited love (Volker, p. 40).

The marks at lower left are traces of the adjacent panel with which this design was originally printed.

Another impression of the Rockefeller print is illustrated in the Spaulding sale catalogue (American Art Association [New York, 1921], lot 732).

1. The *hototogisu* is noted not only for his voice but also for his tendency to be somewhere else when bad weather strikes. It seems possible that the bird in this print is voicing dissatisfaction.

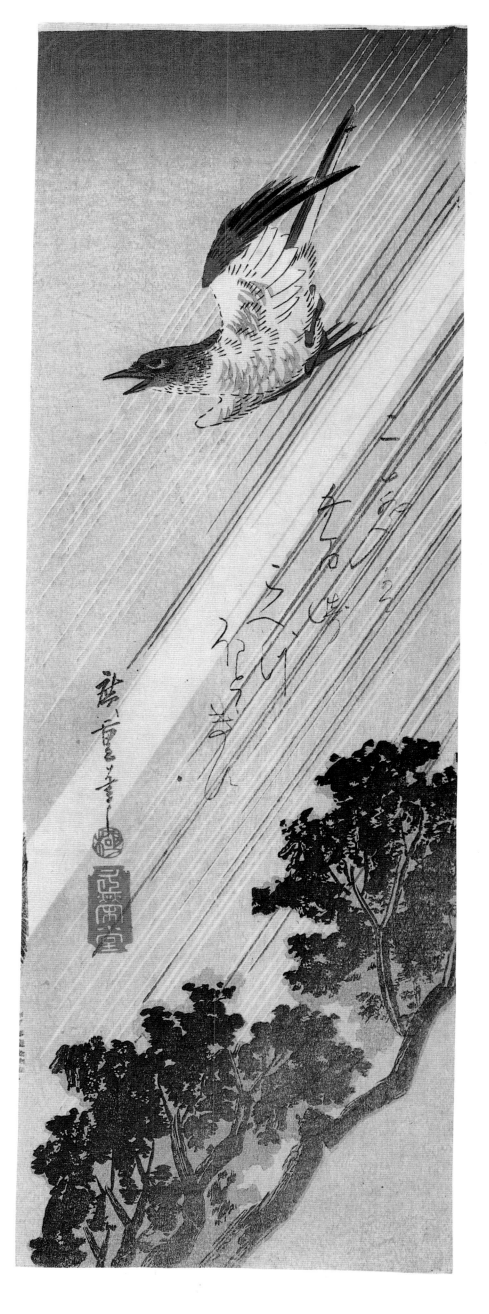

67. A Bird Clinging to a Tendril of Wisteria

Murasaki wo
somuru konya no
mokari hodo
nokiba ni taruru
fuji no hana hira.

Like a purple cloth
dyed and spread upon a frame
in the dyer's shop,
so this wisteria branch
hangs its petals on my eaves.

Size: Medium Panel. 36.9 × 12.8 cm.
Date: mid-1830s
Bird: Parus, spec., titmouse
Flower: Wisteria floribunda, wisteria
Signed: Hiroshige hitsu
Publisher's Mark: Shōeidō han (Kawaguchi Shōzō)
Censor's Seal: Kiwame
Poem: Kyōka
Poem signed: Hachijintei
Provenance: F. E. Church (November 1928)
References: TNM, 3511; Vever, 914; UTK, vol. XI,
* pl. 87; Oberlin, 1309.*
From the Abby Aldrich Rockefeller Collection of Japanese Prints,
* Museum of Art, Rhode Island School of Design,*
* accession number 34.259.*

As is noted in the Amsterdam catalogue (pp. 16–17) this print is from the *kachō-e* series designed for the poet Hachijintei. Plates two, eighteen, and fifty-seven are also in this series.

The prints of this set, like most medium-panel prints, were originally printed two to an *ōban* sheet and then separated. It seems possible that only one design per *ōban* sheet bore the publisher's seal of Shōeidō. This would explain the absence of the publisher's mark in plates two and fifty-seven.

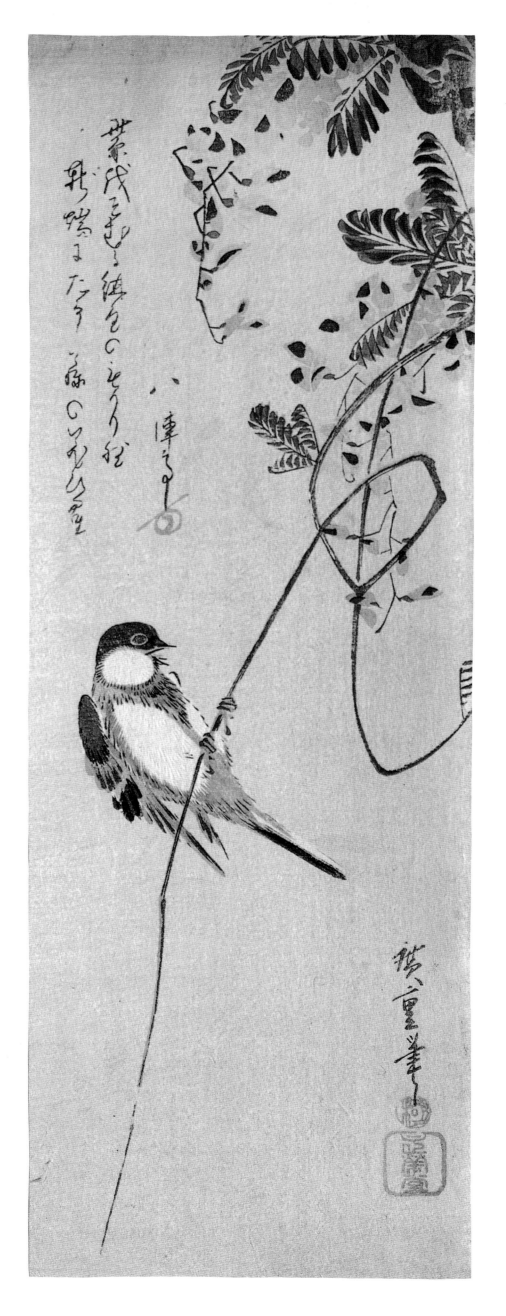

68. Kingfisher and Iris

Kawasemi no
hane wo yosoute
mizu kagami.

Preening his feathers
in a watery mirror —
kingfisher in flight.

Size: Medium Panel. 34 × 11 cm.
Date: ca. 1840?
Bird: Alcedo atthis Linnaeus, *kingfisher*
Flower: Iris ensata, *iris*
Signed: Hiroshige ga
Artist's Seal: Hiro
Poem: Haiku
Season word: semi, *normally "cicada" but here*
 part of the name of the kingfisher, literally
 "river-cicada" (summer)
Provenance: Hayashi; Frank Lloyd Wright
 (purchased through F. W. Gookin, May 1923)
From the Abby Aldrich Rockefeller Collection of Japanese Prints,
 Museum of Art, Rhode Island School of Design,
 accession number 34.179.

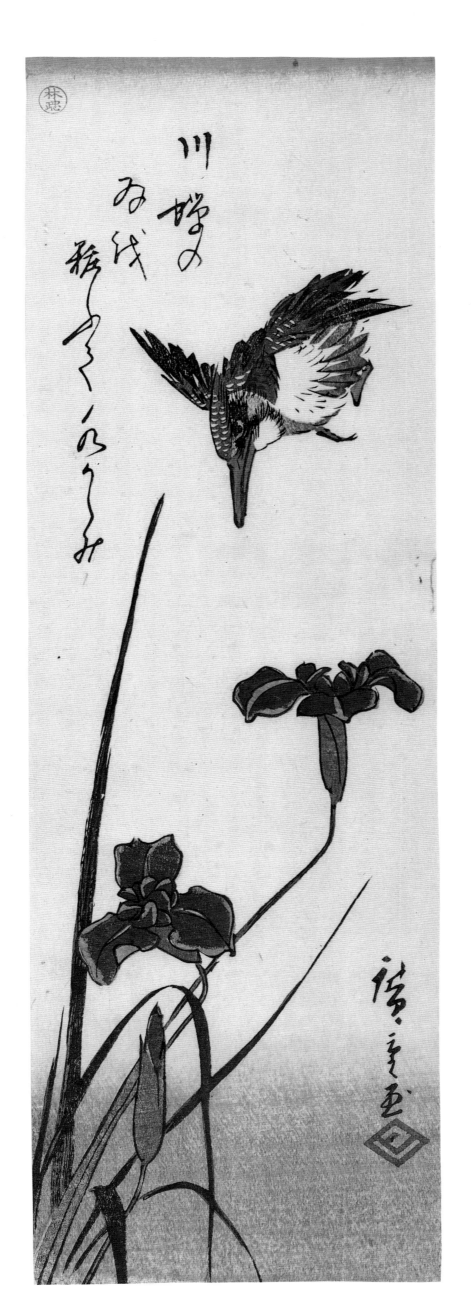

69. A Small Black Bird Clinging to a Tendril of Ivy

Furoshiki[1] no
iro mo kashikoshi
momiji no
shigure ni somuru
tsuta no karakusa.

Ivy arabesques
colorful as a kerchief
tinted with the dyes
of autumn maple leaves
mixed in summer shower rain.

Size: Medium Panel. 37.7 × 12.2 cm
Date: mid-1830s
Bird: Aegithalos caudatus Linnaeus *(?), long-tailed*
 tit
Flower: Vitis *or* Parthenocissus *spec.(?), vine*
Signed: Hiroshige hitsu
Artist's Seal: Ichiryūsai
Poem: Kyōka
Poem signed: Hachijintei
Provenance: F. E. Church (November 1928)
From the Abby Aldrich Rockefeller Collection of Japanese Prints,
 Museum of Art, Rhode Island School of Design,
 accession number 34.260.

A preparatory drawing for this print is illustrated in Richard Kruml, *Birds in Japanese Prints,*
Catalogue 19 (London, 1977). Another impression is in the Honolulu Academy of Arts.

1. The *furoshiki* is a utilitarian square of cloth, variously decorated, which the Japanese use to wrap and carry objects of all kinds. Piles of them, each tied at the corners, used to be a common sight in railroad checkrooms. A stylish woman might carry one under an arm like a handbag, or a man might carry one, tied at the corners and filled with books, let us say. It is not in vogue now, perhaps because Westerners classed the *furoshiki* with eyeglasses and a camera as an identifying characteristic of the Japanese. The word "kerchief" is, at any rate, a mistranslation of the word *furoshiki*, but no other word in English seems to convey more of the many uses of the object it describes.

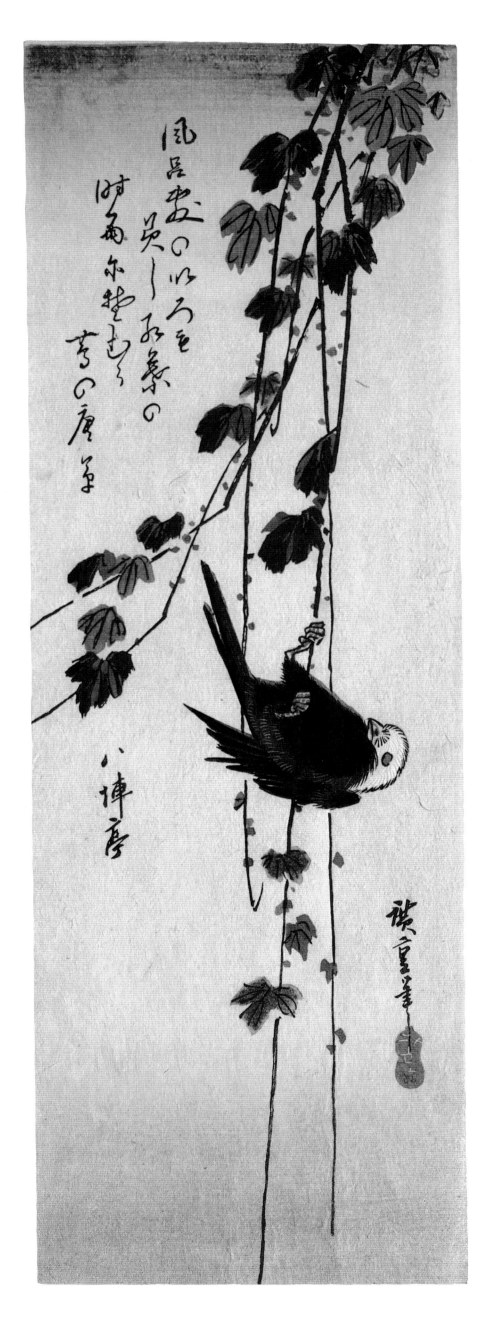

70. A Blue-and-White Flycatcher on a Hibiscus Flower

Size: Medium Panel. 34.1 × 11.1 cm.
Date: Second month of 1854 (Tiger/II)
Bird: Muscicapa cyanomelana *or* Cyanoptila
 cyanomelana Temminck, *blue-and-white*
 flycatcher
Flower: Hibiscus mutabilis, *cotton rose*
Signed: Hiroshige hitsu
Artist's Seal: Ichiryūsai
Publisher's Mark: Tsutaya Kichizō
Censor's Seal: Aratame
Provenance: F. E. Church (November 1928)
From the Abby Aldrich Rockefeller Collection of Japanese Prints,
 Museum of Art, Rhode Island School of Design,
 accession number 34.164.

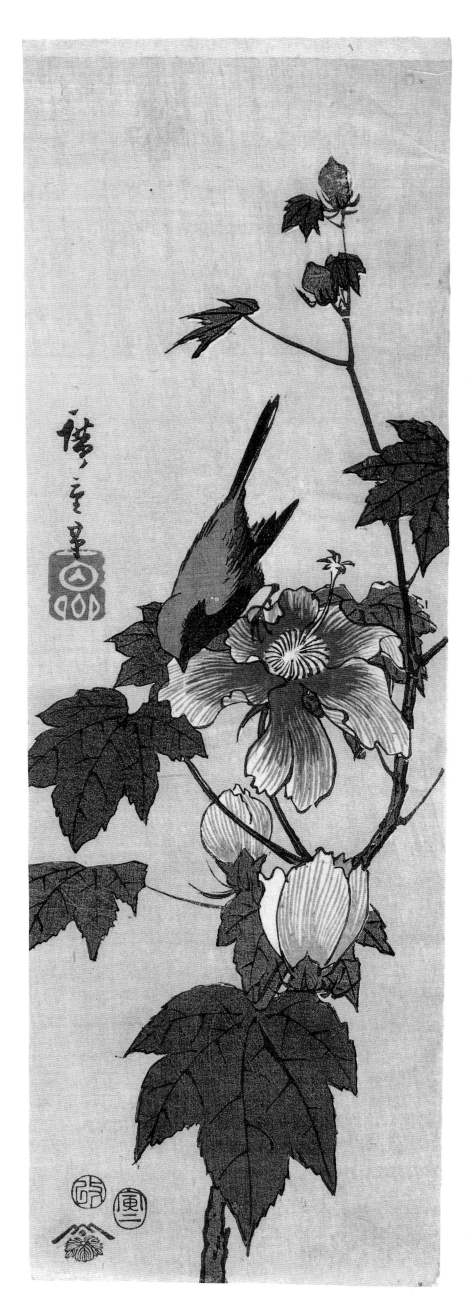

71. Mandarin Ducks in Snowfall

Oshidori no
sakazuki[1] to chiyo
usukōri.

For mandarin ducks
thin ice is a wedding cup
now and forever.

Size: Medium Panel. 34.1 × 11.1 cm.
Date: 1847–52
Bird: Aix galericulata, mandarin duck
Signed: Hiroshige hitsu
Artist's Seal: Hiro
Censors' Seals: Igasa; Watanabe.
Poem: Haiku
Season word: oshidori, "mandarin ducks" (winter)
Provenance: Hirakawa (American Art Association
* [New York, 1917], lot 336).*
From the Abby Aldrich Rockefeller Collection of Japanese Prints,
* Museum of Art, Rhode Island School of Design,*
* accession number 34.132.*

1. See note, Plate #28.

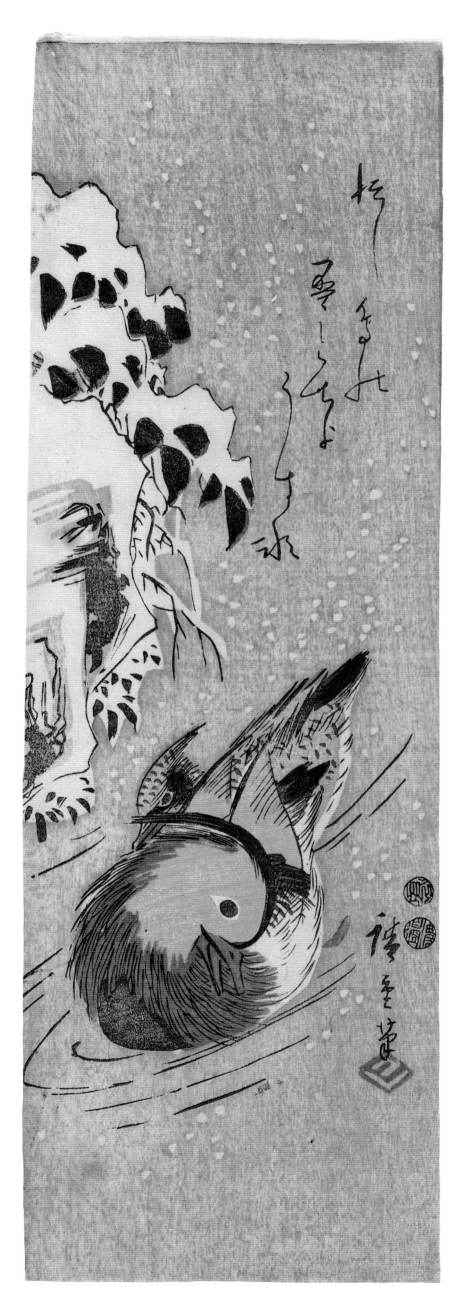

72. Crane and Wave

Size: Quarter-block. 12.7 × 18.4 cm.
Date: mid-1830s
Bird: Grus japonensis Muller, *Japanese crane*
Signed: Hiroshige ga
Publisher's Mark: Kawashō (Kawaguchi Shōzō)
Censor's Seal: Kiwame
Provenance: F. E. Church (October 1928)
From the Abby Aldrich Rockefeller Collection of Japanese Prints,
* Museum of Art, Rhode Island School of Design,*
* accession number 34.040.*

Hiroshige's *koban*, or quarter-block prints, were initially printed four to an *ōban* sheet and then separated. They are as consistent in quality as his larger format prints. Unfortunately, due to their general rarity and small size, they are often neglected and have only rarely been reproduced in the literature. The Rockefeller collection is particularly rich in these small, exquisite prints.

In addition to the Rockefeller collection, the Honolulu Academy of Arts contains a large number of *koban* prints, and an important group were in the Blanchard sale (American Art Galleries [New York, 1916], lots 515–34) including this brilliant design (lot 515, illustrated).

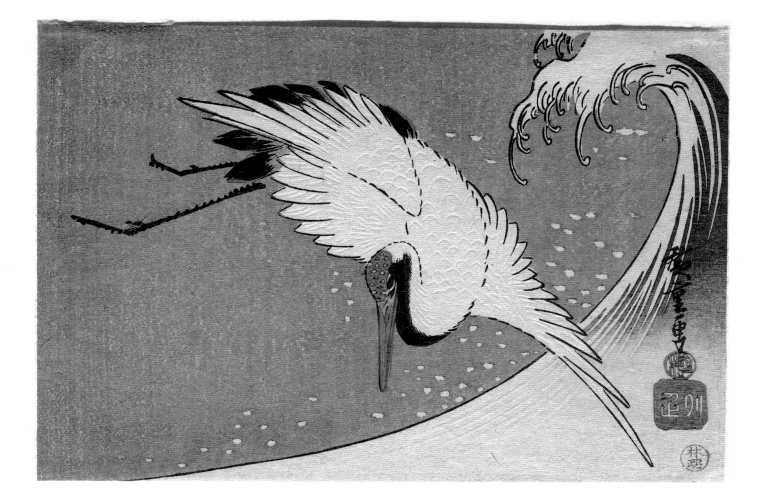

73. Tit and Peony

Size: Quarter-block. 18.7 × 12.9 cm.
Date: 1830s
Bird: Parus varius Temminck & Schlegel, *varied*
 tit
Flower: Paeonia lactiflora, *herbaceous peony*
Signed: Hiroshige hitsu
Publisher's Mark: Kawashō (Kawaguchi Shōzō)
Provenance: F. E. Church (November 1928)
From the Abby Aldrich Rockefeller Collection of Japanese Prints,
 Museum of Art, Rhode Island School of Design,
 accession number 34.059.

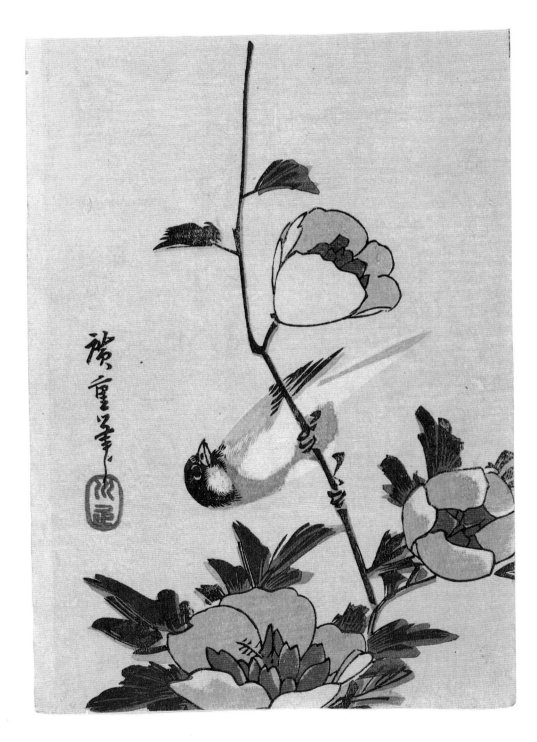

74. Sparrows and Morning Glories

Asagao ya
akarenu sono hi
sono hi kana.

The morning glories
are out today! The morning
glories bloom today!

Size: Quarter-block. 12.3 × 17.8 cm.
Date: late 1830s
Bird: Passer montanus (Linnaeus), tree sparrow
Flower: Pharbitis nil, morning glory
Signed: Hiroshige ga
Artist's Seal: Ichiryūsai
Poem: Haiku
Season word: asagao, "morning glories" (autumn)
Provenance: S. H. Mori (March 20, 1924)
From the Abby Aldrich Rockefeller Collection of Japanese Prints,
* Museum of Art, Rhode Island School of Design,*
* accession number 34.067.*

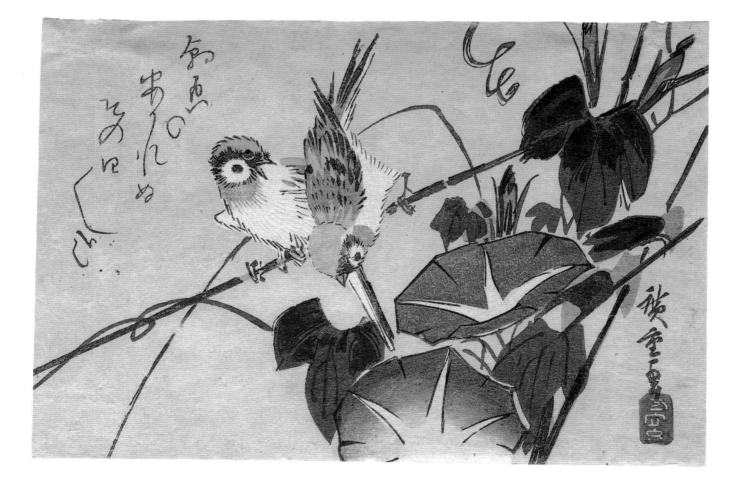

75. Sparrow and Bamboo

The sun goes down;
 a breeze cools the bamboo grove.
I have a drink in autumnal seclusion
 in my high tower.

Size: Quarter-block. 18.1 × 12.1 cm.
Date: late 1830s
Bird: Passer montanus (Linnaeus), *tree sparrow*
Signed: Hiroshige hitsu
Publisher's Mark: Kawashō (Kawaguchi Shōzō)
Poem: Kambun. Shichi-gon-koshi. Two lines of
 seven characters each
Provenance: F. E. Church (November 1928)
References: Buhl, 59.
From the Abby Aldrich Rockefeller Collection of Japanese Prints,
 Museum of Art, Rhode Island School of Design,
 accession number 34.058.

The Buhl impression shows an adjacent print with which this design was originally printed. The use of woodgrain to emulate the texture of the bamboo is brilliantly conceived.

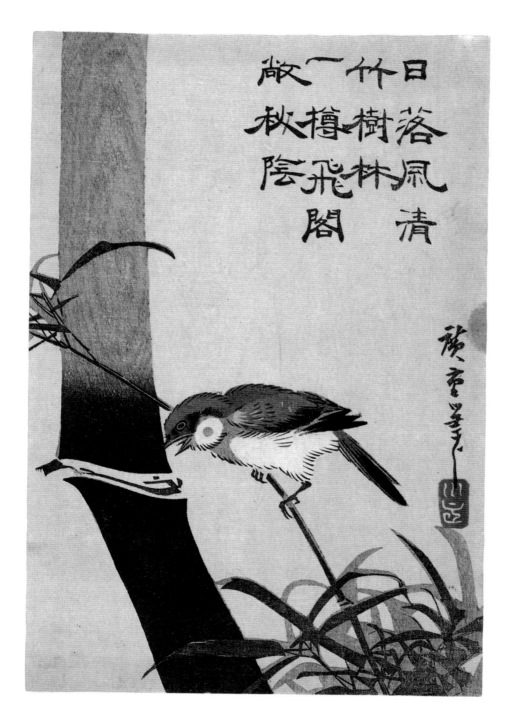

日落風清
竹樹林閣
一樽飛
敝秋陰

76. Fish Swimming in a Stream in which a Duck is Half-Submerged

Size: Quarter-block. 12.2 × 18.4 cm.
Date: late 1830s
Flower: Berberis thunbergii(?)
Signed: Hiroshige hitsu
Publisher's Mark: Kawashō (Kawaguchi Shōzō)
Censor's Seal: Kiwame
Provenance: F. E. Church (November 1928)
From the Abby Aldrich Rockefeller Collection of Japanese Prints,
 Museum of Art, Rhode Island School of Design,
 accession number 34.051.

When designing this print, Hiroshige may have been inspired by a plate from Utamaro's poetry album of ca. 1791, *Momo Chidori Kyōka Awase* ("Numerous Birds Compared in Humorous Verse"), which similarly shows a bird half-submerged in water with small fish swimming by.

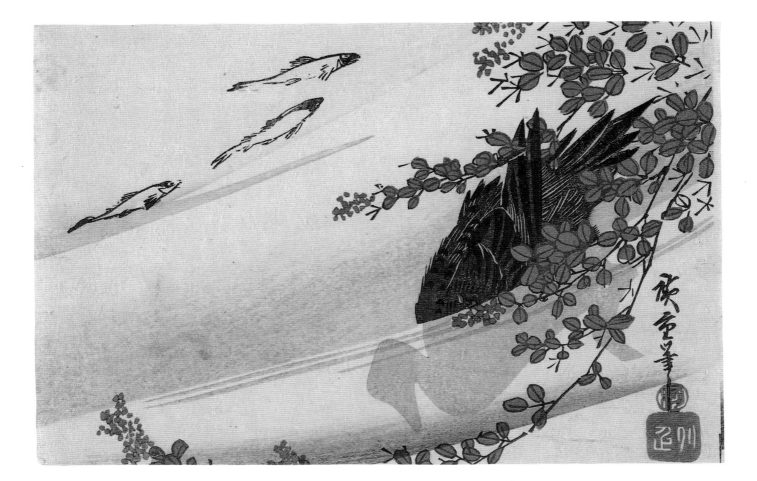

77. Crane and Marsh Grasses

Size: Quarter-block. 16.9 × 11.4 cm.
Date: late 1830s
Bird: Grus japonensis Muller, *Japanese crane*
Signed: Hiroshige hitsu
Artist's Seal: Utagawa
Poem: Kambun. Text unreadable.
Provenance: Frank Lloyd Wright
References:
From the Abby Aldrich Rockefeller Collection of Japanese Prints,
 Museum of Art, Rhode Island School of Design,
 accession number 34.045.

78. Crested Blackbird and Flowering Cherry

Kaidō[1] ya
haru wo shizumete
saki ni keri.

They call it "sea pear,"
and it submerges the spring
when it comes in bloom.

Size: Quarter-block. 12.2 × 18.3 cm.
Flower: Prunus, *ornamental cherry*
Signed: Hiroshige ga
Artist's Seal: Ichiryūsai
Poem: Haiku
Season word: kaidō, "sea pear" (spring)
Poet: Otsuyu
Provenance: Blanchard (American Art Galleries
 [New York, 1916], lot 517).
References:
From the Abby Aldrich Rockefeller Collection of Japanese Prints,
 Museum of Art, Rhode Island School of Design,
 accession number 34.038.

1. An aronia, *Pirus spectacilis.*

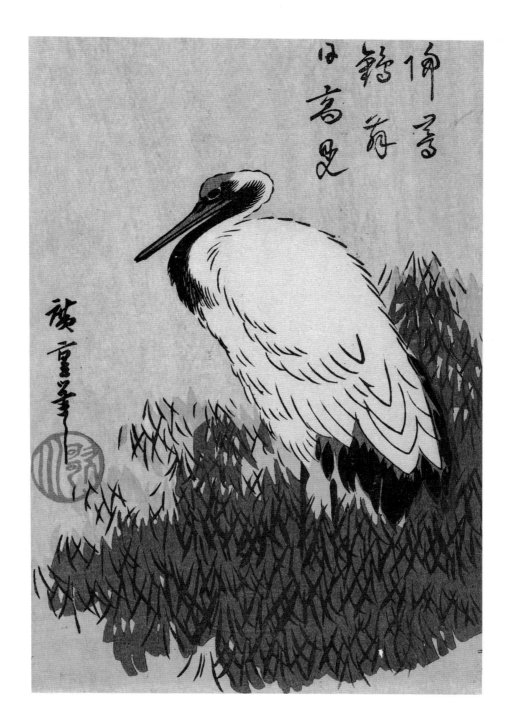

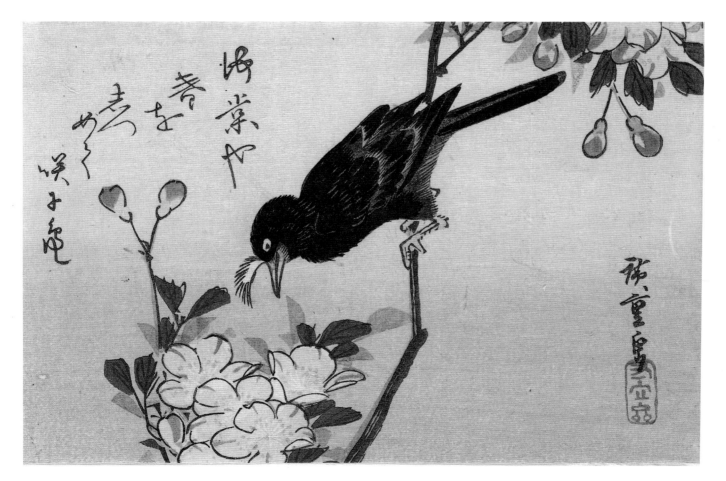

79. A Wagtail Perched on a Leaf

Sekirei ya
futami[1] no ishi o
futa[2] hashira.

Wagtail makes a pair
with the stones at Futami —
a two-winged pillar.

Size: Quarter-block. 11.9 × 17.2 cm.
Date: mid-1830s
Bird: Motacilla alba, white wagtail
Flower: Monochoria korsakowii Regel & Maack
Signed: Hiroshige hitsu
Publisher's Mark: Kawashō (Kawaguchi Shōzō)
Censors' Seal: Kiwame
Poem: Haiku
Season word: sekirei, "wagtail" (autumn)
Poet: Chōsui
Provenance: F. E. Church (November, 1928)
From the Abby Aldrich Rockefeller Collection of Japanese Prints,
* Museum of Art, Rhode Island School of Design,*
* accession number 34.036.*

80. Green Bird and Camellia

Hana no michi
chiru chiru yomo no
akatsubaki.

A flowery path,
covered with fallen petals
of red camellias.

Size: Quarter-block. 11.5 × 17.1 cm.
Date: mid-1830s
Flower: Camellia japonica L., camellia
Signed: Hiroshiga hitsu
Publisher's Mark: Kawashō (Kawaguchi Shōzō)
Artist's Seal: Utagawa
Poem: Haiku
Season word: akatsubaki, "red camellias" (spring)
Provenance: T. Kita (Kyoto, 1921)
From the Abby Aldrich Rockefeller Collection of Japanese Prints,
* Museum of Art, Rhode Island School of Design,*
* accession number 34.054.*

1. The stones at Futami-ga-ura, frequently referred to as the "husband and wife rocks," are the inspiration for countless puns. *Futami* means "two views" or "second meeting." Strong allusion to the mythical connection of the *sekirei* with the sexual education of Izanagi and Izanami, the divine progenitors of the Japanese islands, is made in the pairing of which the bird is a part in the poem.

2. The word *futa* can combine with the syllable following to read *futaba*, which means "two-winged."

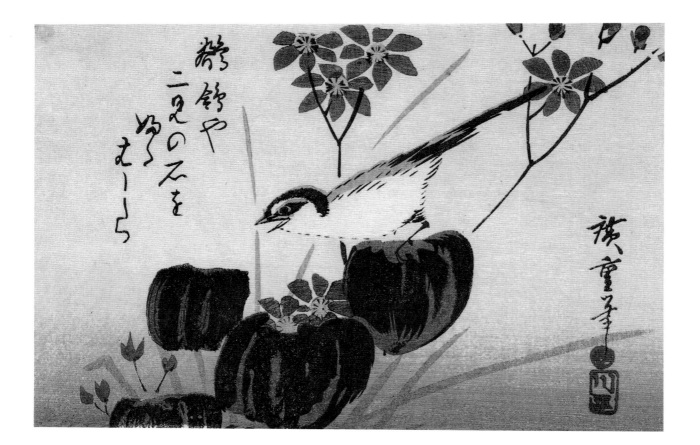

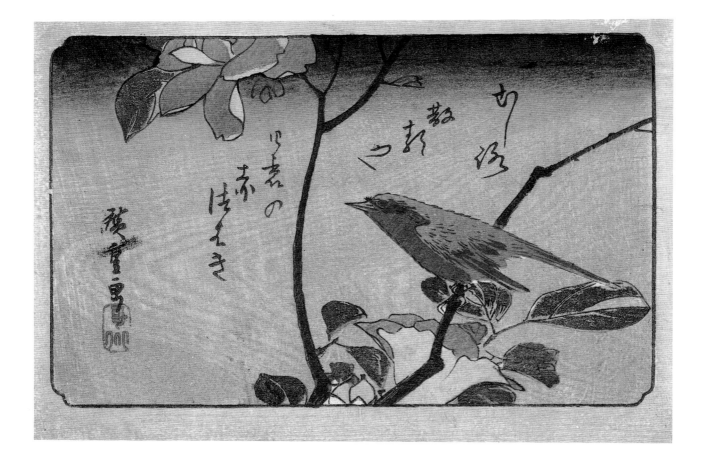

81. A Great Knot Sitting Among Water Grass

Shigi tachite[1]
hitosuji nagaki
shizuku kana.

Starting from the tip
it's a long-distance drip
into the spoonbill.

Size: Quarter-block. 12.1 × 17.7 cm.
Date: mid-1830s
Bird: Calidris tenuirostris, great knot
Flower: Monochoria Korsakowii Regel & Maack
Signed: Hiroshige hitsu
Artists' Seals: Ichiryūsai; Utagawa.
Poem: Haiku
Season word: unclear
Poet: Eika
Provenance: F. E. Church (November 1928)
From the Abby Aldrich Rockefeller Collection of Japanese Prints,
 Museum of Art, Rhode Island School of Design,
 accession number 34.052.

82. A Bird on a Bank of Water

Ato ato wa
shian mo nashi ni
oriru kana.

They fly rank to rank,
but then come to earth again
without a pattern.

Size: Quarter-block. 12.1 × 18.4 cm.
Date: late 1830s
Bird: Anser fabalis Latham (?), bean goose
Signed: Hiroshige ga
Artist's Seal: Utagawa
Poem: Haiku?
Season word: None. Bird in print indicates winter
Provenance: F. E. Church (February 4, 1927)
From the Abby Aldrich Rockefeller Collection of Japanese Prints,
 Museum of Art, Rhode Island School of Design,
 accession number 34.074.

1. If we read this word *tatte*, the translation of this poem becomes:

> When the spoonbill stands,
> there is a long straight line
> of dripping, indeed.

The reading *tachite*, or *tachi de*, however, makes a pun with the word *tachi*, meaning "sword," or *tachite*, meaning "starting with." The last possibility seems to lend itself best to translation in English.

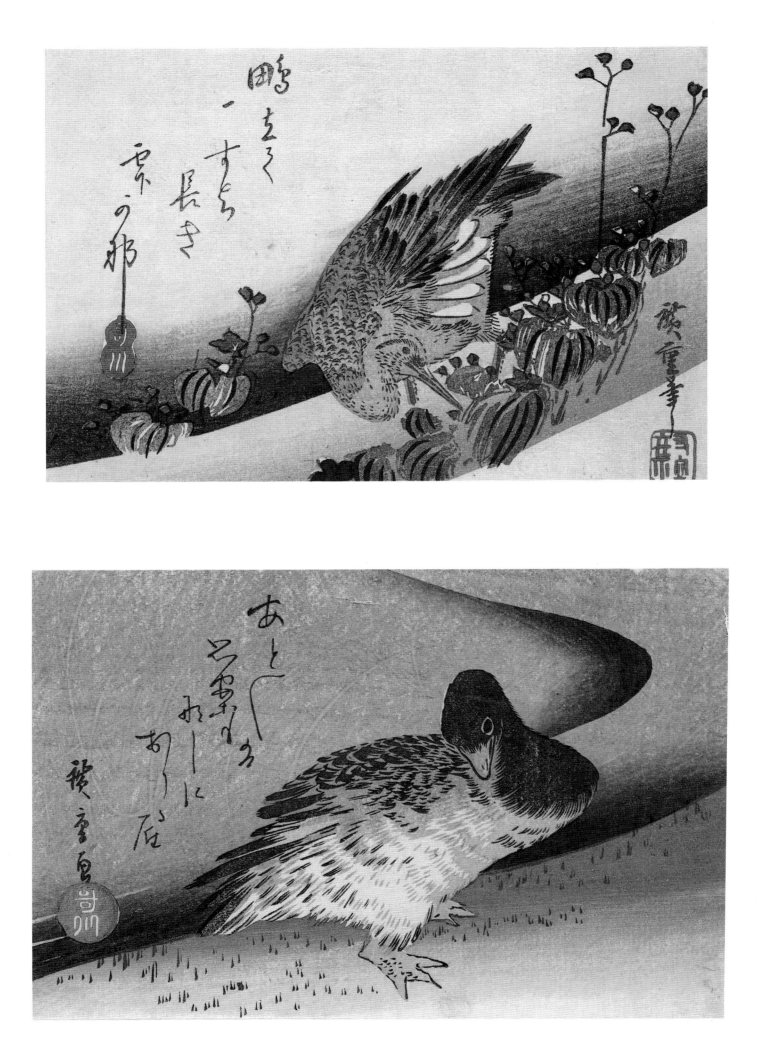

83. A Blue Bird and Iris

Kakitsubata
nitari ya nitari ya
mizu no kage.

Kakitsubata —
it's the same thing, the same thing
in a water mirror.

Size: Quarter-block. 13.1 × 17.7 cm.
Date: late 1830s
Flower: Iris ensata, *iris*
Signed: Hiroshige ga
Publisher's Mark: Sen'ichi (Izumiya Ichibei)
Poem: Haiku
Season word: kakitsubata, *"iris" (summer)*
Poet: Bashō
Provenance: S. H. Mori (March 20, 1924)
From the Abby Aldrich Rockefeller Collection of Japanese Prints,
 Museum of Art, Rhode Island School of Design,
 accession number 34.065.

84. Three Swallows on the Wing

Yo no naka no
yokohaba shiranu
tsubame kana.

All the world's concern
with the horizontal plane
is lost on swallows.

Size: Quarter-block. 12.2 × 17.2 cm.
Date: ca. late 1830s
Bird: Hirunda rustica Linnaeus, *house swallow*
Flower: Salix babylonica, *weeping willow*
Artist's Seal: Hiroshige
Publisher's Mark: Sen'ichi (Izumiya Ichibei)
Poem: Haiku
Season word: tsubame, *"swallow" (spring)*
Poet: Ryūkyō
Provenance: F. E. Church (November 1928)
From the Abby Aldrich Rockefeller Collection of Japanese Prints,
 Museum of Art, Rhode Island School of Design,
 accession number 34.053.

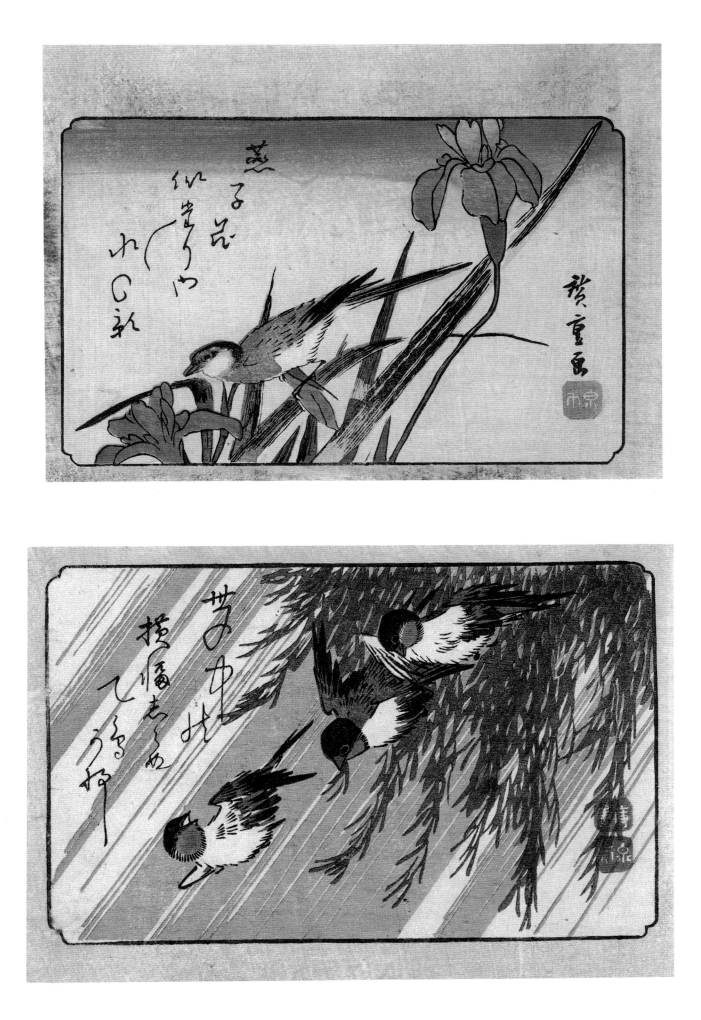

85. A Black Paradise Flycatcher and Blossoms

Karisome ni
haete momo saku
hatake kana.

A field all in flame,
shining for a brief moment
with peach blossoms.

Size: Quarter-block. 12.7 × 19.5 cm.
Date: mid-1830s
Bird: Terpsiphone atrocandata Eyton, *black*
paradise fly-catcher
Flower: Rhododendron *spec., "azalea"*
Signed: Hiroshige hitsu
Artist's Seal: Ichiryūsai
Poem: Haiku
Season word: momo, *"peach" (spring)*
Poet: Shinryū
Provenance: F. E. Church (November 1928)
References: Oberlin, 1350.
From the Abby Aldrich Rockefeller Collection of Japanese Prints,
Museum of Art, Rhode Island School of Design,
accession number 34.057.

86. A Sleepy Owl Perched on a Branch of Pine

Size: Quarter-block. 12.8 × 18.7 cm.
Date: mid-1830s
Bird: Ninox scutulata Raffles *(?), brown hawk owl*
Flower: Pinus *spec., pine*
Signed: Hiroshige hitsu
Artist's Seal: Utagawa
Provenance: F. E. Church (October 1928)
From the Abby Aldrich Rockefeller Collection of Japanese Prints,
Museum of Art, Rhode Island School of Design,
accession number 34.041.

87. Bullfinch Flying near a Branch of Clematis

Size: Quarter-block. 12.5 × 18 cm.
Date: 1830s
Bird: Pyrrhula pyrrhula Griseiventris
 Lefresnaye, *bullfinch*
Flower: Clematis florida Thunberg, *clematis*
Signed: Hiroshige ga
Artist's Seal: Hiroshige
Provenance: Hayashi; F. E. Church (November
 1928)
From the Abby Aldrich Rockefeller Collection of Japanese Prints,
 Museum of Art, Rhode Island School of Design,
 accession number 34.055.

88. A Titmouse on a Branch of Cherry

Hi no tsukanu
tokoro ka mo nashi
yama sakura.

With not even one
place that is not afire —
the mountain cherry.

Size: Quarter-block. 11.5 × 17.2 cm.
Date: mid-1830s
Bird: Parus major Linneaus, *great tit*
Flower: Prunus, *cherry*
Signed: Hiroshige hitsu
Artist's Seal: Utagawa
Poem: Haiku
Season word: sakura, *"cherry" (spring)*
Provenance: T. Kita (Kyoto, 1921)
From the Abby Aldrich Rockefeller Collection of Japanese Prints,
 Museum of Art, Rhode Island School of Design,
 accession number 34.037.

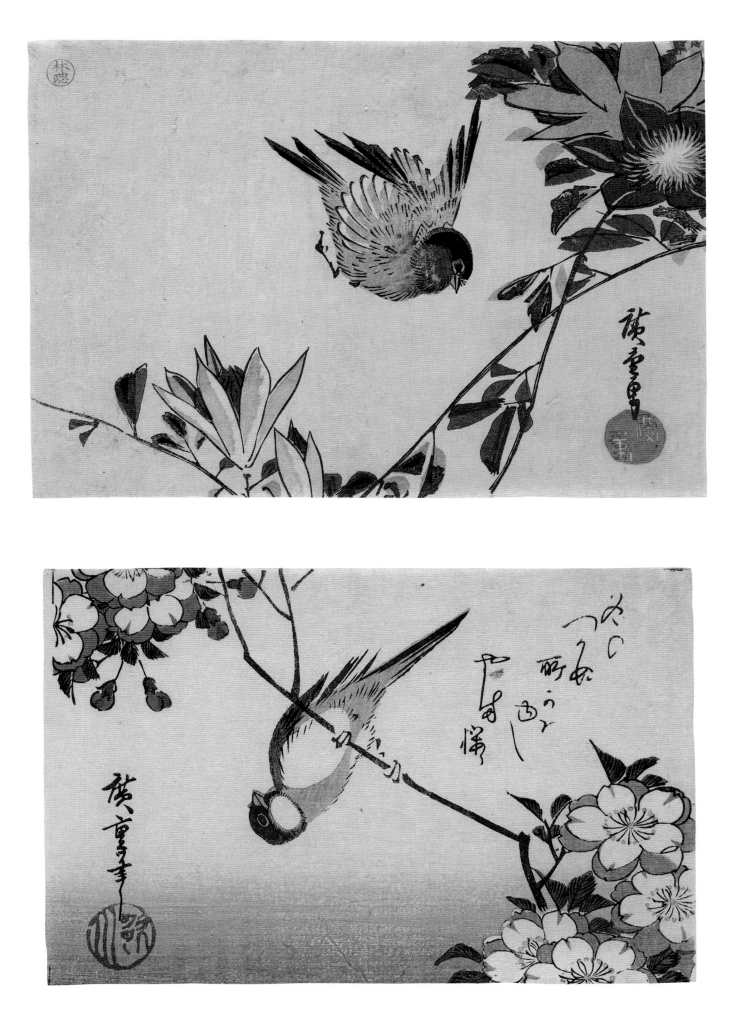

89. A Cuckoo Flying over Ships' Masts

Ho bashira no
tonari mo jōryū
hototogisu.

The shipmasts' neighbors
are of the highest water —
cuckoo, for instance.

Size: Quarter-block. 12.1 × 18.2 cm.
Date: mid-1830s
Bird: Cuculuys poliocephalus Latham, *little cuckoo*
Signed: Hiroshige ga
Artist's Seal: Ichiryūsai
Poem: Haiku
Season word: hototogisu, *"cuckoo" (summer)*
Provenance: S. H. Mori (March 20, 1924)
From the Abby Aldrich Rockefeller Collection of Japanese Prints,
 Museum of Art, Rhode Island School of Design,
 accession number 34.066.

90. Wild Geese Flying across a Crescent Moon

Size: Quarter-block. 13 × 18.3 cm.
Date: mid-1830s
Bird: Anser fabulis Latham *(?), bean goose*
Signed: Hiroshige ga
Artist's Seal: Ichiryūsai
Provenance: S. H. Mori (March 20, 1924)
From the Abby Aldrich Rockefeller Collection of Japanese Prints,
 Museum of Art, Rhode Island School of Design,
 accession number 34.064.

91. An Eagle Flying over the Hundred-Thousand *Tsubo* Plain at Susaki near Fukagawa (*Fukagawa susaki Jūmantsubo*). From the series *Edo Meisho Hyakkei* ("One Hundred Famous Views of Edo")

Size: Oban. 35.8 × 22.5 cm.
Date: Fifth month of 1857 (Snake/V). (The date
* seal is lost in this impression due to the*
* trimming of the left margin.)*
Bird: Spizaetus nipalensis orientalis Hodgson (?),
* Hodgson's hawk eagle*
Signed: Hiroshige ga
Publisher's Mark: Uoya Eikichi (trimmed)
Censor's Seal: Aratame (trimmed)
Provenance: F. E. Church (November 1928)
References: TNM, 3649; Ledoux, 49; Tamba, 274;
* Suzuki, 174; Vever, 950; UTK, vol. XI., pl. 51;*
* Oberlin, 730; Amsterdam, 91; Buhl, 139.*
From the Abby Aldrich Rockefeller Collection of Japanese Prints,
* Museum of Art, Rhode Island School of Design,*
* accession number 34.420.*

This is a fine, early impression of the first edition. Later impressions lack the extra shading in the eagle's beak and the lacquer gloss on the claws. The "One Hundred Famous Views of Edo" was among the most popular of mid-nineteenth-century series, and as successive impressions of this print were pulled, the sky became progressively darker, so that in late editions of this print, the design is printed as if it were a night scene.

Hiroshige had earlier experimented with integrating birds within the landscape setting of his native Edo in an interesting and rare series of the mid-1830s, *Shinkoku Tōto Meisho* ("A Newly Engraved Series of Famous Places in the Eastern Capital") (See Amsterdam, fig. 36). Several other plates from the "One Hundred Famous Views of Edo" also make use of birds and flowers. None of these prints, however, captures the feeling of a bird's flight amidst a vast and spacious landscape as naturalistically as in this extraordinary design.

Bibliography

This list includes the basic sources used for the essays and plates in Japanese and English. An extensive bibliography for Hiroshige in Japanese can be found in Suzuki Jūzō and "Hiroshige," *Kobijutsu* (below).

Secondary Sources

Addiss, Stephen, ed. *Japanese Quest for a New Vision; The Impact of Visiting Chinese Painters, 1600-1900.* Lawrence, Kansas: Spencer Museum of Art, 1986.

The Art of Shibata Zeshin; The Mr. and Mrs. E. O'Brien Collection at the Honolulu Academy of Arts. Catalogue by Howard A. Link. Essays by Mary Louise O'Brien and Martin Foulds. London: Robert G. Sawers in association with the Honolulu Academy of Arts, 1979.

Bartlett, Harley H. and Hide Shihara. "Japanese Botany in Japanese and Chinese Book Illustration." *ASA Grey Bulletin,* NS III (1961).

Bowie, Theodore with James T. Kenney and Fumiko Togasaki. *Art of the Surimono.* Bloomington: Indiana University Art Museum, 1979.

Bickford, Maggie, et. al. Sheila Schwartz and Barbara Hofmaier, eds. *Bones of Jade, Soul of Ice: The Flowering Plum in Chinese Art.* New Haven: Yale Art Gallery, 1985.

Brindle, John V. and James J. White. *Talking in flowers: Japanese Botanical Art. Catalogue of an Exhibition.* Pittsburgh: The Hunt Institute for Botanical Documentation, Carnegie Mellon University, 1982.

Cahill, James. *Scholar Painters of Japan: The Nanga School.* New York: The Asia Society Galleries, 1972.

———. *Parting at the Shore: Chinese Painting of the Early and Middle Ming Dynasty, 1368-1580.* Tokyo and New York: Weatherhill, 1978.

Catalogue of the Valuable Collections of Japanese Color Prints, Illustrated Books and a Few Kakemono, the Property of John Stewart Happer, Esq. London: Sotheby's, 1909.

Chartier, Roger. "Culture as Appropriation: Popular Cultural Uses in Early Modern France." In *Understanding Popular Culture: Europe from the Middle Ages to the Nineteenth Century.* Edited by Steven L. Kaplan. New York: Mouton, 1984.

Chibbett, David. *The History of Japanese Printing and Book Illustration.* New York and San Francisco: Kodansha International, 1977.

Crighton, Robert A. *The Floating World: Japanese Popular Prints 1700-1900.* London: Victoria and Albert Museum, 1973.

Edmonds, William H. *Pointers and Clues to the Subjects of Chinese and Japanese Art.* London: Sampson, Low, Marston, n.d. (1934). Reprint. Geneva: Minkoff, 1974.

Flowers and Birds Motif in Asia; International Symposium on Arthistorical [sic] *Studies.* Kyoto: The Society for International Exchange of Arthistorical [sic] Studies, Kyoto National Museum and the Taniguchi Foundation, 1 (1982).

Forrer, Matthi. "History and Development of Edo Egoyomi and Surimono." In *Proceedings of the First International Symposium of Surimono.* Winter Park: International Surimono Society, 1979.

French, Calvin L. *Shiba Kōkan: Artist, Innovator, and Pioneer in the Westernization of Japan.* Tokyo and New York: Weatherhill, 1974.

Goodman, Grant John. *Japan: The Dutch Experience.* London; Dover, N.H.: The Athlone Press, 1986.

Gunsaulus, Helen C. *Japanese Prints by Early Masters.* Chicago: The Art Institute of Chicago, 1946.

Hibbett, Howard. *The Floating World in Japanese Fiction.* New York: Grove Press, 1960.

Hickman, Money L. "Views of the Floating World." *MFA Bulletin of the Museum of Fine Arts,* 76 (1978), pp. 4-33.

Hillier, Jack. *The Art of the Japanese Book.* 2 vols. London: Sotheby's, 1987.

———. *Catalogue of Japanese Paintings and Prints in the Collection of Mr. and Mrs. Richard P. Gale.* 2 vols. London: Routledge and Kegan Paul, for the Minneapolis Institute of Arts, 1970.

———. *Japanese Prints and Drawings from the Vever Collection.* 3 vols. London and New York: Sotheby Parke Bernet and Rizzoli International, 1976.

———. *The Uninhibited Brush: Japanese Art in the Shijo Style.* London: Hugh M. Moss, 1974.

——— and Lawrence Smith. *Japanese Prints: 300 Years of Albums and Books.* London: The Trustees of the British Museum and British Museum Publications, 1980.

Hiroshige: A Shoal of Fishes. New York: The Metropolitan Museum of Art and The Viking Press, 1980.

"Hiroshige." *Kobijutsu.* Special issue no. 3 (March, 1983).

Honjo, Eijiro. *Economic Theory and History of Japan in the Tokugawa Period.* New York: Russell and Russell, 1965.

Hulton, Paul and Lawrence Smith. *Flowers in Art from East and West.* London: British Museum Publications, 1979.

Illustrated Catalogues of the Tokyo National Museum. Ukiyo-e Prints. 3 vols. Tokyo: Tokyo National Museum, 1960-63.

Ives, Colta. *The Great Wave: The Influence of Japanese Woodblock Prints on French Prints.* New York: The Metropolitan Museum of Art, 1974.

Izzard, Sebastian. *Hiroshige: An Exhibition of Selected Prints and Illustrated Books.* New York: The Ukiyo-e Society of America, 1983.

Japanese Birds and Flowers; Twelve album paintings by Kōyō. London: The Trustees of the British Museum and British Museum Publications, 1978.

Kachō no bi (The Splendor of Kachō). Kyoto: Kyoto National Museum, 1982.

Kachō no Sekai (The World of Birds and Flowers). 11 vols. Tokyo: Gakken, 1981-83.

Kanō Hiroyuki. "Hiroshige and Keisai" (in Japanese). In vol. 8, *Kacho no sekai* series. Edited by Kōno Motoaki. Tokyo: Gakken, 1982.

Kenney, James T. "A Brief History of Kyōka and the Edo Kyōka Movement." In *Art of the Surimono.* Edited by Theodore Bowie. Bloomington: Indiana University Art Museum, 1979.

Keyes, Roger S. *Japanese Woodblock Prints: A Catalog of the Mary A. Ainsworth Collection.* Oberlin: Oberlin College, 1984.

———. *Surimono: Privately Published Japanese Prints in the Spencer Museum of Art.* Tokyo and New York: Kodansha International, 1984.

Ledoux, Louis V. *Hokusai and Hiroshige. Japanese Prints in the Collection of Louis V. Ledoux.* Vol. 5. Princeton: Princeton University Press, 1951.

Link, Howard and Toru Shimbo. *Exquisite Visions; Rimpa Paintings from Japan.* Honolulu: Honolulu Academy of Arts in association with Japan House Gallery, 1980.

Marks, Alfred H. and Edythe Polster. *Surimono: Prints by Elbow.* Baltimore: Lovejoy Press, 1980.

Meissner, Kurt. *Japanese Woodblock Prints in Miniature: Surimono.* Rutland, Vermont: Charles E. Tuttle, 1970.

Narazaki Muneshige. Trans. John Bester. *Studies in Nature: Hokusai and Hiroshige. Masterworks of Ukiyo-e* series. Tokyo and Palo Alto: Kodansha International, 1970.

Pulverer, Gerhard. "Nigiri Kobushi: The Book of Falcons and Falconry." In *Essays on Japanese Art Presented to Jack Hillier.* Edited by Matthi Forrer. London: Robert G. Sawers, 1982.

Robinson, Basil W. *Hiroshige.* London and New York: Blanford Press and Barnes and Noble, 1964.

Sansom, George. *A History of Japan, 1615-1867.* Stanford: Stanford University Press, 1963.

Sheldon, Charles David. *The Rise of the Merchant Class in Tokugawa Japan, 1600-1868.* Locust Valley: J.J. Augusta, 1958.

The Shogun Age Exhibition from the Tokugawa Art Museum, Japan. Tokyo and Nagoya: The Shogun Age Exhibition Committee and Tokugawa Reimeikai, 1983.

Smith, Henry D. II and Amy G. Poster. *Hiroshige: One Hundred Famous Views of Edo.* New York: George Braziller, 1986.

Stern, Harold P. *Birds, Beasts, Blossoms, and Bugs: The Nature of Japan.* New York: Harry N. Abrams in association with the U.C.L.A. Art Council and the Frederick S. Wight Gallery, Los Angeles, 1976.

Strange, Edward F. *The Colour-Prints of Hiroshige.* Cassell and Co., n.d. (1925). Reprint. New York: Dover, 1983.

Suzuki Jūzō. *Utagawa Hiroshige* (in Japanese). Tokyo: Nihon keizai shinbunsha, 1970.

Tamba Tsuneo. *The Art of Hiroshige* (in Japanese). Tokyo: 1970.

Toda Teisuke. "Chinese Painters in Japan." In *Japanese Painters in the Literati Style.* Edited by Yoshiho Yonezawa and Chu Yoshizawa. Trans. Betty Iverson Monroe. New York and Tokyo: Weatherhill and Heibonsha, 1974.

Uchida Minoru. *Hiroshige.* Revised ed. Tokyo: Iwanami shoten, 1932.

Utamaro: A Chorus of Birds. Introd. by Julia Meech-Pekarick and notes and translations by James T. Kenney. New York: The Metropolitan Museum of Art and The Viking Press, 1981.

Van Rappard-Boon, Charlotte. *Catalogue of the Collection of Japanese Prints. Part IV: Hiroshige and the Utagawa School.* Amsterdam: Rijksmuseum, 1984.

Vignier, Charles and H. Inada. *Estampes japonaises exposées au Musée des Arts Décoratifs.* 6 vols. Paris: Musée des Arts Décoratifs, 1909-14.

Volker, Tye. *The Animal in Far Eastern Art.* Leiden: E.J. Brill, 1975.

———. "Ukiyo-e Quartet: Publisher, Designer, Engraver and Printer." *Mededelingen Van Het, Rijksmuseum Voor Volkenkunde* 5 (1949). Leiden: E.J. Brill, 1949.

Watanabe S. *Hiroshige Go-kaiki Tsuizen Kinen Isaku Tenrankai Mokuroku (Catalogue of the Memorial Exhibition of Hiroshige's Works on the Sixtieth Anniversary of His Death).* Tokyo: n.p., 1918.

Yamanouchi Chōzō. *Nihon nanga shi (The History of Japanese Nanga).* Tokyo: Ruri shobo, 1981.

Yoshizawa Chu and Yonezawa Yoshiho. *Bunjin-ga (Literati Painting).* Vol. 23. *Nihon no bijutsu* series. Tokyo: Heibonsha, 1966.

Primary Sources (modern editions)

Bukō nenpyō: Kaneko Mitsuharu, ed., *Zōtei Bukō nenpyō.* 2 vols. (original compiled by Saitō Gesshin, with a sequel) Tokyo: Heibonsha Tōyō bunko, 1968.

Reference Works

Fujimura Tsukuru, ed. *Nihon bungaku daijiten.* 8 vols. Tokyo: Shinchosha, 1950-52.

Harigaya, Shokichi and Suzuki Jūzō. *Ukiyo-e bunken mokuroku.* Tokyo: Mitō Shooko, 1962.

Ishii Kendō. *Nishiki-e no hori to suri.* Tokyo: Geisosha, 1929.

Kano Kaian. *Kyōka jimmei jisho.* Tokyo: Bunkyodō and Hirota Shoten, 1928.

Maeda Isamu, ed. *Edogo Daijiten.* Tokyo: Kodansha, 1974.

Mitchell, C.H. and Osamu Ueda. *The Illustrated Books of the Nanga, Maruyama, Shijō and Other Related Schools of Japan. A Biobibliography.* Los Angeles: Dawson's Book Shop, 1972.

Nihon Ukiyo-e kyōkai, ed. *Genshoku ukiyo-e daihyakka jiten.* 11 vols. Tokyo: Taishukan shoten, 1980-82.

Ukiyo-e Taikei. 17 vols. Tokyo: Shueisha, 1975-77.

Wakatsuki Shiran. *Tokyo nenjū gyōji.* 2 vols. Shunyodō, 1911. Reissued with annotations by Asakura Haruhiko, 2 vols. Tokyo: Heibonsha Toyo bunko, 1968.

Yoshida Teruji. *Ukiyo-e jiten.* 3 vols. Second edition. Tokyo: Gabundō, 1972.